Sex Spoken Here

Good Vibrations
Erotic Reading Circle Selections

Carol Queen & Jack Davis, Editors

Down There Press
San Francisco

Sex Spoken Here © 1998 by Carol Queen and Jack Davis
Individual contributions © 1998 by their authors

Library of Congress Cataloging-in-Publication Data

Sex Spoken Here : Good Vibrations Erotic Reading Circle selections / edited by Carol Queen & Jack Davis.
 p. cm.
 ISBN 0-940208-19-9 (pbk.)
 1. Erotic literature, American. 2. American literature—20th century. I. Queen, Carol. II. Davis, Jack, 1950- . III. Good Vibrations Erotic Reading Circle.
PS509.E7S48 1998
810.8'03538—dc21 97-44294
 CIP

We offer librarians an Alternative CIP prepared by Sanford Berman, Head Cataloger at Hennepin County Library, Edina MN.

Alternative Cataloging-in-Publication Data

Queen, Carol, 1950-
 Sex spoken here : Good Vibrations Erotic Reading Circle selections. Carol Queen & Jack Davis, editors. San Francisco, CA: Down There Press, copyright 1998.
 Forty-three erotic short stories and poems—by Blake C. Aarens, Trebor, Tristan Taormino, Rachel Power, Lori Selke, and others—originally read aloud at Good Vibrations Erotic Reading Circles in Berkeley and San Francisco.
 1. Erotic fiction, American. 2. Short stories, American—20th Century. 3. erotic poetry, American. 4. American poetry—20th Century. 5. Gay erotica. 6. Lesbian erotica. 7. Good Vibrations Erotic Reading Circles. I. Davis, Jack, 1950- II. Down There Press. III. Good Vibrations, San Francisco, California. IV. Title. V. Title: Spoken sex. VI. Title: Good Vibrations Erotic Reading Circle selections.
810.80353

Additional copies of this book are available at your favorite bookstore or directly from the publisher:
 Down There Press, 938 Howard St., #101, San Francisco CA 94103
Please enclose $18.75 for each copy ordered, which includes $4.25 postage and handling.

Cover design by Revel Graphics Printed in the United States of America

Visit our website: *www.goodvibes.com/dtp/dtp.html* 9 8 7 6 5 4 3 2 1

Contents

Dedication

To the writers,
including those who haven't yet visited
the Erotic Reading Circle.

Reprinted Stories

"What A Man and A Woman Can Do" is an excerpt from the final draft of Blake C. Aarens's novel *Cowards of Conscience*. An earlier version appeared in *Tasting Life Twice* under the title "Angels and Ministers of Grace."

Mark Elk Baum's performance piece "Song of Solomon" first appeared in *RFD*.

Scotty Brookie's story "Walking in Circles" first appeared in *The Lavender Reader* (Santa Cruz, CA).

"Artemis," by Carol Queen, first appeared in *Frighten the Horses*.

"Anthony" first appeared in *Skim Lizard*, Issue #2 (Puppytoss, Berkeley, California), © 1992 by Thomas Roche, and subsequently in *Dark Matter* (Rhinoceros Books, 1997).

Lawrence Schimel's story "Clothes Make the Man," appeared in *Paramour*, Spring 1997, and *Best Gay Erotica 1998* (Cleis).

Simon Sheppard's "Afterlife" originally appeared in Drummer #201. "Good Humored" was published online in *Fishnet* (www.fishnet-mag.com).

horehound stillpoint's "Open Throttle Full Steam Ahead" was first published in *Waterboys*, a San Diego 'zine.

Earlier versions of Tristan Taormino's story "Bombshell" appeared in *Blue Blood* and *The Femme Mystique*, edited by Lesléa Newman (Alyson Publications, 1995).

Trebor's poem "Faerie Gathering" has appeared in *Nomenews*; "Religion" and "Sex With Him" appeared in *Dingus*; "Sex and Death" appeared in *Eidos*.

All selections reprinted with permission.

Acknowledgments

Carol's thanks: Robert, Lawrence Schimel, the nice guy from Sherlock's Haven (for looking up cigar names so I could make sure everything was spelled right), and Mark Stuertz, whose story "Sophie's Smoke" made me want to put together this book. And of course Jack, who was — and is — a pleasure to work with.

Jack's thanks: My parents who said, "We don't want to be in your book, but we want to have a copy when it comes out," and to Carol. It is one of my life's goals to have as much fun as she does.

Introduction

FOR MANY YEARS I WROTE THE INTENSELY PRIVATE erotica that is probably more common than the writing we find in books and magazines: hot love letters, explicit journal entries, a story or two that I had no real plan to show anyone else. The road to publication for new writers is rarely easy, and a couple of rejections had left me not especially inclined to try again, especially with something as personal as my erotic writing.

Then I heard about the Erotic Reading Circle at Good Vibrations. I don't remember in exactly what year I first ventured into the tiny store on 22nd Street in San Francisco, but it must have been before 1989, the year the store moved to its bigger digs on Valencia. It was certainly before 1990, the year my first erotic story was published. In those years, the ERC was a small, friendly group of women, founded by Joani Blank and hosted by Laura Miller and Cathy Winks, and reading there—to applause!—changed my ideas about what was possible. Before long I was sending the stories I wrote to small sex-oriented 'zines, getting them published, reading in front of audiences much larger than the one at the Reading Circle. But I'm certain that the Circle kick-started my writing career, gave me a safe and supportive place to trot out ideas, get a little feedback, and—most importantly—be heard. I started working at Good Vibrations myself in 1990, and before long I began facilitating the Circle. It was still a women-only event, and writers who read their work there often submitted it for inclusion in one of the *Herotica*® volumes edited by Susie Bright and Joani Blank (and later Susie alone, and then Marcy Sheiner). Other readers brought short pieces they'd sold to *Penthouse Letters* or read passages from their favorite erotic stories. Mixed up with the original stories,

poems, and journal entries were the words of Anaïs Nin, Marco Vassi, Anne Rice, Pat Califia. The ERC was a wonderful venue for learning how many answers there are to Sigmund's old question, "What do women want?" The gamut, apparently: raunch and romance, tenderness and titillation. And married ladies from the suburbs were reading their favorite stories right next to Mission District dykes. You couldn't help but be impressed by the range of female fantasy and experience after an evening at the Circle, even if only six women had been in attendance.

The lightly-attended events were especially interesting, in fact, because sometimes we had time to discuss sex, erotic writing, and individual women's stories. The ERC was never set up to be a writing workshop or critique-fest. Thus it didn't function always to give writers access to the suggestions or criticism of their peers. But because it was an open circle that any woman could attend, the variety of writing styles and topics covered more ground than you'd find in most writers' workshops, at least as far as sex was concerned. Throughout the years Good Vibrations has sponsored erotic writing workshops featuring editors and published writers. New writers joined these to learn about style and craft—and more often than not, we'd then welcome them into the Erotic Reading Circle.

I had been wanting to experiment with opening the Circle to men. Joani Blank, Good Vibes' founder, had initially started it as an all-women's event because it was felt (correctly, I think) that women writers of erotic or explicit work had almost nowhere to go to connect with other women writers, to publicly read and share what they wrote. Trouble was, male erotic writers really had no place like that either. Also, I felt that the feminist erotic revolution was in pretty full swing. Every year new collections of women's erotic writing hit the shelves. This often paradigm-breaking work influenced and entertained male writers and readers as well as female—but where was the men's work on the shelves? Ironically, women writers banded together for support in part because they didn't have the same publishing opportunities male writers had, but in the mean-

time, Olympia Press and most of the other places straight male erotic writers used to publish disappeared. Henry Miller and Marco Vassi had died, *Penthouse* and *Playboy* could publish only so much material, and I had a feeling plenty of creative men weren't finding support or publishing opportunities either.

Then writer and performer Jack Davis joined the staff of Good Vibrations, and we decided to work together to create a "co-ed," mixed gender Erotic Reading Circle. The all-women's circle continues, but now it shares calendar space with an event that welcomes all writers (and listeners!) regardless of gender, sexual orientation, and erotic interest. From day one, this mixed circle was packed. Talented writers came out of the woodwork. First-time writers tried their hands at a story. At least twice couples came and read together. People continued to read diary entries and love poems, and readers brought new favorite excerpts—J. G. Ballard and Georges Bataille joined Califia and Nin. Poets, their performance skills honed at poetry slams, declaimed. Hardcore S/M stories followed by subtle haiku followed by true-life tales of '70s swinging—now there was *really* no telling what an evening at the ERC would bring.

It is this wonderful, diverse jumble that we compiled *Sex Spoken Here* to share. Since you can't all come to San Francisco or Berkeley every month to come to our already-crowded readings, we are exporting a slice of the lively, sexy, unpredictable Bay Area writing scene to you. Ours is not the first erotic writing anthology that embraces diversity in erotic orientation, theme, and gender—Susie Bright's *Best American Erotica* series does that, as do many terrific themed anthologies like *Sex Spoken Here* contributor Thomas Roche's *Noirotica*. Before these volumes hit the shelves, sexzines and small erotic magazines broke ground—pioneer publications like Lily Braindrop Burana's *Taste of Latex*, the late, lamented *Frighten the Horses*, as well as *Libido*, *Black Sheets*, and others tore down the literary fence between gay and straight and introduced their readers to a more polymorphous sexual world. Some of our contributors' bylines are well known in the 'zine scene.

Think of *Sex Spoken Here* as a slice of the world's erotic

diversity laid down on paper, performed before an audience, and then captured between these covers. You may well have read diverse anthologies before, but probably not *this* diverse— what many editors would cut out, we have chosen to leave in, because we want *Sex Spoken Here* to reflect the circle our writers have created. So you'll find crafted work by seasoned writers and early efforts by, perhaps, the seasoned writers of tomorrow; poetry hand in hand with prose; queer stories next to heterosexual ones (and bisexuals all over the place, though you can't always tell); and everywhere the erotic eye being trained on unexpected things: cigars and jumping jacks, orange nail polish and teddy bears, The Song of Songs and a really satisfying meal. Some stories may raise eyebrows—just remember, we're all adults at the Circle and we write to explore fantasy as well as our lived realities. Taboo fantasies have a long history in erotic writing, where readers and writers explore activities they wouldn't choose to do in real life.

Some stories don't read as strongly on the page as they sounded in the author's voice—other writers mumbled out their work shyly, but when you read it, it sparkles. It's an honor, now that I'm a published author, to edit and share the pages of *Sex Spoken Here* with all the writers who have mustered the nerve to get out of the house and into the store (did I forget to mention that we hold the Circle right in the Good Vibrations stores, in the very midst of the dildos and condoms that line the walls?)—whether they read from a polished manuscript or a scrawled-on napkin.

It's an honor, too, to be part of the Circle with the writers we didn't have room to include here. Each of us, to author erotica, has to silently shout down the cultural voices that tell us we're not supposed to talk about sex, certainly not openly or explicitly, certainly not to strangers. In addition, many of these writers had to brave the further silencing imposed on people with non-mainstream erotic fantasies or desires. Add to this the courage every writer must muster in the first place, standing up to inner voices that sneer, "You'll never be a writer" or "What makes you think anyone is going to care what *you* have to say?"

Sex Spoken Here is, in a way, a nervy and defiant gesture against conservative cultural mores that would like us to keep quiet about who we are sexually and what we think about sex.

But mostly *Sex Spoken Here* is a lot of fun. It's wild to sit in a circle of writers who, taken all together, paint a vivid erotic picture of how different we all are and how much we share. It's inspiring to be surprised into finding something mundane suddenly sexy. (Hearing Mark Stuertz, now a regular contributor to *Paramour,* read his arresting story "Sophie's Smoke" kick-started me into wanting to create this anthology in the first place.) It's wonderful to see writers who are very different on the surface support, appreciate and applaud each other's work. The Erotic Reading Circle builds bridges and understanding even as it turns us on—may *Sex Spoken Here* do the same for its readers.

And may it inspire *you* to put pen to paper. When you do, come to San Francisco and read with us!

— Carol Queen, May 1997

WHEN I WAS IN EIGHTH GRADE SITTING AT MY DESK in St. Mary's grammar school, thinking about what my life would be like as an adult, I could not have possibly envisioned that I would be an out faggot working in a worker-owned cooperative that sold sex toys and books and videos all over the world. Nor could I have foreseen that I would be co-facilitating the Good Vibrations Erotic Reading Circle and co-editing a book of original work that was read at that Circle.

Good Vibrations has always had a focus on making sex toys and sex information available to women and their sex partners. This just about covers everyone except gay men. Now we are working on reaching gay men as well. When we started having Erotic Reading Circles that were not just for women,

heterosexual and bisexual men felt comfortable bringing their work to read. That is really no surprise. But I think we get gay male material as well only because we make a conscious effort to say that the Circle is open to all genders and all sexual persuasions.

Each time we host a reading I am amazed at the diversity of the crowd. When the brave souls sign up, I never know what it is that they will read. And one of the things that I have learned is that it is just a waste of time to guess what someone will present based on what they look like. At each Erotic Reading Circle there is a range of genders, orientations, images and writing experience. Pieces range from sweet to down and dirty, with some having a little of both.

I should point out that in the Reading Circle people do not always read work that matches their orientation or gender. As much as I would like it to be the case, I have to remember that just because some man reads a story about raunchy queer male buttfucking it does not mean that he has ever done it himself, or that he even wants to. What is important is that there is a space for him or anyone else to read any erotic writing they choose in a non-judgmental atmosphere.

I enjoy the way that the Circles progress. People are called on in the order that they sign up. We alternate between male and female readers, with each person getting about five minutes. And what unfolds, unfolds. A story about a master whipping his boy and forcing him to lick his boots could be followed by a poem about newlyweds having cuddly sex in front of a fireplace and next could be a piece about vampire sex followed by two dykes forcing a straight man in a suit to jerk off on a bus.

As much as we would like to, we can't recreate an Erotic Reading Circle for you. What we have done with *Sex Spoken Here* is put together some of the amazing stories and poems that have been read out loud there. We suggest that you try reading them out loud as well. Try reading to your partner in bed or take this book along to spice up a long car trip.

Whether you read to someone else or read alone, M. Christian's "The Naked Supper" is very appropriate to accom-

pany a meal. Speaking of food and sex, Lori Selke shows us
some interesting new ways to serve vegetables in "Cucumber"
and Simon Sheppard's "Good Humored" brings a new meaning
to the term "vanilla sex."

In Katia Noyes' "My New Girl" two women have sex in the
dressing room of a club where women strip for men, which is
different from a club where women strip for women, as in
"Bombshell" by Tristan Taormino. Both places are different
from the sex party including both genders in Jim Herriot's
"Ceremonies of Self-Love: All Creatures Big and Wet" or the
S/M party that is the setting for Debbie Ann Wertheim's "Jump-
ing Jacks." Still different is a sex club for women; we see some
pretty rough stuff in "The Dragon Means," a second story by
M. Christian. A queer men's sex club before safer sex is the
setting for both Scotty Brookie's "Walking in Circles" and
Simon Sheppard's "Afterlife." We are reminded that there are
places other than sex clubs where men have sex with strangers
in "Live-Work" by Matthew Hall. But men are not the only ones
who have anonymous sex, as Janice Heiss shows us in "Pleasure
Reading"—and in broad daylight too. Cathie Poston tells us
what kind of trouble a woman can get into after dark in the
notorious Ringold Alley in her story "Night."

Mark Elk Baum's performance piece, "Song of Solomon,"
involves the mysteries of sex at a radical faerie gathering, while
Trebor Healey's poem, "Faerie Gathering," is about a faerie
gathering *as* sex. My piece, "Men in Skirts," includes faeries
having sex because they are wearing skirts. Lawrence Schimel's
"Clothes Make the Man" has faggots having sex despite the fact
that they are wearing skirts.

Rampujan's "Peeping Tom" is a series of vignettes about a
man who likes to watch. In "I Need More Hands," Brian D.
Young likes to watch himself. "For Joe" by Patricia Engel is a
fantasy about adults not playing the way adults usually do.
They are on vacation now, but the implication is that things in
the past have been very intense between Jonathan and Carrie in
"It Will Do For Now" by Molly Weatherfield. In "Return to
Rawhide," horehound stillpoint tells us quite clearly why he

prefers rough sex.

We sometimes think that good erotic literature has to be kinkier than the kind of sex we usually have, but that is not always the case. We have some very sweet stories that have to do with sex that is very regular, yet very hot. Cat Ross's "A New Adventure" is an adventure with a new type of sex partner for her, a man. Caprice's "Watching the Late Show" has a wife taking cues from watching her husband masturbate. "What a Man and a Woman Can Do" by Blake C. Aarens is a story of the caring relationship between a nurse and her patient.

What would a collection of writing from the Good Vibrations Erotic Reading Circle be without stories with sex toys? "Anthony" by Thomas Roche is a funny, yet sad, tale of a dildo gone wrong. J. A. Vasconcello's "All I Want" is a poem about real feelings and that includes a real dildo.

Some stories feature unusual objects that aren't commonly eroticized—or at least aren't usually acknowledged as erotic. "Sex and Death" introduces us to Trebor Healey's old teddy bear. "Sophie's Smoke," Mark Stuertz's story, shows us that, indeed, sometimes a cigar is not just a cigar. Will Keen's "A Good Hair Day" brings out the eroticism in the accoutrements of grooming, certainly helping readers think of new uses for the common hairdryer.

Outdoor sex is well represented here. "Midsummer" by Rachel Power takes us to a pagan gathering in a sacred grove. Carol Queen's "Artemis" presents pagan communion of a slightly different kind. Calla Conova's story "Ali's Secret Garden" features the outdoors come alive, while "Featherfall" by Will Keen contrasts the wild eroticism of nature with the not-so-tame feelings that exist between two lovers. And "Kindred Spirits" by Blake C. Aarens shows us what kinds of wild things wait outside in the night.

Lovers and love relationships are the subjects of many stories, of course. Doubtless many of the Erotic Reading Circle stories and poems were first written for writers' partners. "Hotter Than Tallboys" by Al Lujan, "Rainbow Rainboy," "Sex with Him," and "Religion" by Trebor Healey, "Fucking Jen" by Marianne

Hockenberry, and "Open Throttle, Full Speed Ahead" by horehound stillpoint all explore love, romance, or just plain lust between partners. "Leaving" by Anna Hausfeld and "Seeds" by Al Lujan look at some ways that relationships end.

I am a gay man, a faggot, a queer boy—and I am always glad to hear the pieces about sex between men. At the same time I am consistently blown away by an image or the telling of a story that is not something that is a part of my sex life. There aren't many places like the Good Vibrations Erotic Reading Circle. One of the reasons that people come to read is to be exposed to stories and writing styles different from their own. One of the reasons you are reading Sex Spoken Here, we hope, is to experience a new and different range of sexual images.

Read *Sex Spoken Here*. Write about sex. Write about what you like. Have sexual experiences so that you can write about them. Write your fantasies. Read what you write. Read it to other people. Do it loud.

— Jack Davis, May 1997

The Naked Supper

M. Christian

WITH LEGS LIKE BAGS OF CEMENT, the Fat Man was led to his regular table. Sitting in the offered chair, his creamy mass rolled over the seat and around the straight iron back. Nervously, he lingered over the menu, only occasionally lifting an elephant-like head to free jowls from stiff collar. Then, with great expertise, the Fat Man ordered.

First, rushing out of the noise and turmoil of the kitchens, was the bread. Buns soft as down, lying poised and inviting on a plate. Tender to the touch, with a firm, barely yielding, crust. Delicately parted, the buns steamed from pale white seams— the crust delightfully resilient, but easily kneaded and clutched by gripping hands. The insides were velvety smooth, warm and subtly moist. Butter streamed down tanned sides, pooling on the plate: tempting an eager tongue. A softening cube of brilliant yellow slipped gently by, ringed with clear, hot fluid—bubbling around the edges and sinking into the dough.

With a clatter, the soup was brought: a lake of liquid ecstasy. Onions, small and nymphish, played hide-and-seek among rafts of cheese, flirting with the spoon, pushing up against the firm, curved shape—splashing and faintly giggling at the clumsy attempts to snare them. But for all their acrobatics and squeals of playful delight they finally surrendered, their furtive advances giving way to a ballet of fire and verve when tasted. The rest of the pool held tempting secrets, hiding beneath a broth of warmth and stimulation.

A salmon was brought to the table; so fresh and untouched. She was delicate enough to tear under brutal handling, never to be whole again, but with enough spirit to allow a hold, a grip to go onto greater things. The salmon lay sublime on a cool platter,

staring out with eyes full of innocence, yet with a hidden, mischievous glimmer of wanton surrender; a quiet invitation to a ravishing. It patiently waited advances, the release of that innocence: awaiting a firm hand to take what she offered, lying there on her side. She waited for someone to consume her with mad abandon and the touch of a trained palate. The salmon eagerly awaited consummation.

A bowl was delivered: a secret forest concealing deep and mysterious pleasures. In a fold of green, hidden beneath a creased lettuce leaf, lay a subtly enticing tart. A juicy little tomato that darted through the forest and folds, from the strong support of the cauliflower to the entrancing hypnosis of the fork. Tempting disaster, the fragile thing played with the chase—filling the air with the smell of her slick, oiled skin—and then vinegar when it looked as if she might be passed by.

Two breasts, upthrust and firm, golden in the sun's setting rays. Daring and obvious, challenging all comers. No innocent this chicken. Young, yes. Spring, definitely. Outrageous and provocative, stomping a shapely drumstick and demanding, in a loud aroma of heady spice, that she be consumed. Here! This minute! Now! Glistening butter rolled slowly, melting more and more with each steamy inch towards the thighs, down browned skin with the hint of hidden, pale, white meat imminent. Pluck-ed nude, with her thighs wide apart, breasts exposed, the chick-en leered and demanded—before possibly growing cold.

Pert. Good body. Excellent aroma. Full of vigor. No doubt of French extraction. Aged just enough for experience, not so young as to be easily bruised, and not too old to sour. A dazzling little '25, lazily floating in the glass, tantalizing with eager provocations. Comfortable to taste, to kiss, to embrace with lips, and to drink—just as that tart beauty with the good body and a distinctive heady aroma loves to consume.

A perfect cone of delight, upthrust and ready, a velvety cherry precariously poised on the brink, ready to topple into a debauchery of whipped cream and strawberry preserves. The dessert coyly avoids all advances, leaning one way, then the other. Toying, playing with and being played with. The cool

dish wiggles a frosty lady-finger, inviting all comers to break her ice cream exterior and get to the rich, sweet insides.

Coffee. Steaming hot and fierce. Spicy, waiting to break free and run rampant: raising temperatures and setting hearts a-pounding with ferocity. A true Colombian spirit, bubbling secretly in a china cup, struggling to break free with steamy excitement, a mad Amazon fighting the trap.

With lips to cup, a little swish for taste—that delicate bouquet of strong urges, overriding everything else: driving the heart and raising the temperature, the blood pressure. Wild power, tickling tongues and warmed cockles. Building towards a pleasurable pain, straining for release, any release, to escape the burning, the steaming concentration—and with an exhausted sigh, to swallow the hot coffee.

Finished with his meal, the Fat Man pushed himself away from the table and leisurely smoked a cigarette.

Anthony

Thomas S. Roche

ANTHONY WAS A REALLY BIG DICK. Everyone knew it, and people treated him accordingly. He couldn't get service in restaurants, and travel agents always laughed and hung up on him when he tried to book flights.

He was a misunderstood genius. Of course, misunder-stood geniuses have no problem getting laid. Everyone wanted to fuck Anthony. There was little risk and almost no real guilt involved in going to bed with him; he was the perfect quickie. Women loved him. Guys loved him, too. He had no compunctions about going to bed with straight chicks, lesbians, faggots. There were a (perhaps) surprising number of straight guys who would do anything to get to Anthony. He'd drop by the straight pickup joints, and guys with chest-wigs and gold chains would scramble over each other to buy him a drink, not even minding that his favorite poison (Astroglide, slightly warmed) was incredibly overpriced. Next thing he knew they'd be taking him home (he rarely even got to finish the first drink). There was no need for subtlety in such situations.

Sex was cheap and easy for Anthony. Health concerns were non-existent, since a nice pot of boiling water would take care of even the most dreaded STDs. All he needed was a warm orifice (properly lubricated, of course) and he was happy.

He never really asked for much in bed, and he didn't smoke afterwards but he didn't mind if his lovers wanted to. He never failed to bring incredible pleasure to his partners, or at the very least get them off. Still, he often felt used after completing the act. Time and again, he would stand in the shower, washing off the fetid slime of yet another cheap fuck who had tossed him haphazardly on the floor after getting her/his rocks off, sobbing

4

to himself that the whole world knew he was nothing but a big dick.

He fell into a cycle of self-destruction. First it was just a little snort now and then, so he could perform better. Soon his life was a whirl of drugs and despair. He tried to mask the emptiness by falling into bed with dozens of lovers every night. He switched from Astroglide to the hard stuff. Pretty soon it was Vaseline. First he would just ask his lovers to smear it all over themselves; then he wanted it on himself. By the end of the summer he was mainlining.

Anthony kept up an incredible pace of self-destruction. Toward the end he was a wreck, trying to satisfy his appetite for love with cheap, tawdry sex. I remember one time in this dyke bar in New Orleans, wasted on snort, pills, baby oil, and Vaseline, he leapt onto the bar, waggling up and down obscenely, and screamed with reckless abandon, tears leaking out of his hand-sculpted urethra, "I'll fuck you all! God damn it, did you fucking hear me, I'LL FUCK YOU ALL!!!!!!"

And he did.

The end of the story isn't pretty. Any of you who have seen the effects of oil-based lubricants on latex can guess that Anthony lost his will and ability to live. He was incapable of getting it up. Maybe he'd walked down that soft wet road one too many times. Maybe he really was just a big dick.

Anthony came over to my apartment late one night on BART. He was wearing an overcoat that looked like it had been pissed on. I offered him a cigarette and he took one. We smoked in silence. He was an awful sight; his body was pitted, and the beautiful, life-like veins which had created such delightful sensations so many years ago—they had turned to rotten, wasting sores, like bits of his soul that had died.

That's when he came on to me. I got mad and told him to fuck off, that if he wanted to die, he could do it alone. I wasn't going to part my hairy cheeks for a goddamn dick!

He went out into the rain. If I had known, oh God if I had known...I would have stopped him. But how could I guess that the synthetic tofu plant next door had raised the pH content of

the clouds overhead to a point where the rain could dissolve latex?

When I found Anthony the next morning, he was little more than a spot on the road. I picked him up in my arms and carried him back to my apartment, a great weight on my soul. I laid him on the bed, praying that he might live—but he didn't have a chance. He had never had a chance. He was bound for this sorry end from the start. He was a crazy doomed genius on the black velvet road to hell.

I sobbed at the bedside, afraid to look at my dead friend. I screamed, "You crazy motherfucker. You coulda been mine!" I fashioned a little dick-shaped coffin out of steel wool and nylon underwear, and found an empty plot of land near my apartment. It was a solemn funeral, with only me attending, since I was Anthony's only friend in the world. I read from the Bible, the *Kama Sutra* and *The Joy of Sex*. The acid rain broke the skies open like a welcoming orifice, mingling with my tears as the thunder exploded overhead. I played "Taps" on a comb and tissue paper, but the tissue paper got soaked and I soon found myself sobbing, kneeling in the mud. There was no brass band.

What A Man and A Woman Can Do

Blake C. Aarens

NETTA JEAN BLACKWELL'S cream-colored, mint condition '75 Monte Carlo glided up the driveway. Gravel crunched beneath the whitewalls. Irvin turned around. The car stopped and a big-boned, high yella tree of a woman emerged from inside it, her kinky gray hair a braided crown above her head. She was a woman with sternness and softness. With a no-nonsense grip on her nursing bag and a starched white uniform. With laughter in her eyes and in the roll of her belly.

"How you doin this mornin, Irvin James?" Netta Jean said as she sashayed up to the front door.

Irvin James Casey stared at Netta Jean Blackwell like a deer caught in the headlights of a car. The swift and flowing rush of desire cleared his mind of the morning's worries. And of the will to move.

"You gonna step aside and let me in the front door?" Netta Jean asked, "or do you want me to squeeze on past?"

Irvin wheeled out of the way. Netta Jean passed in front of him. He reached out and cupped the curve of her rump. Felt the power in her hip and groaned a deep baritone in his chest.

"Jus what you think you doin, Irvin James?" Netta Jean stopped and looked over her shoulder at him.

"Jus sayin good mornin, Netta Jean."

"Talkin with your hands again? I done tole you bout that."

"You done tole me a lotta things. Like what a man can do to make a woman moan and sigh when he ain't got no control over his legs nor what God done put between 'em. You done taught me how sensitive be my hands and this bare spot on the top a my head. And how to put my lips to yours and take your breath in."

"Well, ain't you in a mood."

"Ain't you?"

"Don't you muss my uniform; I got folks to tend to besides you." Netta Jean laughed as she said it. She walked into the living room and set her nursing bag on the coffee table. Irvin followed her. "You walk yesterday?"

"Naw. Found a sore on the inside of my left knee. Probably from the braces."

"Lemme see."

"Jus a second." Irvin wheeled himself into the remodeled bathroom off the living room and shut the door.

He locked his wheels in front of the toilet and hefted himself from his chair to the toilet seat. It took long moments before his muscles relaxed and his body weight settled. He reached behind himself and stimulated his sphincter while keeping his balance with a tight grip on the sink's edge. More long moments of concentrated relaxing and he was able to void his bowels. He emptied the urine collection bag strapped to his shin and maneuvered himself back into his chair. He flushed, washed his hands, and returned to Netta Jean without retying the drawstring of his pants. The loosened waistband made him conscious of his own readiness, of his hunger for her touch. He equated it with walking around with his fly open. The desire embarrassed him even though his body no longer gave any outward sign of it.

Netta Jean waited for him at the foot of his bed. He locked the chair's brakes and pressed himself up so she could lower his pants. She moved in closer than was really necessary to strip the fabric down his legs. He turned his head to the left and pressed his face into the curve of her neck. She put a hand to the back of his head and pressed him closer.

Then she was gone. Sliding his pants to his ankles, spreading his knees, squatting between them. She examined the skin on the inside of his left knee. Comparing it to the surrounding skin, she pressed and watched how it responded. She grabbed his foot and bent his leg at the knee. She glanced up into his eyes but refrained from asking the question, "Does this hurt?"

He answered her anyway. "I feel the movement in my hip, but not what you're doing to my leg."

"The skin ain't broken, but it does look tender." She stood. "It's up to you. You wanna get up on your feet today?"

Irvin let his eyes wander over her body.

"What? You gotta check me out to decide if you wanna walk?"

"You never did answer my question bout what kinda mood you in."

Netta Jean's smile compressed the dimples in her cheeks. "I'm in a good mood. And yourself?"

"I be needin a bath this mornin, Netta Jean."

"Humph. Only thing dirty bout you is your mind."

Irvin guffawed. He closed his eyes and fingered his irritated knee. There was a definite difference in skin temperature. He looked at Netta Jean. "Probably best not to put the braces on today. Let this skin toughen up again."

"Sounds like a good idea to me, but you need to get some exercise."

"Well, if we go through my old physical therapy routine, I'm liable to work up a sweat. Then you gonna be obliged to bathe me. Now, ain't you?"

Smiling, Netta Jean walked away from him to the far side of the hospital bed. "Well, come get on up here so I can warm them muscles up."

Irvin did as he was told, first stripping his pants the rest of the way off, then lifting himself unaided onto his bed. When he was settled in the center of the mattress, Netta Jean placed a hand on his belly and lowered the bed to its flat position. She took his legs through their full range of motion: front, back, and sides. The series of exercises left them both panting and sweating a little.

Netta Jean stood beside the bed and looked down at him. "Reckon we can see bout that bath now. You comin, Irvin James?" She gave him a grin full of mischief and disappeared into his bathroom.

Still lying prone on his bed, Irvin checked his fingernails for rough edges. He flexed his big arms. Raised the head of his bed and lifted the broad muscles of his chest. After transferring himself to his wheelchair, he joined Netta Jean in the bathroom.

She was bent over the tub adjusting the temperature of the water coming from the faucet. The wide expanse of her behind strained the seams of her cotton uniform.

"Netta Jean, Netta Jean. Woman, you know how glad I am you got a patient nature? And no shame bout makin your pleasure known?"

"I know." She didn't look up at him, but busied herself with preparing the tub.

Irvin leaned toward her working fingers. He rested his hands lightly in his lap and closed his eyes.

Netta Jean sensed his settling. "You not fallin asleep on me, are you?" she asked over her shoulder.

He kept his eyes shut. "Naw, Netta Jean. I'm jus sittin here thinkin lustful thoughts."

"I got a thought or two of my own."

"I bet you do."

Netta Jean turned from the tub to look at him. She took in his bowed head, the steady rise and fall of his chest, and his hands, upturned and wide open on his lap. Walking toward him she murmured, "Them big hands of yours. That broad chest. Them arms like thick brown poles." Irvin didn't stir.

She bent over him and pressed her bosom into his face, startling him into a deep inhale. His mouth opened before his eyes did. Opened and closed over her nipple through the fabric of her uniform. His insistent sucking left a wet spot. His love bites sent a deep shudder through her flesh. She grabbed the back of his wheelchair and pressed the V of her pubic mound into his knees. When she brushed her lips over the exposed flesh of his head, he cried out.

Netta Jean straightened and pressed Irvin's head into her belly. She whispered into his ears. She told him, "This pleasure ain't jus mine. It's a gift shared between us."

"Sho is," he said.

Netta Jean stepped back and looked down into his eyes. He took her hands in his.

"You ready for that bath now?" Netta Jean asked.

He laughed and said, "Humph. I been ready."

My New Girl

Katia Noyes

"LOOK AT THAT ONE. She makes me stiff," said the businessman in front of me. His friends laughed.

I sat at the bar. The place was packed. With my hair greased back and my butch garb, I looked like a man and felt unobtrusive. The guys around me were so turned on you could hear their breathing over the loud music; they panted like dogs in heat. I got scared when Melody made her way into the crowd for the lap dancing. Someone could jump her, tear her clothes off. She was so near naked in her little bikini. I'd rescue her in a minute.

"Come here, lady." The businessman held money over his head. A bouncer followed Melody as she made her way over. She saw me and smiled, but I knew she couldn't pay me any attention. Yet.

I met Melody just last week, and I'd taken her home after a party. I was entranced with her large body: the lush thighs, the creamy skin, the full breasts. But most of all, as I soon found out, it was her cunt that was to die for. It felt like heaven. I couldn't believe her. She drove me crazy.

Melody had given me a call that morning and asked me to come watch her dance at a suburban strip joint an hour's drive from the city. All day at work, I thought of fucking her again. I thought of the way her body jerked and went into spasms, and the way she grabbed me and held me tight afterwards.

MELODY SANK DOWN on the guy's lap. The bouncer held a flashlight above her head so all the men in the club could see her. She licked her lips and pouted, looking like a cross between Geena Davis and Marilyn Monroe. She stretched one leg high in the air

11

and swung it over the man's head so she could straddle his waist. She pushed her crotch into him while she faced me. As she wiggled and gyrated against his body, she stared straight into my eyes.

I stared back. My strap-on pressed against the inside of my thigh. I imagined taking my toy and making her happy. I wanted her drained, spent. I wanted her not to be able to walk the next day. I wanted to make her ache.

The next part of the act featured three dancers wearing bathing suits. As they kneeled and pouted, men squirted baby oil over them. Melody sat on her heels, arched her chest and let her head drop backwards toward the floor. She opened her thighs wide, and the men shot oil on her blue satin crotch. At least a couple hundred men were screaming, chanting and clapping. The guys around me pounded their fists on their thighs, grinning as if they had each won a prize.

But she was my prize. I couldn't wait to take her. Soon.

After the show ended, the men tromped through the exits and back to their wives. I ordered a brandy for Melody and made my way to where I figured the dressing room would be. I opened my leather jacket so my tits showed under my white t-shirt: I knew if the bouncer saw I was a woman that he'd let me inside.

Melody gave me a cheerful hug and introduced me to her stripper pals, Gigi and Stormy. The atmosphere in the dressing room was very cruise-y and I figured they were dykes.

Stormy and Gigi were fighting over a pink lace bra. Each one said it belonged to her. Gigi, a small woman with perky breasts and short blond hair, swung the bra over her head and skipped around the long make-up table in the middle of the room.

"Come over here and give it up," said Stormy. She grabbed Gigi and held her with her strong arms. Stormy had nut-colored skin and one of those tall, supple, dancer bodies.

So my girl wouldn't get jealous, I turned away. I took Melody aside and whispered, "You put on a great show out there. You're beautiful. The most beautiful stripper around."

"Really?" she asked. I told her yes, that I meant it. I rubbed

her cheek with my hand and pushed my dick against her thigh so she's know it was there. Her eyes widened, soulful and calm. It was how she looked at me when I kissed her for the first time.

"I want you, honey," she said.

I told myself to be patient and let her finish getting dressed. I should drive her back to the city, serve her dinner at my house, let her take a shower. I could pamper her and make her comfortable, carry her to my bedroom and make slow love all night long. But I couldn't wait.

I pushed her against the wall.

"Oh, girl. We heard you fast, but you doing it here?" said Stormy, collapsing her sleek body on a chair beside us.

"If she can handle it," I said and gave Melody a questioning look.

As Stormy sank into her chair in anticipation, little Gigi pranced over and swiped the bra from Stormy's hands and swung it around our heads.

"Go for it. We aren't gonna stop you," Gigi said, giggling.

"Lock the door. My new sweetheart is going to make me happy," purred Melody in her sexiest voice.

"Let's see if daddy is all talk," said Stormy, licking her lips.

I winked back at Stormy, but Melody pulled my face away and kissed my lips hard. She put her lips to my ear and whispered, "Play with me, baby."

I unzipped my pants and lubed my dick. I decided it might be fun to fuck Melody standing up. She had on a short black leather skirt, and I lifted it up. No underwear. Must not have had time to put it on yet, which was fine with me. Her bush was just gorgeous: silky, curly hair that was still a little damp with sweat. I knew the goods nestled underneath that reddish-brown tousled hair, and I couldn't wait. I bit through her shirt to her breasts and lifted it to reveal her breasts. The nipples smelled like talcum powder. I rubbed my dick against her thigh and let a couple fingers stroke her pussy. It was so plumped and slippery that I wanted to get down on my knees and say a prayer.

Stormy raised her eyebrows and eyed my protruding strap-

on. "You getting that big thing inside her? Girl!"

"Shut up or leave, girlfriend," said Melody. She stuck out her tongue at Stormy and swiveled her hips against the wall.

"Do you girls have sex back here often ?" I whispered to Melody, rubbing her thighs.

"Only when visitors come," Melody whispered back. She circled her tongue in my ear.

I tickled my toy against the lips of Melody's cunt. I teased her with the head and at the same time rubbed my thumb on her clit. Melody leaned back, resting against the wall. She closed her eyes and sighed.

"I want you satisfied," I said. "I want you happy, baby."

"Yes."

"Do it right," said Stormy as she put a Soul II Soul tape in the boom box on the dressing table. "Let's watch the girl take a trip." She tapped her foot and drank the brandy I'd brought for Melody. Gigi snuggled onto her lap.

As Stormy taunted and the music played, I teased my way inside Melody, pushing slowly in and out.

"Come on, baby, " I said. "Come on sweetheart, let me in."

Melody bit her lip and said, "More."

I pierced all the way inside with my cock. The force of my motion slammed her hips hard against the wall. I liked fucking her hard. As hard as I could, thrusting my big, loving dick into her sweet, dripping pussy.

"Make the slut happy," said Stormy, laughing.

"Stop talking and help me grab her legs," I taunted back.

Stormy strutted up behind me, pressed her crotch into my butt, and lifted Melody's legs in the air so that she could open wider. Melody's large breasts jiggled and her thighs squeezed my waist. As the three of us mashed together, the dick pressed against my own clit so that I was about ready to die.

"More baby," Melody kept saying. With the help of Stormy behind me, I shoved my crotch forward and got a nice, rhythmic pumping action going. I was sweating hard and never wanted to stop. It was so easy to slide in and out—her cunt was pure wetness. I could smell baby oil on her skin. I pumped harder,

and she moaned. I gave it all I could.

Stormy pulled away from me, and Melody crossed her ankles around my back.

"I want you to fly, baby," I said and carried her to the long dressing table and placed her at the edge. She pushed a can of hair spray to the side and leaned her head back. My dick was still inside her, but with her body resting on the table I could easily massage her pussy.

"Don't stop," begged Melody.

"Don't anybody stop!" said Gigi.

Stormy had pulled Gigi down to the floor. Out of the corner of my eye, I could see her slapping Gigi's butt. Melody watched them and her breathing got faster. The chorus of women's moans and the blaring music made me feel I could go on all night.

I worked a steady rhythm with my hand and let my cock circle around. I thrust in shallow for a while and then—just when Melody wouldn't expect it—I plunged deep.

The fucking got better, higher, past sweat and exhaustion, where everything turns black and deep for a while, a long while, where you can't stand it anymore, and you fuck faster and harder till the stars come out behind your eyes and flood the dark place that needs light bad, bad as you've ever wanted it.

"Yes. That's it. That's it. That's it," said Melody. She shivered and got rigid.

"Baby, I'm right there for you. Go ahead. Go ahead," I said. I closed my eyes, heard the panting of Stormy and Gigi from what seemed a long distance away. "Get high, baby. Come on, baby. Let your sweet body fly."

Melody gasped and stopped breathing for a second. Her jaw dropped and she squeezed my arm. Her hips jerked upwards. Her thighs squeezed me tight. She got a ride to heaven and took me with her. I took a deep breath and stayed there as long as I could.

Hotter Than Tallboys

Al Lujan

as drunk and as high as i could possibly get
i could still make twenty men come
with banshee sirens, chaos and deep throat commands
"second floor, down the hall, apartment #204, go!"
I heard my landlord scream, at three in the fuckin' morning
204, wait, that's my apartment

I used to be a writer, whose big dream was to have a story
published in *Penthouse Letters*
but Madam Xaviera Hollander, that bitch, if she in fact did
exist and wasn't just a pen name for some skinny dude with bad
teeth named Javier, never picked any of my highly erotic,
highly unique stroke stories for her column
I even used the words throbbing and engorged freely
just like she liked
what's wrong with her to turn down my stories with titles like
Two Headed G I Joe
Squirly Temple Digs Big Nuts
Vanilla Semen Secrets
Cannabis Honey Airlines
You Got Your Chocolate Bar in My Puny Bootie
You Got Your Puny Bootie on My Chocolate Bar
Rod Hotter than the Red Hottest Hard On, about Satan's fierce
rod leaving blisters on the inner thighs of bad girls and bad
boys
even the one about the Flintstones and Rubbles mateswapping on
the cold stony floor of their modest bungalow
with each story I tried to include a photocollage
of events depicted in the story that I cut out from porno and

Star magazines
towards the end she would just send them back unopened
with the same four words printed on the front in red marker,
"you suck, seek help"
it dawned on me just that night, at three in the fuckin' morning,
that, man, I couldn't write worth shit. I did suck
all I had going for me was my youth and a tall lanky boy
who told me I was foxy and made me believe it
a tall, black haired, shy play boy
who would rather fuck than talk about fucking
would rather do it than view it
he was incessantly on my mind
I scratched his initials on gumwrappers' silver sides
and misplaced them like numbers on matchbooks
I rubbed his name by mine on dusty counters and steamy
 mirrors
index finger gliding intentionally and soft
he was candy stuck in my hair and was probably the reason I
couldn't write, well probably not, but he was the reason I drank,
that's probably a lie, but he was definitely the reason for some
 things
like the chubby in my trousers in awkward settings
and the stupid smile on my lips every time I conjured his face
even at three in the fuckin' morning in my old bed, droopy in
the middle, which made it hard to fuck but easy to jerk
my hand was wed to my dick in holy matrimony, spit slick
my other hand on a beer, a joint between my lips and Chet Baker
 on the stereo
I was a hard little ball in a soft mitt surrounded by beercans
and puffs of cum smeared white Kleenex that looked like little
clouds hovering across the light blue shag

I visualized him waxy and lit
face down ass up on the sofa or the floor at the foot of my
bed
east coast speech impediment
"I feel so unnecessary" his eyes lilt

"*a toda madre, mijo*, you are very necessary"
euphoric red nonsense lips pout "really?"
"yeah" ready, willing and anal, always
I entered from behind and began that boiling water dance again
I reached around and held his cock in my fist
the veins were raised along the length and energized the head
they ran up, down and across like a pulsing map to familiar
 places
"bear down and buck" I whisper in his ear, wet with my spit
I clamp down on his neck and vacuum his warm blood to the
 surface
of his creamy neck in hopes of leaving my initials there before
I cum
he tells me the only two words he knows in Spanish
chupa—suck, I taught him that and *goza*—enjoy, which he
 probably
picked up in some taqueria in the Mission
he grinds his back against me "*goza* daddy" I do and it feels
real, my toes curl, my eyes clench, my balls draw up and my
cock is on fire, mighty real, I'm there
he sings hot breath into the pillow
"water"

"#204, go! 204 go!"
my landlord is hysterical, man that's my apartment, I'm 204
the smoke detector in my hall is crying low and urgent
oh baby, shut up and go back to sleep
there was stomping and shouting outside my door
I jumped up and looked around
man, a lit roach must've slipped from between my fingers as
I fucked my hand
my old Sealy Posture-Pedic never looked more appealing
amber, incandescent and hypnotic
I was trapped in the hot now
black smoke hovered like a bad genie
I made towards the window and looked out into the cold, dry
night with longing

I threw out all my writings, the pages fluttered downward like
fruit flies the crowd assembled outside picked the sheets of
paper off the floor and held them up under the orange sherbet
glow of the street lights, then crumbled them and dropped them
two fire engines and twenty men in uniform came to do what
 my
flat Colt 45 failed to do
douse, extinguish, satisfy

I climbed out my window onto the fire escape usually reserved
for climbing in whenever I lost my keys, usually every couple
of weeks around paydays or tax returns before they were
 garnished
my face, neck and hands black with smoke, ashes on my tongue
I looked around to the crowd, hands on throat high drama
"tell my boy I think I'm starting to fall in love with him"
I pleaded with a puff of greyish smoke that came from within
me
the door imploded with thunder force as I leapt barefoot from
the second floor onto the pavement
my limp cock still dangling out of my barrio baby blue boxers
"don't shoot me, someone likes me"
I begged the two SFPD officers greeting my survival on
the sidewalk, lean with firehose and clutter
they ignored me in my collapse

twenty men, two fire trucks, a crowd of gawkers, a couple of
pigs, my hysterical landlord, a half empty or half full
very warm tallboy can in my fist
and a hot tall boy on my mind

Seeds

Al Lujan

I planted seeds in my garden last April. Three days later I dug
 them up.
I'm impatient, you see, a Capricorn, like Jesus.

He told me I looked like a post-mortem Jesus Christ. Limp and
 off the cross, as I slept
diagonally across creamy sheets. Sheets wet with sweat, spit,
 precum and cum.
Perhaps blood. Perhaps tears, but that would be too, too fucking
 lyrical.
On a frigid afternoon, last month, when the fog reached the deep
 Mission.
25th and Treat St. That frigid afternoon I let him fuck me for the
 first time.
For real, not just dry-humping, thrusting and rubbing thighs
 scissor-locked.
Really real and drunk with want. Eyes fixed and lashes lulled.
Fingers tensed and arched then folded and gripped. Nipples
 hard-pressed to offer
themselves. Smooth cocks and looks. Padlock fistsize.
Shaved skull, cool and moist. Nape of neck, hard throat.
My mouth clamped on his adam's apple till hot and red as he
 stepped rhythmically inside.
Vacillating, lubricated to the base. I felt grateful and painful and
 full. From 6:15 till 7:45.
And then; "Enough! Cum or I'll make you cum."
Night's approaching. Guaranteed. Like poems about getting
 fucked or brief encounters
at 'Daddy's Ditching Party'—a sex club for skinhead college

boys on 17th and Valencia.

On his box, Nick Cave, for the third time, sang to us; "Hold me up baby for I may fall." He was finally making himself cum, loud and irresponsible, eyes skyward.

Mechanical in the best of ways. On top of me, inside of me, he broke.

I'd never believed guys who told me they could feel their lovers cumming in a scumbag, inside of them. But that time I felt it and it made me nervous and hot then cum into the sheets.

I awoke at twilight, he was still inside of me, over me. His lips next to my ear.

"*Pareces JesuCristo,*" he whispered, "*muerto.*"

The confusion of waking at dusk or dawn always devours me. "What the fuck is that supposed to mean?" I shot back.

"Nothing. Nevermind. You just betrayed a vision I was having."

"Get off of me and get the fuck outta here!"

He made for the bathroom, telling me over his shoulder,

"Things were going so well, then you turned into this *pinche diablo.*" He turned,

"Besides, this is my flat, you get out."

I picked up the family-sized bottle of Probe and lobbed it at him.

Caught him straight in the face. Thump!

Sometimes in the midst of trauma, as deliberate as it may seem, and reality is too sudden and freaky to interpret, the surreal grabs the reins. Action slows to a dreamlike glide.

The motion of an overhand. A cry uttered fills an eternity.

Little things. The light. The hair that traveled from his sternum in a straight line down his belly into the soft, dark mound of his pubis. The dull burn of my ass. These things are magnified, brought from the background into painfully clear focus. And that's what happened then. Watching from the bed, it was like a painting too vivid to be real. Every vein, blue-greens and purples traveling the length of his soft cock. His face so flushed red it was painful to look at.

Blood and spit formed a cat's-cradle across his swollen lips. Black-cherry stars spotted the cream-colored sheets. Spots the size of nickels.

Blood ran from between his fingers as he held his nose and
watched me dress.
"Things were," swam through his dripping hand as I walked
towards the door, "going so well." He read my mind. Or I his.
Jesus. Fuck.

I planted seeds in my garden last Spring, three days later I dug
them up.

I'm impatient, you must understand.
A Capricorn.

Afterlife

Simon Sheppard

WHEN MAC CLOSED HIS EYES for the last time, he was lying in a hospital bed. The young priest, cuter than he had to be, seemed disappointed at being deprived of a final confession. His mother cried and cried. And his lover, past tears, sat on the bed, a funny look on his face, holding Mac's bony hands.

When Mac opened his eyes again, he was in a bathhouse. The faint voices of an angelic choir wafted through the air, along with a whiff of Pine-Sol.

"I.D., please," said the bearded bear behind the glass window. His silvery name tag said "Pete." Mac discovered a plastic-covered card in his pocket. He showed it to the man behind the window and got handed a towel and a little tube of lube. *No condom*, Mac thought, but then he realized *Of course! Nobody needs one. Not up here, not at the baths.* Pete buzzed him through and he walked into the locker room. There were a few other guys there, stripping down, cruising each other, wrapping snow-white towels around their waists. And a saggy old guy lounged superciliously in the corner, playing with himself and puffing on a cigarette in a long holder. Mac did a double-take: it was Noël Coward.

Mac caught sight of himself in a full-length mirror. Huh, not bad. He hadn't looked so hunky in years. His eyes fixed on the image of the near-naked man undressing behind him. He turned around to watch.

Is there any sight more holy, Mac wondered, *than watching a man from behind as he takes off his underwear? The way his haunches move, the hidden promise of his shifting buttcrack....*He felt himself getting hard.

So they did have erections up here. Well, of course they

would. They *should*.

The guy he was watching, staring at really, looked Italian, a little disreputable. A little like rough trade. Just his type. A beautiful, hairy butt. And a big uncut dick. The guy had noticed him watching, stroked his furry Italian chest provocatively, wrapped his towel around his waist, clicked his locker shut. And, with a haughty half-smile, headed off down the hall.

Mac followed, caught up with him by the wood and glass door of the sauna. The Italian guy was lounging against the wall, hips thrust forward, cock pressing against terrycloth, an expression of insolent disinterest on his face. He looked Mac directly in the eyes, opened the door and went inside. Mac hesitated; after all, he'd just gotten there, and his journey had been tiring and somewhat...surprising. He thought of his grieving boyfriend, probably still back there at his bedside. His heart gave a tug. Oh well, too late to do anything about that. He pulled open the sauna door and stepped inside.

The Italian was sitting there, alone in the piercing dry heat. He was on the lower bench, leaning back with arms resting on the upper bench. Legs spread, obviously hard dick just barely concealed by the white towel. His hard body was already shiny with sweat. Expressionless, the man stared at Mac, then half-closed his dark eyes. Mac dropped to his knees between the man's legs. The guy reached down and pulled open his towel. Beautiful fucking hard-on. He stuck his face between the man's hairy thighs. The dark smell of the man's sweaty crotch rose to his nostrils. He leaned into the flesh, tongued the guy's sweat-slick ballsac. The dark man moaned slightly, thrust his hips further forward. Mac ran his tongue up the underside of the shaft, kissed the soft flesh that had emerged from the foreskin, wrapped his lips around the dickhead, then slid his mouth down over the man's cock till he felt it pressing against the back of his throat. His throat muscles milked the guy's dickhead as the hard, hot shaft pumped into his mouth.

Swallowing that big Italian penis made breathing difficult, and the sauna's heat didn't help matters. Just when he thought he was going to pass out, he felt the man's hands under his arms,

pulling him upward from the floor. Pulling him up till they were face-to-face. The man held Mac against him, wrapped his arms around him, kissed Mac violently, shoving his tongue in Mac's hungry mouth. Their slick bodies slid and glided, Mac's smoother skin against the dark man's hairy torso. Mac drew his face away, stared into the other man's piercing eyes. Wordlessly, the Italian raised one arm over his head, exposing a bush of dark hair. Mac buried his face in the armpit, rubbing his face deep into the smell, inhaling deeply.

The man's hands were on both cocks now, squeezing them, rubbing them together, jacking them off, manflesh against manflesh. Mac wanted him to slow down, prolong the sensations, but when he tried to pull away, the man's grip just tightened, stroking remorselessly. "Oh God—FUCK!" Mac grunted into the man's smelly pit as the two men exploded into twin jets of cum. The man grabbed the back of Mac's head, pulled his face to his own and gave him a wet, long kiss. Their slippery bodies were stuck together by a flood of cum. Mac looked around. Another man had entered the sauna, had been sitting on the opposite bench, watching them and jerking off, and was now lazily licking his own juice off his hand. "*Doccia*," the Italian man smiled. "Shower."

As they stood side-by-side, steaming hot water washing over their flesh, down over dicks still half-hard, Mac broke the silence. Maybe it wasn't standard procedure, but he'd always been friendly at the baths. "Name's Mac," he said. "I just got here."

The other man had a heavy accent. "My name is Caravaggio."

"The artist?"

"*Si*."

"Holy fuck!"

Caravaggio grinned, reached over, and gave Mac a smart slap on his soapy butt.

They towelled off and set out down one of the corridors. The place was a lot larger than it had seemed at first, a maze of corridors and cubicles bathed in a soft, unearthly light. Many of the rooms' doors were closed, but others stood open. Through

one Mac saw a well-built black man lying back on the bed, playing with his stiff dick. Mac recognized him. He had been one of the stars of Mac's favorite soap opera. In the next room, two boys lay on their bellies, side-by-side on the little bed, their upturned asses inviting exploration. They looked like twins. And so it went, room after room, hallway after hallway, men in every conceivable size and shape. A cute, slightly chubby Chinese guy working a big dildo up his butt. A handsome older man whose facial hair suggested a Civil War soldier. Mac was sure he'd seen one guy in a PBS documentary on the Great Depression.

As they turned a corner, a craggy middle-aged man grinned at Caravaggio. "*Ciao, bello!*" he said, and they exchanged air kisses. "Pasolini," Caravaggio confided when the man had passed.

Mac was relaxing into the swing of things. It had been years since he'd been to the tubs, but it was just as he remembered it: the parade of desirable flesh; the circles and cycles of cruising, trying to stare with just the right degree of barely-concealed desire; the gropings at hard flesh; the delicious shock when man-to-man contact was made. The flirtations. The frustrations. The never-ending deliciousness of hard, dripping cock.

And he remembered Corey. He'd met Corey at one of the huge, fancy bath houses of the late '70s, pleasure palaces as elaborate as any theme park. It was the one with the cab of a two-ton semi in the middle of the Trucker's Room. The Campground, with tents-for-rent and crickets chirping over the P.A. system. The two-tier Cell Block. Just the memories brought a smile to his face.

He'd been in the steam room, a Byzantine maze of curvilinear white-tiled walls. The mists and Mac's myopia concealed the face of the man sitting there, feet propped up on the bench, knees spread wide, asshole exposed and inviting. In a flash, Mac was on his knees, running his tongue down the stiff shaft, over soft scrotum, down to the man's juicy hole. Holding on to the man's firm, hairy calves for dear life, he nuzzled into tangy sweetness, shoving his tongue deep into the guy's insides.

Those were the days! And that was how he met Corey, the man with whom he was to spend the better part of a decade. Till Corey was faded and gone, leaving him the way he'd just left Jim.

Whack! The sound of leather meeting flesh echoed down the halls. He and Caravaggio turned as one, heading for the sound.

The sound was coming from the dungeon. In one corner of the room, a bald-headed man was bound up, back to the wall, hands chained above his head. A well-built man was slapping the bald guy with a leather paddle, working over the vulnerable flesh of the man's inner thighs. Every blow made the bottom's rock-hard cock bobble and jump. Mac recognized the man with the paddle. Even recognized his dick. And why not? He'd seen that dark, bulky cock in plenty of porn videos. Al Parker. The guy had been a star.

Whack! The bald guy with the reddening thighs looked familiar, too. He turned to Caravaggio. "Who's the bottom? Do you know?"

The painter seemed distracted. He was staring at a thin, long-haired young guy in a broad leather collar who was kneeling, hands behind his back, and staring up invitingly at the Italian. "Who? Oh, *si*, that's Foucault. Michel Foucault. He does like to take his punishment."

And so he did. Parker was swatting at Foucault's dick now, rhythmically slapping at the bulging flesh while the French philosopher whimpered and squirmed.

"If you'll pardon me, my friend," Caravaggio said, "there's something I must do." And he sauntered off toward the kneeling boy.

Parker was standing right up against Foucault now, still torturing the man's pain-hungry dick while he shoved his left hand in the Frenchman's open, moaning mouth. Parker dropped the paddle and started slapping Foucault's face with his right hand. Every blow made Foucault's body arch and tremble, until his wide-stretched mouth let out a loud, long groan and the Frenchman came in shuddering spurts.

It was entertaining to watch, Mac thought, but not really his

thing. (Truth to tell, Corey had been the kinky one. Every so often, he had come home on Sunday morning with welts on his pretty ass and a silly grin on his handsome face.) His artistic new friend was standing above the kneeling boy, grabbing a handful of hair and guiding the boy's mouth up and down on his insatiable dick. The rings on the boy's collar gleamed. Mac went off in search of the Jacuzzi.

"Know where the Jacuzzi is?" he asked a bleached-blond kid with at least a dozen piercings in each ear. "Dunno," the kid said, scratching his head, well-bitten fingernails running through black roots. "Just got here myself."

The kid seemed awfully young to be there. Mac wanted to ask but didn't. The kid told him anyway. "Some guys in school threw me off a bridge," he offered. "It's nice here, huh?" He smiled.

Mac wandered through throngs of men in towels, receiving lustful glances, smiling in return. His dick was getting hard again. Already. Up here, clearly, the old limits didn't apply. When he got to the door of the dark orgy room, he decided to postpone a soak in the tub.

The unlit orgy room was full of naked men. He moved away from the light shining in from the doorway, into a heaving sea of naked flesh. Within seconds, someone's hand was on his hard-on, someone else's mouth on his nipple. A big, slippery dick pressed against his thigh. He'd forgotten how good it felt, this abundance of undifferentiated flesh in the dark. Hands were on his ass now, stroking, probing, pushing his asscheeks apart. A wet finger was working his hole loose, stroking and pushing till Mac opened up and let him in. The well-lubed finger worked its way inside him, finger-fucking him expertly until he wanted more. Had to have more. He reached behind, ran his hand over the man's hard belly, down to a stiff dick, and guided the man's hard-on to his ass. The unseen man slid his finger out, wrapped his arm around Mac's chest, and pulled Mac up against his warm, muscled body, guiding his cock into Mac's butt. Mac spread his feet, trying for balance. As the man pumped into him, his grip on Mac tightened. His other hand

grabbed Mac's face, turning his head till he felt the unknown man's lips against his own. It wasn't a kiss, not really, just a sharing of breath. The man's hand moved down to Mac's dick and started tugging at his nuts, stretching out the sac. "Oh yeah, fuck me hard," Mac whispered into the man's mouth. "Fuck me good." The man grabbed Mac's cock and used it as a handle, sliding Mac up and down on his cock. Mac's muscles tightened, started shaking. Their mouths were wide open now, sharing hot breath. Rivers of hot sweat dripped between their bodies. The man grunted with every thrust. His hand tightened around Mac's cock, almost to the point of pain, and he exploded deep inside Mac's wet, yielding ass. Their tongues met. Mac shot off in an endless, delicious spasm of cum.

The man pulled out, spun Mac around till they were face to unseen face, and threw his arms around him. Mac rested his head on the man's shoulder and stroked his broad back. Mac's breathing slowed and he regained his balance. The man's arms loosened. He said, "Take care, buddy," slapped Mac on the ass, and was gone, reabsorbed into the flow of flesh.

Like Moses parting the Red Sea, Mac unsteadily made his way through the tides of flesh, back to the corridor. He stood there, still shaky, dick still half-hard, blinking in the light. Time to hit the Jacuzzi.

It was just down the hall, a big turquoise tub filled with warm, churning water. A familiar smell of chlorine. Only a couple of other guys were there. Most of the men, Mac figured, were busy in the orgy room. He lowered himself into the tub. The warm water tingled against his well-used hole.

A trim man with the face of a Mayan prince was sitting on the opposite rim of the tub, legs dangling in the water, while a mostly submerged boy with shaved head and tattooed shoulders knelt between his thighs, bobbing up and down on his dick. The man getting blown stared into Mac's eyes. "Want to watch me come?" he asked.

Sure, Mac nodded. The man pulled the boy's head away from his dick and, without touching himself, shot big gushing streams of sperm all over his lean brown belly. The Mayan

prince smiled at Mac. "See you," he said. He looked down at the boy. "We're going, cockslave."

"Yes, sir," the boy said, raising his colorful, chunky body from the swirling water. They walked off together, the boy several paces behind the lean prince.

Mac was alone. He closed his eyes and threw his head back, the whirlpool of water jets caressing him into a state of torpid pleasure. He had almost drifted off to sleep when he felt another man's foot on his.

Mac kept his eyes closed, didn't move as the underwater foot moved up Mac's leg, pushing at his knees till his legs were spread apart. As the man's toes went further up, caressed his inner thigh, Mac felt himself getting hard again. Three times in an hour! He was going to like it up here.

The toes were on his ballsac now, gently playing with his nuts. Mac squirmed and sighed. The big toe moved down the sensitive ridge between his legs, down to his still-pulsing hole, and started teasing the sensitive assflesh. Mac slid down so the toe pressed deeper into him. His hard-on was throbbing now.

The man's foot moved back up, over Mac's balls, till it was pressing against the arc of Mac's hard dick. Mac bucked his hips, rubbing his dick hard against the sole of the man's foot.

Mac thought he heard it above the rush of swirling water. His name. "Hey, Mac...." He *had* heard it. He opened his eyes.

The other man in the Jacuzzi. Corey. It was Corey.

He grabbed Corey's foot, held on to it for dear life.

The moistness in Mac's eyes transformed the soft light behind Corey's handsome, smiling face into a glowing halo.

"Hey, Mac," said Corey. "Welcome to Heaven."

Jumping Jacks

Debbie Ann Wertheim

WE GO TO A PLAY PARTY, in a space we've been to many times before. I take off all my clothes, just like I usually do, and we go downstairs.

Okay, he says, do ten jumping jacks.

And I can't, won't, don't. He sits in a chair, looks at me and says, I'm waiting.

I squirm. I want to please. I want to obey and I can't do this, don't make me do this, I'll feel so *stupid*. Nobody else is doing jumping jacks. Nobody else ever does jumping jacks here. My breasts will bounce, people will look at me. I can't.

And he's still waiting. After your jumping jacks, you'll get a spanking, but until you do them, I'm just going to sit here.

I try kneeling and begging and pleading. He pushes me away.

Go on. Stand up. You can't even do this simple thing? I'm going to make you do push ups next.

Nonono. I can't. I squirm. It's still early, but people are here and the space we're in is pretty visible. I'm miserable. I can't disobey so much as to actually walk away, but neither can I do them. I feel stuck and trapped and unhappy. I want out. I don't want to be seen or watched. I don't want to see anyone else. I want the ground to open up and swallow me whole. I think I'd rather die, but I know that's not true. I could never do gym stuff, couldn't kick balls, or catch them or hit them. I hated gym.

I feel so uncoordinated.

I'll look so stupid. I struggle with that. Why do I care, but it's not just that I'll look stupid to other people, but that I'll look awful and dumb in front of him, but why should that matter, but it does, and maybe it is the other people, too and how out

of place it'll look and they can all do this and I can't. I stand there, but my own internal anxiety over it won't allow me to stand still for long.

I'd rather be cut, pierced, whipped, tortured, flogged. I can do any of that, and I can't do this simple, stupid thing. I'm terrified out of my mind. The more time that goes by, the worse it gets. It's my own fear—and my own mind preventing me—I hate fighting myself.

I think about it. It makes me cry. Kids making fun of me in school, people choosing sides and not being chosen. It's everything that hurt.

I stare. I stomp my feet. I pout. I hate this. I don't know how to find a way through it. It should be the simplest thing in the world but it's not, it's everything, it's my father making me exercise.

I can't. It takes too much coordination. I can't do it. It's not possible. I put my hands over my eyes, stuff my fingers in my mouth and feel like I've never had to do anything harder in my whole life.

I can't tell if five hours or twenty minutes have gone by. We seem to exist in this bubble, the party a blur around us. I can't see or hear or focus. I want out. I briefly think, well, I could just safeword. Not that we've even remotely negotiated a safeword. Right. But I can't. Now I know I'll be miserable if I do this, but more miserable if I don't. It is a matter of pride. It is such a stupid little thing and that only makes it worse—'tis noble perhaps to agonize over a branding, a cutting, a whipping, but jumping fucking jacks? Right.

I try bargaining. I try denial. I try any of the other stages of grief that I can remember.

It's wearing us both out. Well, more accurately, it's wearing me out. I'm emotionally and physically exhausted from anger to crying to pleading to trying to disappear. The other people in the room have stopped mattering to me. This is personal. This is just between us. This is mine to get through. Nobody else really exists.

And then I do them. In a haze. And then just crumple into a

heap and cry.

And he walks over to me, gently puts me face down, rearranges my limbs, which are completely limp, and sits on my back and starts to spank me and I sob harder and then softer, sniffling, ragged breathing, and I know I'm safe and cared for and not stupid and awful and it's going to be ok. And I love being spanked, like nothing else, it's the sweetest reward in the world, it's the only thing that makes me feel loved and cherished.

And when the spanking is over, I curl up under a blanket and fall into a half sleep of emotional exhaustion. I made it through this. It wouldn't make sense to anyone in the world but me / us— it was just my own personal terror, dredged up into the open, and it can't ever be so terrifying again. It can only ever be the second time.

Ali's Secret Garden

Calla Conova

IT WAS THANKSGIVING WHEN I STEPPED IN, flush-faced, from the back yard just in time to hear the doorbell. It was my friend Claudia, bringing with her the spicy freshness of autumn. I noticed she had lost weight. She had been gone all summer to Mexico on an archaeological dig. I hugged her through her bulky coat. Her first breathy words to me were, "Ali, you look great!" I replied, "Hardly, I'm jealous. You're thin and tan! I'm glad you came so early, though. I don't even have the turkey in the oven yet." She followed me to the kitchen.

"When are the Dan and Marcie *familia* arriving?" she asked using a Spanish accent. "I missed all my buddies this summer. So, what can I do?"

I handed her the sack of flour saying, "They just called and said they might be able to get the kids rolling by three. You can make your famous pie crust." The slanted sunlight poured through the kitchen window onto my hands. They showed my age from too much sun and gardening without gloves. You can't feel with gloves on. Claudia stood in a white dust cloud of flour, holding a tattered handwritten pie crust recipe she'd gotten from her mother. She still followed that recipe.

"Why do you look so good? Is it a new lover?" Claudia was starting her usual stratagem of questions. The flour dust was settling on her long brown hair as she waited for a reply. We had been best friends since high school when we had fought the boredom of conformity by wearing bells around our ankles and our skirts one inch shorter than dress code. Something kept us friends all these years. Maybe it was our differences. But that season seven years ago, when I worked too hard and almost died of pneumonia, it was Claudia who had stayed with me

through the fever. We were different but we had history.

I tipped the turkey on its end, handfuls of cornmeal stuffing went into the cavity, as they call it. The head or tail end I can never remember how it goes. Claudia persevered, "Who is it? Aren't you going to tell me?" Her hurt look caught me. It reminded me how much I had kept from her recently. *She always expects to get the details, like in the old days.*

I shifted my feet in a false lightness directing my attention to the turkey in the sink under the window. My mother taught me to put it in the sink while stuffing and I still did it. A couple of acorns dropped from the oak tree with a thud on the eave of the roof. Two rivalling blue jays heard and swooped over to fight over them. "No, there's nobody new. Actually there's nobody at all right now. Must be the workouts at the gym." *Why didn't I want to tell her?* I betrayed my thoughts by looking at the garden. *The first time had been next to the fig tree, a hot July night. My kimono slid off like a cobra's shedding skin.* The sense memory rushed through me. My hands slide in and out of the moist stuffing in the turkey, chunks of celery wedged between my fingers.

"Where's the butter?" Claudia spoke into the open refrigerator. She shoved a package of cheese out of her way and caught a bottle of juice that started to fall. She was getting mad. "I mean, Ali, what have you been up to? You are oozing sex!"

"What have I been up to?" I put another handful of stuffing through the opening of the turkey, my hand wedged tightly past the raw opening. *Would she believe me? Does she really want to hear it?* "Well I've been thinking about sex a lot. Maybe it's a kundalini thing." *She won't get it and I'll feel stupid.* "You know, sexual awakening." *Here it comes, I know this look. Why does she always have to know this stuff? Like that time she had to know all about the affair up north.*

Claudia held the butter with both hands as if it were precious, "You too? God, Ali, I've been going nympho-crazy for months." Jokingly pumping the butter stick down near her crotch. "Tell me what's been going on." I looked at her and welcomed the humor between us. Her eyes tried to pry me open like an oyster.

I wanted to show her the soft and real center of myself, but I just didn't know how. I closed up the turkey and offered it to the dark hot mouth of the oven. With the heat on my face I recalled: *The desert-dry air and the moonlight washing the leaves blue. Dancing to the rhythm of the swaying sycamore tree. All the grass blades gazing up between my legs, admiring my pink pussy. Squatting down to give the dandelions a better view.*

"Claudia, what's been going on with me is kind of complex. I don't know if I'm ready to talk about it."

She paused, tearing the paper off the butter, leaving white shreds still stuck in it. "You were always complex. So what's new?"

"Okay, you roll the crust. I'll make the filling," I said, letting out a big breath. The can opener bit into the lip of the pumpkin can. A whoosh of earthy squash smell greeted my nostrils. My shoulders dropped, preparing for verbal undressing. "Last summer, I was really engulfed in it, really hot all the time for weeks. I tried to ignore it. And when that didn't work, I invested a fortune in vibrators and sex toys." *My garden lover called me for months and I resisted. Why? He's the best.*

Claudia slowly pressed the thin discs of pie dough into pie pans. "Yeah, I know what you mean." *Does she? Does she know what it means to be tapped on the heart by a secret lover? To spit-wet your fingers and stroke for the sake of the camellia bushes who spent themselves moons ago in their own wild display?*

Brown sugar, cinnamon and ginger swirled in the bowl. "One night," I continued, "I walked naked out the back door. I didn't want the neighbors to see me, but it was exciting to think some lovely stranger might be waiting for me out there." Claudia stepped aside as I poured the spicy filling into the shells.

The whole garden my stranger, my lover. For months my only lover.

Gently, she placed the pies on the rack below the foil covered turkey, then, closing the oven, she blinked at me.

Wondering how much to tell, I sat at the table. She picked up the nutcracker and cracked a walnut, waiting. "I started imagining there was a stranger in the yard who wanted to make love to me."

Claudia commented, "I've had fantasies like that. Once Tony and I pretended to be strangers and we fucked in the car." *She doesn't understand. This was not fucking! This was communion. It was sorority with the calla lilies.*

I chose a pecan from the bowl of nuts, rubbing its smooth shell along my lower lip. "The fig tree became the stranger. And I don't know how it happened, but...the calla lilies... You know how they have those pointed yellow things in the center? Just looking at them made me come."

The dry bark of the tree against my back. It knew exactly what I wanted. Then the lilies beckoned me. I opened and invited them deep inside.

Tossing the pecan back into the bowl, I finished by telling her, "I tried to cover my mouth so the neighbors wouldn't hear, but it was too late."

Claudia's eyes were wide, her mouth slightly open. "My cry echoed down the street and three dogs started barking." She laughed and I laughed. I was relieved, but I wasn't off the hook yet. Her brow gathered in a furrow, trying to comprehend. More acorns showered the yard.

"So....Let me get this right. You didn't take your vibrator out in the yard with you. You imagined a stranger watching you masturbate with the fig tree. And the dogs barked when the lilies pointed their yellow things at you. Ali, you are weird."

A white flour smudge on her nose made her look ridiculous. "I knew it! I shouldn't have told you."

She stated her case. "But you've got to admit it's weird. In high school, when you sent all those love letters to George Harrison, I could handle that. And at State, when you talked about shaving your head in protest of the Cambodian thing, I actually admired your individuality. But this. You've been alone too long."

I paused and lowered my voice. "No, you never have understood me." The images floated up again to reassure me. *My garden lover. That night. It was real, and it was beautiful. He understands.*

"Ali, I'm sorry. Let's just forget it. But I have to say that

whatever it is, you still look great." I looked at her silently and recognized the chasm that was still part of our friendship. The doorbell rang and the moment dissolved.

LATER, WHEN EVERYONE HAD LEFT, I made my way past all the dirty dishes standing in mismatched stacks on the kitchen counter. I turned off all the lights. The back door opened. I surveyed the yard and found the broad butter-colored leaves of the fig tree beckoning. Clothes dropped in a pile on the top step, I felt him watching me undress. The cool windless night air made turgid gumdrops of my nipples, my fingers played with one, as my feet crunched through spicy sycamore leaves into the center of the yard.

Do I see a shadow moving behind the draping branch of the fig? I stretch up luxuriantly and sigh to coax the shadow to reveal itself, then let my hands smooth down the front of me to my lightly pulsing crotch. There I take no time in parting the dark hair and pink lips—I'm happy to find I'm already slick, my longest finger skates back and forth, while I search the shadows for my lover's figure. He likes me to give him a little show before he comes out. Maybe I like it more than he does. I skate figure eights, then try to surprise my cunt by poking in quickly a couple jabs, and continue to slide my juices all over my swelling pussy. I can feel his eyes on every move I make. My eyes close, steamy clouds of breath puff quickly. A few growls vibrate my throat and I concentrate on my clit now, never rubbing, but pressing and circling on it until it peeks out of its cover saying "ooo ooo ahh ahh." I ram two glistening fingers up my vagina, spreading and bending my legs. Juicy drops are watering the little weed seedlings beneath me. Ram, ram, ram some more and I give in to an exquisite shudder.

As I squat and inhale the earthy odor on my glad hand, I hear crunching leaves. Covering my breasts I unbend, turn and wonder if Claudia has come back for something. I amaze myself to think I would like her to see me now.

But there he is—Mr. Greenleaf, my lover, standing among the fig leaves, eyes glowing, a certain mythological puissance about

him. He's naked as always, which is why I greet him in the same state. His words don't come out of his mouth, rather they sound themselves in my mind. He's asking now, "Do you mind if I smell the sex on your beautiful hand too?" He's archaically polite sometimes. Hence the title of Mr.; having sex with a Mr. makes it deliciously naughty. Pictures of a married bank president meeting his mistress at their uptown hideaway come to mind. I notice he has spread a maroon and green tapestry between the white tree trunk and the privet hedge.

I start toward him, my vaporous fingers extended when I notice there are more figures moving in the shadowy yard. My body is alert and excited at this veritable crowd. He mentioned he might bring his friends sometime. What looks like Adam and Eve grinning on the gravel path; and Leonardo da Vinci standing behind the acanthus that has not grown tall enough to conceal his hard on; giggling draws my attention to two nymphs picking and playfully smearing pyracantha berries on each other's breasts.

I greet each with a look and a smile, but continue toward my lover whose cock concurs with the Italian artist's. As I step onto the carpet, he takes my hand, inhales and kisses it. My eyes take him in like a second dessert, but he obviously hasn't had any dinner at all. His hunger drives him to his knees and between my thighs. Warm mouth on my already slicked pussy buckles my knees. I lay on the carpet looking up at the stars through the trees, while his most precise tongue travels to my clit.

I don't hear the nymphs, who are quiet now. They approach me, one on each side. One has long straight hair with freckles all over her plump body. She has the kind of sensuous and innocent puffed-lidded eyes that Flemish artists love so much. The other's black wavy hair, coal-colored eyes, and pear-like breasts with large brown areolas arouses an interest in women I didn't think I had. They caress their soft palms down my body to my hands where they bring them above my head and pin them there. I struggle a little to heighten my excitement, then surrender under their sweet kisses on my forehead. Next with a professional air they draw my thighs wider. The dark one's

hand lingers on my thigh, massaging the inner flesh. Mr. Green-leaf is still at my clit and I'm just about to burst. Adam and Eve's moaning from the hedge triples my excitement. They are match-ing my moans, my gasps and breaths until I'm gripped with the sweetest explosion. They all are making love to me in different ways.

Mr. Greenleaf's rosy, broad face emerges from my furry mound. I see his curly beard is wet as well as the tendrils of ivy that are plaited into it. His smile-crinkled eyes still glow. I turn my head to see Adam shining at me over Eve's shoulder as he proceeds to slide his erect and massive organ into Eve from behind. On the first out-stroke Eve winks at me and pouts her lips in pleasure. Leonardo has positioned himself at my feet with his paper and pencil—a three-ring circus in my garden! Looking back at my ever-attentive lover between my thighs, the girls loosen their hold. I reach up to kiss him hard and taste my sex flavor mix in our mouths.

The inseparable girls kiss and pinch each other's nipples, then focus on me again, gently pulling me down to the carpet again. I wish and guess what their next lovely service to me might be, then hum my pleasure when their luscious mouths descend simultaneously on each of my breasts. I feel like a goddess, my priestesses worshipping at my electrified body. Mr. Greenleaf has chosen his moment to arch back and plunge his full and shining cock into me. I yelp and the dog down the street pricks up his ears. Beautiful rhythm, my greeting hips and his thrusting mythological rod. For a brief moment I look past my lover's attentive face and see Leonardo. He sketches faster with one hand while his other is occupied with accelerating strokes on his meaty dick. They say geniuses can do more than one thing well at a time. Now I know. I also know my lover is giving me lots to be thankful for. I wrap my legs around his neck and close my eyes. I feel his cock tip intentionally work across and press my G-spot for what seems like hours. His persistence is my undoing. One brilliant orgasm gives way to another and another until my sobs and yips splash against every leaf of my yard.

Mr. Greenleaf never gives any indication of coming himself and I guess it doesn't matter to him. As we settle into a floating bliss, an unannounced and solitary gust of wind rattles the criss-crossing branches of the tree canopy above. A rain of acorns strikes the branches, each other, roof tops, and finally the ground around us. Not one but several dogs bark now. I wonder if it's my love cries or the acorns. Mr. Greenleaf, ever the gentleman, shields me, taking the pelting acorns to his own agile body. But when the acorns stop, my body feels the coolness of the calm garden air—my lover is fading back into the foliage. Of course, he never departs until I'm satisfied, my heart full, my mind at peace and my pussy polished and happy. His friends leave last. Adam and Eve continuing to experiment with positions as they fuck and fade away. The girls holding each other arm in arm blow kisses to me as they disappear into the fig leaves. But Leonardo hasn't yet signed his sketch, which lays in the dry autumn debris. He's too busy stroking with both hands on his cock taking aim at the new green shoots of the daffodils. A great laugh bellows as spurts of creamy cum fertilize the flowers. The dogs bark briefly, then he too disappears along with the drawing. I stand for a moment, brushing off the leaves that stick to my butt. Shuffling dreamily, to the steps where I pick up the pile of clothes, I turn and am grateful for my secret garden. *Claudia will never know what she's missing.*

Ceremony of Self-Love

All Creatures Big and Wet

Jim Herriot

AS I ROUND THE CORNER of a darkened plushly furnished room with its old paintings and ruffled furniture barely visible, my eyes halt on the sight of a semi-circular wall of round bare asses of a dozen naked standing close-together shapes. Even in this dim light, the moistness of their skin glistens as they silently undulate in like rhythm to a music I strain to see. I am enchanted. My mind chatters wonderment of what strange beautiful world I have dreamed into. My body wants to halt along with my eyes in awe, but it cannot. I tiptoe softly, lightly forward.

I am pulled, drawn closer, to this orchestra of embodied motion. I feel my own unclothed body beginning to sing to a primal silent drum beat. I feel beadlets of my own wetness begin to gush over my smooth touch-me skin. My hands instinctively reach down to my long curved runner's thighs and smooth youthful chest and spread these tiny perspiring droplets out into a cleansing bath of growing desire.

I glide my naked torso between a tall long-tresses-to-her-waist woman and a man with the lithe body of a ballet dancer. I can feel the taut skin of their hips barely skim the outstretched electric hairs of the curve of my buttocks. My body begins to sing the same song as the rest of our chorus. I feel the musty moist night air invade my nostrils and the length of my body inhale a hot steamy wind dancing off the center forms of our group embrace.

And my eyes can now see, feast, on the altar: the smooth luscious ever-moving interwoven, intertangled bodies of a

woman and a man making full fucking love on a clean starched white sheet, right there, so close I suck in the sweet scent of her pussy juice, the pungent odor of his sweating body, and my cock finishes its upward ascent of open admiration.

My hands act on their own to find a bottle of slippery lube, set out earlier for us in easy reach by some divine planner, by some earthy hostess or Queen of Heaven—I am not sure. The oil pours easily on my waiting cock and my hand slithers the oil into every pleasure-starved crease and fold. The furry skin of my balls flinches. My lips quiver. My mouth waters. My hands caress my cock following the rhythm of the lovers. My ever-snaking sinuous body moves more smoothly now. I glance at the woman next to me with her fingers softly rubbing on her throbbing open-flowered pussy moving to the same slow lovers' tempo. And the bodies of the others in our circle are in sync too. My eyes are moving in and out of the pussy of the woman being fucked on those stiff white sheets, and the man's cock sliding hungrily between her outstretched hugging lips, pussy juice every so often dripping and beading up on the curve of her yummy ass, and for a brief moment reflecting as a twinkling starlet in the pale night light.

As the lovers' tempo quickens my hands follow these sen-suous directors' lead. The circle formed by our wet-drenched naked bodies moves in and out as we together make dancing love to this delicious couple in our center. My hand follows the quickened pace of the lovers as it slides ever faster up and down my shaft. I can feel electric energy coursing up and down the full head-to-toe length of my deepest insides, moving ever faster. I am riding the same wave as the lovers in their ecstatic frenzy of fucking madness. The woman is now riding on top of the man's cock, squirming, writhing, barely holding on. Her pussy is pulsing, thrashing, voraciously gaping wide open to demand all of his swollen engorged heaving muscle, all the way deep into her inner most-intimate heaven.

All of a sudden I hear only breathing. All of us are inhaling and exhaling a single breath together along with the loud pant-ing of the woman on the white sheets now scrunching her face

in blissful almost-too-much pleasure, and the man's sinuous muscles tensing and relaxing in near-explosive power. I hear my own breath gasping in and out. The vital air seems to enter my wet insides through my screaming cock with my hand furiously pumping a new rush of pleasure with each stroke. And my breath moves in a white hot arc though my viscera, up my spine, into the pounding center of my heart, into the full expanse of my open ready panting lungs. I expel the finished breath out my mouth in a tongue of fire, and in the same instant a single shiver spirals through the length of the inside core of my oily solid cock.

I glance out at the plush warm room with its Louis the Fourteenth just-so chairs with their erect backs and the soft cloth covering their long sculpted arms. I feel a welcome waft of cool sweet air wash over my drenched breasts and feel the tingle of my hot glowing skin drinking up this surprise fresh wind. In the flurry of my nearly exploding cock, and the ever more urgent piston pumping of my hands, I recognize an odd calmness of this brief moment of "just before." In this stolen partial second, I have slipped "between the worlds" and have defied the deities and stopped time cold. Or hot, because already this moment is now past....

I feel a rush and the familiar quiver of a quickened heart as the couple blast through the walls of the universe in a scream of eternal happy I-am-alive orgastic orgasm. I feel the same wave of orgasm sweep though our circle, through the imploding pussy of the woman on my left, the tensing explosion of the man's cock on my right, and my own cum shooting in spattering droplets running down my slippery vibrating hands. My entire body shutters and vibrates to the erupting of my juices flooding out of me into the everything, the everywhere. I scream again as a second wave engulfs me with even more force than the first. The room turns a bright pure white, then blue, and finally I am enclosed in a sphere of soft purple light.

Our breathing slows and the lovers relax into a quiet embrace. I linger in the warmth of this perfect moment. The bodies in our circle smell of sweet stickiness and our legs are

streaked with trails made by streams of wet juices. The tightness of our dozen-body circle relaxes as our breathing subsides. People's eyes unglaze and one by one, we wake up from our group real-dream. Bodies stretch, feet begin to move again. And slowly we drift off in different directions into the dim light of this temple-room of sacred-orgasm pleasure.

It Will Do For Now

Molly Weatherfield

JONATHAN: My hotel was small, no elevator. I was glad of that. We'd sat quietly in the taxi, a little space between us. Hardly touching each other—I mean, not *not* touching, every so often one of our hands would creep over that little space. But hardly touching. Waiting. Which wouldn't have worked very well if we jammed ourselves into a little French ascenseur. I kept my eyes on her butt as we climbed to the third floor.

We were silent as we entered the room. She wandered to the window, opening it out wide, and looked out into the courtyard, the geraniums in pots, deep red and pale purple. You could hear birds, and you could see two young women taking in the fragrant, billowy sheets they'd hung out to dry that morning. "Nice," she said.

I stood next to her, facing her, and closed the curtains. I looked down at her neck, rising from the crisp, oversized white shirt under her leather jacket. She didn't have a bra on—the shirt was loose and opaque enough so that wouldn't immediately be apparent. But, trust me, I knew. I looked at the inverted triangle of chest at the neckline of that shirt, the shadow at the apex where I knew her breasts began. I almost reached up to unbutton it. And then...I had a better idea.

I took off my own jacket instead, tossing it on a chair. Sweater and shirt, too. T-shirt. Her mouth twitched a little at the corners, and I kicked off my shoes, reached down and pulled off my socks.

She put her hand on my belly, and I knew she could feel it tremble. I leaned over to kiss her, lightly, quickly, just grazing her lower lip with my teeth.

She sighed, and then she backed up a step and folded her

arms across her chest. Well, she'd certainly gotten into the spirit of this vacation thing. She was smiling now, full out, looking tough in her leather jacket. And her eyes were on my belt buckle. Hungry, amused, challenging. If she'd ever, during the time we'd been together, if she had ever dared look at me that way...well, it would have been unthinkable—she'd have gone off the chart, that informal and arbitrary chart of punishments and transgressions I'd maintained in my head. Arrive late at my house, five strokes with the rattan cane, forget to address me by name, ten....

Well, if I'd wanted to guarantee her (hey, and *me*) a monster erection, I guess I'd succeeded. Probably it was the memory of those beatings—coming in loud and clear amid the static of little signals she was putting out now. I fumbled with my belt, remembering those beatings, using them to keep myself focused. Tossing aside my pants, pulling off my shorts. And then there was nothing for me to do but stand there and submit to her appraising gaze.

"Well," she murmured, "you're still a very beautiful man, Jonathan. And you're right—it's crazy how little I know about you in some ways. Like how old are you anyway?"

"Thirty-eight," I answered, trying to sound casual. *Still...* the word had a cold edge to it.

She nodded noncommittally. "Help me take off these boots, please?"

She sat on the bed and I knelt to take off the stiff, pretty new boots with their intricate, multicolor stitching. She took off her jacket but sat still. I pushed her skirt up. She had on long black stockings, a black garter belt, no panties. Slender, very white thighs. Her pubic hair was short, like the hair on her head; they'd shaved her cunt, the hair was just now growing back. The black stripes of the unadorned garter belt drew the stockings up very high, very taut. The whole effect was so ambiguously situated between whorish and conventlike—after a year, did she really remember so precisely what I liked? Or maybe it was just what Constant—the guy who'd bought her at the auction—liked.

I undid the garters. And then I put my head down and grabbed the embroidered edge of a stocking with my teeth. I could feel her thigh under my lips and I slowly pulled the stocking down, my mouth sliding over her knee, her calf, her foot. I kissed her bare instep and then I did the same thing for the other stocking, the other leg, the other foot. She had just the slightest, heartstopping trace of a purple welt on that second thigh, not quite healed—I lingered on it. It made me want to eat her alive.

I reached for the hook of the garter belt, pulled it softly, and it fell away. The little black miniskirt was made of some stretchy fabric. It was easy to pull off, and she helped me, lifting her ass slightly. I pushed her back on the bed, very gently, so that she was still sitting up, and straddled her. And, much more slowly than I wanted to, I unbuttoned her shirt, while she kissed my neck, my shoulders.

And there she finally was, and I stopped caring about what she might want. I fell on top of her, grabbing her ass, tonguing her breasts, moving her up to the pillows. Later for sensitive lover tricks like the stockings; at that moment all I wanted to do was get as much of her into my hands as possible, before I got as much of me as possible into her. She moved against me, wrapping her arms around me, arching her back, so that our fronts were pressed together, and then I was in her, her legs around my neck, her hands on my chest. I stroked in and out, long, slow strokes. I wanted to last forever, I was afraid I wasn't going to last at all, I guess I lasted long enough—to hear her cry out, anyway, loudly.

And afterwards, after a space of time that I can't describe, I felt her come, once more, just a last little one—she was hardly moving at all except inside. And then I heard—maybe felt—a low laugh in her throat, bubbling up from somewhere deep inside her. I'd forgotten that laugh, but now I remembered it—her laugh that meant when it was especially good there was always something just a little ridiculous about it.

She hadn't let me hear that little laugh too often. And rightly—I would have had to punish her for it. So, as she'd gotten to

know me better and had become cleverer, she'd only let me hear it when she knew that I'd fucked myself into a stupor—that I was too wiped out to whale her for such flagrant disrespect. I liked hearing that laugh again. And I'd like punishing her for it. Not right now, of course, but soon, soon enough. For now, though, it was good enough that she was here, under me. For now, anyway.

CARRIE: We must have fallen asleep. Because the next thing I remember was the sun coming through the curtains. It was low, and the light was pink. Sunset.

I was lying on my side. Jonathan was behind me, one arm flung across me, his hand on my breast. Long, tapering fingers, beautifully articulated bones spreading out from his wrists. My skin looked pink in the light, pale pink against the olive of the back of his hand. I could probably bend my head down to kiss that hand if I tried, I thought.

I wanted to, a little. To show him how good I was feeling. Not that I'd exactly been keeping it to myself, but still. It was all so luxurious, so warm and indolent. During the past year I'd occasionally thought of his hands, the bones in his wrists. They'd drift, these images, unbidden, into my thoughts, late at night, perhaps when the day's challenges had overwhelmed my defenses. I'd remember the weight of them on my body, their elegant curve around my breasts. And I'd remembered correctly, too, I thought. I'll move, I'll do something soon, I kept promising myself. But right at that moment I didn't want to do anything but lie there with the slanted light of that sunset lengthening against us on the bed. Well, perhaps I could shift backward a little, a little closer to his hip....

His hand tightened. He was beginning to wake up. I lifted my head and licked his fingers. I inched my ass closer to him. He turned a little, and I could feel his cock—still a little moist, but not yet hard—jumping a little against me.

I turned a little more so that my ass was directly against his cock, and he moved his other hand under me, reaching for my other breast. He kissed the back of my neck. I arched my back,

stroking his belly, his stiffening cock, with my ass until I felt him move into its furrow. Slowly now. I moved back and forth—teeny movements really, stomach contractions, rotate an inch forward, an inch back—while he grew against me.

"Okay," he whispered, and we moved onto our knees, him on top of me.

The bed had a headboard. I grasped it. I didn't want him to have to balance on his hands. I didn't want him ever to take his hands off my breasts. He spread his fingers a little, enough to catch my nipples between them, and then tightened. And while I gasped at the pinch, while I lost a beat in thralldom to that sensation and he felt me lose that beat, he moved his cock against my asshole.

I wasn't ready for him, quite. He knew that, he'd been looking for that moment. He wanted to feel me yielding to him. He pushed slowly and I gave way, arching my back, opening to him, forgetting everything except that yielding, that opening, that always frightening letting loose.

It hurt a little on every thrust. (It always does. I hope it always will.) I pushed back against him, making it hurt just a little more. He moved more deeply into me, and I began to cry out guttural, unrecognizable sounds that came from deep inside. I teased myself a little. It hurts, I thought, I have to ask him to stop. Yeah, right. I felt myself opening my mouth and trying to shape some words—please, or slower, or something—and the words lost their form and became cries of pain, of pleasure, of desire and delight, and I heard and felt myself coming loudly.

He moved his hands from my breasts to the wall above the headboard, leaning heavily forward, surrendering to his own loud orgasm. Somehow we slid down together to the bed, my sweaty back plastered to him while I felt him shrink slowly in me.

I began to believe, for the first time that day, that I was actually here. With Jonathan. In a hotel with faded blue shutters at the windows and geraniums in the courtyard. There were lavender and lemon vervain in a vase on the dresser. And the sheets of our bed still smelled of sun and fresh air. Well, of

sweat, too, and of cum. Wonderful, I thought. Well, but right at that moment I was finding just about everything wonderful. No fantasies, no reciting his little letter to myself as though it were a catechism, no dreams about romantic endings. Just this lovely, wonderful, all-enveloping lust. Vacation. No rules, no plans, no idea what would come next. It would do for now. It would do quite nicely.

Excerpted from the forthcoming novel *Safe Word — Carrie's Story II*.

Faerie Gathering

Trebor Healey

Wolf Creek is one big 80-acre faggot
I've got a crush on

These ten days have been
like one long slow delicious fuck
looking into that lovely faerie face
I can feel the smooth friction of the muddy land entering me

I see the shadows of his faerie wings
flitting across the moonlight
my body has become a pattern of magick tokens
offerings to this Great Faggot Spirit
My asshole opens like a rising sun to receive his hot Oregon
 day
Each morning I open my lips to kiss his faerie skymouth
 and out rolls a purple moondisc from his smile

Oh my Whitman cock
sings like a cricket in his sweatdrenched night
and paints a jackson pollock out of blackberries and limestone

All the daylong I lick his drygrass chest
and hold his treebranch limbs
I watch him piss the clear coolness of the spring

I run through his red earth
like tears and blood and cum and mud and honey
 I like the bees that swarm around him
They're the faeries
comin' for to carry me home

My chest is an altar
I've erected to my Wolfboy
and my heart dances under his moongaze
my arms move like my tongue through his breath
I whistle the pipes of Pan
rolling like an echo through the woods
I contort my body into a kiss inside his meadowmouth
all these forested hills are his goatee

I squirm around in his warm muddiness
I sing to him with my blood
my orifices echo with his laughter
they are the pores of his skin

I bathe in his eyes
like cool waterholes in the 100-degree heat

I can barely contain the love of this iron cockring
of trusting faggots
faerie circle molten

Wolfboy heart
an opening timeless meadow
80 acres of sanctuary for fae ones
Our collective body
where we can sit and cry and fuck and share
and gather his magick seeds
 —There are too many to count!
falling from my open cupped hands
I feel like a big messy fruit
 —And I am!
spilling my seeds and sweetness

Wolf Creek is forever

A great ripe mango of joy
in my heart

Rainbow Rainboy

Trebor Healey

You came out of the ground
you handed me a bouquet of cabbage and kale
and the baby's breath of alfalfa sprouts
grew green round the stiff-stemmed flower that pointed at me

You were a dandelion in sexwind
I saw nothing but visions of
zucchini and japanese eggplant for days

I felt like a raincloud
the way your heart sprouted in beanrows
laughing with color
as they climbed through my ribs

I ran through your cauliflower brain
like a fantasy
your hair as fine as wheatgrass
I marvelled in the pumpkin of your ass
with the perfect firm creases and the orange glow
I played in the reeds of your armpits
like the green ends of celery bunches
To say nothing of cucumbers and a scrotum full of russet
 potatoes
Oh your mouth, as light and summer cool as jicama

Your eyes were like sweetpea flowers
but they only lasted a day
Oh your name was everywhere then
because you were earth, wildflower rainbow panboy

there wasn't a fruit or a squash
that wasn't named somehow for you
You blessed me in cum whiteness
generosity
and then you went away
magic cloudboy
Indian summer
It's so easy and so hard to go to seed

I didn't know who you were, satyr

I just chanted and tasted your name
like a bliss idiot in the weeds
Dandelion, Wheatgrass, Cucumber and Jicama

Sex and Death

Trebor Healey

"I have done with Moby Dick *something that I used to do with my teddy bear, many years ago. I have slept with this piece of perfection in my arms."* — A satisfied customer of Easton Press

Me too, Easton Press
Me too

I never told my mother what happened to my teddy bear
why I threw it away
she said it had sentimental value
and I was being a rebellious teenager throwing away my youth

I didn't want to explain it had calcified inside
its stuffing like bone
like an old woman, hard and brittle
as toffee

I'd bored a hole up its back when I was 13
pumped on it
with my newfound toy
that hung off my body
my new candy
that got hard as toffee

I fucked that teddy bear
every way imaginable late at night
'til, like I said,
it was just bones
hard and brittle inside

from dried semen

I threw it out
and momma called me ungrateful
I missed the teddy bear sometimes
but I knew it would be highly suspicious
to purchase a new one at 14
So I tried to read at night to keep my mind off Teddy

I was reading *Moby Dick* for school
the powerful leviathan rising up from underneath
tearing holes in whaling ships
Captain Ahab's leg of bone
the men running their hands through spermaceti

I couldn't go to sea on a whaler myself
but I was hard-bent on *Moby Dick*
I got myself a real nice copy
from the Easton Press
(I had to save the paperback for school)

I'd find the pages where the big white whale
sunk a whaler
to gob on the Vaseline
then I'd fuck all through the words
'til they spoke stiff as tombstones
sealed the book closed tight as a coffin
calcified a classic
buried its bones in the backyard

Call me Ishmael if you want
Call me Teddy
Like death, I just take what's given
And what's given
is a hard and wanting thing
that takes me to the boneyard every time
where I build my temples of stone

Sex With Him

Trebor Healey

Your balls lounging around
and then when the erection erupts
and the balls are suddenly hung by nooses
and hang in the lounge of your erotic restaurant
Arabic women are keening as we cum
Our tongues are doing their own thing regardless of us
pollinating all the skin before them like wind-driven pansies
and the torches of our cocks
which lead us
are burning through the checkpoints at our orifices
It's an international incident
a media frenzy in fantasy
YOUR COCK!! a headline
CUM! on the evening news
Making sensational love
with symphonic soundtrack screaming
Cocksong at the top of the charts
loud with white refrain
and a baritone boner bass line

Religion

Trebor Healey

There are more cocks than saints
and they are as distinguished by their qualities
patrons of pumping
martyred as they shoot their wads and cockdie on sexy
washboard stomachs
I like the black-haired ones best
I like the mystery they're coming out of
I like the light that comes out of darkness
like white mushrooms and black logs
white mushroom clouds of cum exploding out of black missiles
white flowers on black lava
stars at night
moon in a black sky
white cum and black men
white teeth, white eyes, white calvin kleins
his black cock, his white cum
black snake, white tongue

Song of Songs

A Performance Piece in Praise of the Q'deshim of Ancient Israel

Mark Elk Baum

I.

The stage is empty except for four small olive oil lamps set at the corners of an imaginary seven-foot square space, with one lamp at the upstage corner, another stage left, a third stage right, and a fourth downstage. Next to each lamp is a pile of wooden matches and a striking surface. Behind the upstage lamp there is also a covered basin containing oil or alcohol. It sits on a tray, with matches and a striking surface.

[The stage light begins with a full, warm glow.]

[The performer enters, wearing only a simple skirt. He carries a rolled-up prayer mat over his shoulder. He lays out the mat within the square of lamps, while singing:]

Dodi li, va-ani lo, ha ro-eh ba-shoshanim...

[Then he lies down on his stomach with his head by the downstage lamp, while singing:]

Dodi li, va-ani lo, ha ro-eh ba-shoshanim...

It was late November, and I was out in the desert at a place called Second Chance Ranch. I was sharing a tent with Moonfaerie, and every night I'd lie there waiting for him, feeling jealous, and feeling stupid about it. When he finally came to bed, it was so cold that he'd just crawl into his sleeping bag with all his clothes on and pull the covers over his head.

[The lights slowly begin to fade to black.]

One night I could tell he wasn't coming back. I was so tired, I just gave up. I said, "Fine. When we're meant to be together, we will be." And it worked—right away, the tent was mine. I

had it all to myself. So I tucked myself in, sang a little lullaby, and fell asleep.

[The stage is now in total darkness. He lights the downstage lamp.]

 I SLEEP, BUT MY HEART IS AWAKE.

In the middle of the night, I woke up and heard this call, not just in my ears, but in my bones.

 LISTEN! MY BELOVED IS KNOCKING AT THE DOOR.

I wasn't sure why, but I got up, found a pretty skirt to wear, brushed my teeth, combed my hair with my fingers, and put on my favorite perfumes, The Power and The Glory, one for each wrist.

 RISE UP, MY LOVE, MY FAIR ONE, AND COME AWAY.

When I stepped out of the tent, the air was warm.

 FOR LO, THE WINTER IS PAST, THE RAIN IS OVER AND GONE.

The wind had shifted while I was asleep and the Santa Anas had come.

 THE FLOWERS APPEAR ON THE EARTH, THE TIME OF SINGING IS COME,

The full moon was high above my head, surrounded by a bright ring of light.

 AND THE VOICE OF THE TURTLEDOVE IS HEARD IN OUR LAND.

I felt so free, you know, I wasn't calling, for a change.

 THE FIG TREE PUTS FORTH HER GREEN FIGS,

I wasn't tugging on Moonfaerie in my mind, saying, "Where are you? Come back."

 AND THE VINES WITH THE TENDER GRAPE GIVE A GOOD SMELL.

Instead I felt someone calling me.

 ARISE, MY LOVE, MY FAIR ONE, AND COME AWAY.

II.

[He comes to a sitting position while singing:]

 Oo-ri tsafon oo-vo-i tei mahn...

[Then he lies down on his side with his head by the stage right lamp, while singing:]

 Oo-ri tsafon oo-vo-i tei mahn...

I was going to meet my bridegroom, that's what was in my head, and it filled me with joy. So I began dancing under the moon, my wedding dance, and I was singing a song I learned at Camp Sholom, *"Dodi li,"* except I couldn't really remember

it, so I was just sort of making it up, going *"Dodi li, va-ani lo, dodi li, va-ani lo,"* but it didn't matter, it felt right.

I went dancing through the trees, singing my song. I was completely open, every part of me: my cock was warm, my heart was pounding, and I could feel the moonlight shining in my hair. It was like, "Somebody take me now!"

[He lights the lamp.]

IF I MET YOU ON THE STREET, I WOULD KISS YOU,

The first person I ran into, he was gonna be the one, no matter who it was.

AND NONE WOULD DESPISE ME.

That's the whole temple whore thing, you take what comes along. It may scare you, it may scare you a lot, but you do it anyway. So I kept dancing.

I WOULD LEAD YOU,

I had to visit everywhere there might be people,

I WOULD TAKE YOU TO THE HOUSE OF MY MOTHER,

past the kitchen, the big pavilion tent, and the porta-potties too, way up the hillside,

SHE WOULD INSTRUCT ME.

but nobody was awake. Nobody.

III.

[He comes to a sitting position while singing:]

Mi zote olah, min ha-midbar, mi zote olah...

[Then he lies down on his side with his head by the stage left lamp, while singing:]

Meh-ku-teret mor, mor u'leh-va-nah, mor u-leh-va-nah...

That was sort of a relief. I figured I could maybe marry the wind or something. By then, I was way out on the edge of the ranch in this open area where everybody leaves their cars, and I started to open my arms to the wind, when I finally saw somebody, and I was like, "Oh, no!"

[He lights the lamp.]

WHO IS THIS THAT COMES OUT OF THE WILDERNESS LIKE PILLARS OF SMOKE, PERFUMED WITH MYRRH AND FRANKINCENSE?

I thought, maybe I didn't have to stop after all, maybe I could just dance really fast across the parking lot, and if he followed

me, it was meant to happen.

WHO IS THIS THAT LOOKS FORTH LIKE THE DAWN,

I took off spinning across the parking lot and ran down this path past the goats towards the big firepit,

FAIR AS THE MOON, RESPLENDENT AS THE SUN,

but he took a shortcut and was standing at the bottom of the hill, right in my way.

AND TERRIBLE AS AN ARMY WITH BANNERS?

I remember thinking, "Okay, this is it," and then I stopped, and didn't know what to do, because it was Moonfaerie standing in front of me, and all I could say was, "Of course."

THIS IS MY BELOVED, AND THIS IS MY FRIEND, O DAUGHTERS OF JERUSALEM.

IV.

[He comes to a sitting position while singing:]

Dodi li, va-ani lo, ha ro-eh ba-shoshanim...

[Then he lies down on his back, with his head by the upstage lamp, while singing:]

Dodi li, va-ani lo, ha ro-eh ba-shoshanim...

We walked together to the firepit. While we were collecting wood, he told me that he was spending the night with Flutterby in his truck, but Flutterby fell asleep, and Moonfaerie felt very strongly that he was needed at the firepit. So he climbed out of the truck and started to cross the parking lot, when there I was, whirling in the moonlight.

[He lights the lamp.]

OPEN TO ME, MY FAIR ONE, OPEN, MY DOVE, FOR MY HEAD IS FILLED WITH DEW, AND MY LOCKS WITH THE DROPS OF THE NIGHT.

Once we got the fire burning, he spread out his coat, and we lay down together.

I HAVE PUT OFF MY COAT; HOW SHALL I PUT IT ON? I HAVE WASHED MY FEET; HOW SHALL I WALK UPON THEM?

I felt my body growing warm, like a rose in the sun. He took off my clothes, and started kissing every part of my body, my lips, my nipples, my cock, even my asshole.

MY BELOVED PUT HIS HAND IN THE HOLE OF THE DOOR,

I've never had anyone make love to me before—I mean,

inside me.

AND MY HEART YEARNED FOR HIM.

I got raped once, but that doesn't count.

I ROSE UP TO OPEN TO MY BELOVED; AND MY HANDS DRIPPED WITH MYRRH,

When someone starts to mess around with my asshole, I freeze, usually, I go somewhere very far away, and I have to, like, remote control myself to get him to stop.

MY FINGERS DRIPPED WITH SWEET SMELLING MYRRH,

But that night, I felt myself opening more and more,

UPON THE HANDLES OF THE LOCK.

as though a door I had forgotten about was slowly swinging open on its own.

I OPENED TO MY BELOVED.

V.

[He reaches over his head to lift the basin of oil, while singing:]

Li bav-ti-ni ah-cho-ti chalah, li bav-ti-ni chalah...

[Then he lifts the basin, slowly sits up, and places it in front of him, while singing:]

Li bav-tini ah-cho-ti chalah, li bav-ti-ni chalah...

When I felt his cock sliding gently into me, I was so surprised to discover how kind it could be. I just didn't expect it, it was so different from what I remembered. He was moving inside me, and I couldn't stop, I kept saying, "Thank you, thank you, thank you," like a prayer, and laughing, and crying. Then, when he came, he relaxed against me with his head on my chest, and we lay there, looking into the fire, and the moonlight was shining in the sweat on his back.

[He uncovers the basin and lights the oil.]

WHO IS THIS THAT LOOKS FORTH LIKE THE DAWN, FAIR AS THE MOON, RESPLENDENT AS THE SUN—

We kept the fire going until the sun came up. As it rose, we saw—just like the ring of light around the moon—there was a rainbow around the sun.

WHO IS THIS COMING UP FROM THE WILDERNESS, LEANING UPON HER BELOVED?

For a while, both of them were there, together, in the sky.

[He sings:]
 Dodi li...
[He blows out the upstage lamp.]
 va-ani lo, ha ro-eh...
[He blows out the stage left lamp.]
 ba-shoshanim...Dodi li...
[He blows out the stage right lamp.]
 va-ani lo, ha ro-eh...
[He blows out the downstage lamp.]
 ba-shoshanim.
[Covers the basin again.]
[Complete darkness. Pause. Lights slowly fade up again.]

Pleasure Reading

Janice Heiss

WHAT A DAY. IT BREEZED BY ON BUY/SELL TICKETS. In/out, in/out: trading is where the action is. "Write tickets, write tickets and dial for dollars, that's what you're in the brokerage business for, men," my boss harped at the 7 AM sales meeting. Then he noticed me, red dress in a sea of gray suits, and said: "Excuse me, Jennifer, I meant guys and gals."

Got my clients out of DDC (trading at a new high) with a tidy profit and into TIE (trading at an all-time low). Buy at the bottom, sell at the top.

I was revved. A quiet, predictable bus ride home would do me good, settle my nerves. For the one-hundredth and last time that day, I looked at my Quotron to check stock prices. Then I rode the elevator down thirty-three floors and walked out to the corner of Kearny and California. I felt high. This big trading day made my month in commissions.

After only two minutes, I hopped onto a 38-Geary bus at Market and Geary. West Coast broker's hours, 6 AM to 2 PM, made getting a seat easy. I scored a perfect window seat, three-quarters back from the front of the bus. Far from the turbulent front where crazed commuters complained about fares, jostled for seats, and struggled for change, and away from the back where seamier characters dealt drugs, started fights, and knifed and defaced seats.

Ah! Time to settle in. I whipped out the *Wall Street Journal*. Obligatory stuff first, then my pleasure reading. What did these straitlaced secretaries with their concealed paperbacks read, I wondered?

"*The inflation wolf has been banished from the door, but he may be lurking in the woods just outside,*" I began to read. "*Stock investors*

drew that conclusion...."

But I was immediately distracted. First one woman, then another suddenly popped out of her seat. Like popcorn, a few kernels exploding here and there. The women were upset. They got off the bus or moved up front near the driver.

"Oh, no," I mumbled. *"Higher interest rates are unwelcome,"* as was this interruption. Was one of the coach's resident cockroaches making the rounds? I read on guard, ready to kill, holding onto my space like a dog its bone. Another woman popped, closer to me now. Women only. Hmm.... More skittish about bugs? When the last one, only two seats up, vaulted with an indignant "Ugh!," a man in a too-short trench coat sitting next to her got up too. At first, he looked confused, like he was going to quickly exit out the back door but then when she left, after screaming at the driver and demanding a transfer, he stayed. Probably decided not to let a roach scare him off. Or, was he a thief?

Next thing I knew, he was sitting next to me. But I wouldn't budge from my coveted seat. Not a seat was left on the bus, unusual for this time of day. The bus let out a big fart and climbed laboriously the slight incline before Van Ness Avenue.

My seatmate emitted a mixed vapor of sweat, street smells, and something sweet, unidentifiable. Without looking up, I shifted to let him know that I knew he was there. He responded in kind, as if we were in bed, positioning for sleep. As long as I hugged my purse, what could this guy do to me?

Against all odds, I read on, one eye on the paper, the other on the trench coat. *"Competition for investors' dollars intensifies as bond yields become enticing.... We're shifting money out of the stock market and into...."* He was an invisible sort of man wearing weathered, shabby clothes. He was white, slight, late middle-aged, with leathery skin, and sandy streaks of thin hair. A reddish, alcoholic aura glowed from his featureless face. He seemed to be going nowhere. I fancied he lived on the Muni, transferring day and night from bus to bus.

"Many economists have been bracing for another interest-rate hike for weeks...." I never looked directly at him. He gave off timid

and anxious vibes. He's harmless, just as long as I keep my eyes on my purse, I concluded.

Now what! I felt something on my right calf walking down my nylon. The roach? It tickled, like a feather. Maybe just an itch. Trying to keep my cool, I leaned down to scratch it. He stirred suddenly in his seat, and I ignored it. Nothing. There was nothing crawling on my leg.

"Flush with demand for consumer durables...many factors are close to the potential 'flash point.'" He leaned too close, and I moved away. He backed off. *"'I think we're already at the threshold point, but nobody fully realizes it....'"* Again, I felt something like warm sandpaper on my right leg. *"Bonds are hot, being driven by...."* Just perspiration moving down my leg?

Then it started to move up! Slowly, very slowly, so as to be almost imperceptible. Carefully, gently, silently, talking through touch: "May I go further?" And then imploring: "Please let me touch you deep down." "Yes," my body said without moving, my body that had become autonomous. *"Borrowers are squeezing margins and are...harder than before. If an issue isn't attractive enough, an underwriter is forced to swallow a huge chunk...."*

I lost my grip on my purse. Spare change jingled in the bag dangling from my arm. Take it, take it, open that bottomless, black sack full of secrets and dig in. A warm sensation radiated from my urethra, that pleasant teeming I sometimes feel peeing after holding it too long. *"The time is right for bonds to move up another leg...playing a role in the mood of the market."* My legs spontaneously uncrossed from the sweet rush but, a moment later, I thought of the roach and tightened up again. I had had my fun; enough of this fooling around.

But the tickling came back. It was travelling up my leg, higher, under my coat. There was no mistaking it.... *"'We feel the weight of a major top bearing down on us,' Mr. Botts says."* We passed the Kentucky Fried Chicken at Steiner, the half-way point. Concentrate! I commanded myself. It was someone's hand. No insect I knew had fingernails. It felt rough, scaly, foreign.

Wow! My feet were dancing, dead give-away. They arched like perfect high-divers in mid-air. The *Wall Street Journal* looked like a word puzzle. His hand went through the hole in my panty hose, tearing them further. Who the hell does he think he is? I thought, gluing the lips of my vulva together like two fists challenging my contender at the beginning of a fight.

Suddenly the hand stopped moving, asleep on me as if we were lovers, sleeping and waking, having sex and then falling asleep again, repeating the pattern throughout the night. Was this a dream? "*While some strategists have focused on the long end....*" The hand seemed to play dead for hours. What a tease! Keeping my head in the newspaper, I turned my body slightly toward that precious hand. "*Real rates are rising and economic growth, while still positive, is at its peak. When the market realizes this, it's going to cause problems for stocks.*"

I squirmed. The hand awoke. Did it ever! Several fingers whirling like dervishes in my bush, playfully pinched my skin and pulled on my pubic hairs.

My clitoris rose to the occasion. My vagina pulsated and burned, hungry, hungry, waiting for its prey. "*Real rates are rising.... When the market realizes this....*" The bus came to a sudden stop, lurching us forward. My accommodating cubbyhole sucked his long index finger like a thick, luscious malt up a straw. "*It's going to cause problems for stocks. Problems for stocks. Problems for stocks....*" I was a top, bobbing and spinning on his finger. OK, OK, you old lecher, so you think you can screw around with me like this? Tongues of the brightest orange fire licked my swollen opening. Jump in yourself, clothes and all. Put all you have into it, man. Come on, throw it all in, and I'll burn you up as fast as you fill me!

Another finger joined the dance, round and round, wider and wider. My hole was a pliant clay bowl thrown on a wheel, reshaped each moment. In an act of masterful manual dexterity, yet another finger (which one?) tracked my labia like a virtuoso pianist travels up and down a keyboard, playing me by heart. "*If, as expected, the Federal Reserve pushes short-term rates higher....*" Higher, higher....

The *Journal* looked like hieroglyphics. I gazed out the window and imagined crowds gathering all along grand Geary Boulevard cheering me on to my homecoming. Like a dog on a leash, I moved first here, then there, until I felt the pull of my master sharply defining my boundaries. He had me and he knew it.

Begging suddenly seemed second nature to me. My mound was a frisky little dog, jumping and yelping for food and attention. It rose to his fingers, salivating. *"For some strategists, the magic number remains a bit further out on the horizon.... But we don't think that either of those things will happen...."*

The 38-Geary hit a big bump. I came like a cowgirl on a bucking bronco. Bump, bump bump. Parts of me I never knew existed flew out into the world like confetti. I came again and again like endless troops of happy soldiers marching home victorious. I came as I sat looking respectable, professional, sitting up straight and supposedly reading.

"'It's been a weird October,' says Stephen Hughes." Oh, no. Would I leave a puddle of white foam when I got up to go? It felt like a big can of shaving cream had exploded in my pantyhose. The warm ooze dripped off of me, stalactites circling my vagina.

"Arguello! My stop!" I pulled again and again on the request-stop cord, holding onto it like a life raft. He put his lizard hand into his pocket.

I was spent, like a tulip in heat, opened wide, inside out. The mildest breeze could blow away my flimsy skirt of petals, my last disguise. "Driver, driver, please stop, stop, I missed my stop!" He mercifully made an extra stop at Second Avenue.

I rode the buzz from my pants home. I almost wrapped myself around the lamppost in front of my apartment like the mad woman at 2 AM who hugs it like a lover. Like her, I would illuminate all the city streets this way.

As I unlocked my front door, I noted how refreshed I felt after a busy day at work. What a great day; I accomplished so much. Maybe because I'm getting better and better at doing two things at once, I thought.

Watching the Late Show

Caprice

Late at night. The house is silent.
She wakes, feeling the bed empty beside her.
She slowly rises to wake her husband,
 that he might come to bed.
Expecting to see him sleeping in front of
 the murmuring television,
instead she sees him rigidly tense in his favorite chair—
head back, jaws open in a silent scream,
hands working furiously over his glistening genitals.
Hands.
She has never seen him this way, both hands
pleasuring
himself
with two hands, one working with varied tempo
over and along his straining dick, the other pressed deep be-
 tween his legs,
moving.
"Where...what is he doing?" she wonders,
her breath taken.
Sex with them was never like this.
"The Regular," they called it, humor masking the pain
 of their alone-ness,
the disappointment of quick semi-pleasure.
But now
she watches him, sweating in the soft flickering light,
televised words unheard
by either of them.
He quickly lifts his hand to his mouth, licks,
and returns to his pleasure—newly wetted dick

shining in the dark.
All too soon for her
he comes, pulling pleasure from his dick in quick spurts.
His orgasm lasts long, longer than any she has known.
She quickly returns to bed,
so she does not see him lick the come from his hand.

In the dark, waiting,
she thinks of her own furtive pleasures.

After a week of watching him at his
solitary pleasure
she initiates "The Regular."
It is like always—a quick and superficial
prelude to sleep. She tries to caress his scrotum.
He moves subtly to block her hand.
He comes quickly, no straining in his body.
Though she has ignored herself, her pleasure,
the vision of him coming in the flickering light
brings her orgasm.
She lies next to his sleeping self, wondering.

She learns the meaning of the phrase
"Watching the Late Show,"
knows now that it is his time for pleasure—
deep, personal, joyous pleasure—
two-handed pleasure,
pleasure on the recliner, in front of the forgotten TV,
ended by long, long, silent howls
of body ecstasy,
of wild abandon to pleasure
without her.

He becomes *her* Late Show.
Her knees get weak watching him,
drinking in his body-love;
it fills her with desire and lust and wanting.

A sunny Sunday morning, lazy and relaxed.
Over the brightly-colored comics she asks,
"Are you happy with our sex life?"
He looks at her, surprised that she has
broken
the easy conviviality of the morning.
"Of course," he says.
"Are *you* satisfied?" she asks, knowing that she's
pursuing
a topic already clouded,
closed.
"Of course, dear," he says.
He smiles at her, squeezes her hand.
They talk of other things.
She feels closed off from him,
frustrated to be
left out.

In the bathtub, she learns to allow herself
her pleasure.
No longer the quick fingering
with the door locked against sudden intrusion,
but the legs spread, lips spread, feet on the wall
stream of water on her clit.
Her orgasms begin to match
his,
her pleasure is now welcome in her body.
She thinks of him,
sees his whole body engaged,
engages *her* whole body,
expresses with her fingers on
lips, nipples, belly, neck, earlobes;
feels herself,
enjoys herself,
enjoys.

In time she learns to think of
other things, other images.
The water bill goes up.

She joins a woman's group,
talks there about pleasure,
about the barrier between her husband and herself,
the barrier behind which lies the seething
ocean of his pleasure.
Her new friends are intrigued with her pleasures—
some have water bills that go up, too;
others can talk with their lovers, increase their pleasures.
"Perhaps your husband's gay," her new friends say.
"Why," she asks, surprised at the thought,
"would having pleasure make a man gay?"
They say, "He loves a man's body in private,
he licks his come—
our husbands and lovers don't do that."
"I lick my own juices,
taste my own come," she says.
"Am I gay?"
They regard her with silence.

Life goes on.
Sex goes on.
She enjoys his.
He doesn't know of hers.
After the frustration subsides
is left a quiet wanting, a wish to be included.
The bathtub is
too good
not to share with her husband.

So one quiet night
as they both watch TV,
he turns at a slight sound of rustling
to see her sitting

with her hand disappearing underneath her skirt—
wrist slowly moving in a motion as old as time.
He is shocked, looks quickly at her face
to see her head thrown back,
eyes closed
in pleasure.
There is silence
in front of the senselessly talking TV.
As he watches his wife
pleasure herself,
right hand gently moving under her skirt,
left hand roaming over her body
like a gentle lover,
her gentle lover,
he watches, stunned to his roots
to see her so.
She comes, smiling happily, eyes closed,
a low sound deep in her chest.

Released, she relaxes, pulls down her skirt,
lifts her fingers to smell them,
lick them.
She finally looks at her husband's
dumbstruck face.
"I think I'll take a bath," she says.
She takes his hand in hers, sticky with love.
"Come with me."

A Good Hair Day

Will Keen

BY MORNING, THE DREAM OF ENTWINING with my houseguest fades from memory, but not from my body. I wake up aroused, lying in bed, listening for her sounds in the next room.

The first thing I hear is the sizzle of shower water as Marlena turns the faucet. She steps inside the tub, and the rush of water streaming against her body lulls me to fantasize touching every part of her. Imagining myself squirting continuously under pressure, I liquify my lust until I am flying up the hot water pipe, forced out the nozzle to break into a warm spray on every surface of my lovely naked friend. I wet her long tawny hair, darkening it with my weight. I fall across sparkling blue eyes, then pause as tiny diamonds in her lashes. I fill her mouth, only to spill out over succulent lips. For a moment she cups me in her hands, artist's hands, always expressive and moving. I splash against both breasts, drip from her nipples then run down her flat stomach until I am caught in the tangle of her pubic bush. Unknown territory. She turns around, and I rain on her perfect female ass, rouging it with my heat. At last, I slide down her long legs, strong and smooth, shaped by years of dancing, and across the crimson lacquer of her painted toenails toward the sucking sound of the drain. Part of me survives as steam rising from the flush of her skin, ascending to envelop her in a halo of warm fine mist....

I am roused from the vision by the sudden shift in the sound of the shower as Marlena rinses the shampoo from her hair. She uses a creme rinse, the source of the tantalizing scent that imbues her hair. Whenever I manage to draw close, I inhale the wondrous honeyed smell of it. The instant she turns off the shower, I sit upright in bed, waiting, expectant. When she

appears, she takes no notice of me. Wrapped in a towel, she walks out of the bathroom straight into the living room. A minute later, when she reappears in front of the sink outside my open door, she is wearing only a short, tight t-shirt and panties. Bright blue panties.

Marlena begins the ritual of the hair. She stands before the mirror and in one long graceful move bends forward and away from me to cascade her damp ash-blond hair to the floor. Taking a brush in one hand and the hair dryer in the other, she works it from her neck out toward the fine ends. The dryer whirs loudly as it follows each brush stroke the full length of her magnificent hair. As it drys, it seems to fill the room, and lightens to the pale color of her favorite chardonnay.

Watching, I breathe in time to Marlena's slow rhythmic movements as she harvests her own head of ripe wheat, stroking it downwards, flailing it gently to the floor. She cannot see, blindered by her mane as she remains bent from the waist, her behind unknowingly presented to me. Or, does she know? Know that I am watching her, admiring her straight legs, her panties stretched tightly across her untouchable ass? She must know. The unwritten rule of our friendship has been hands-off, but she must know that brazenly bending before me is also bending our rule—to the breaking point.

I leave the bed to stand naked at the door, taking my time, observing her relaxed pose, natural feminine motion, and the cadence of the brush in her hair. I ease toward her, closing the gap between us, unseen and unheard, as the sound of the dryer cloaks my approach from behind. I kneel down before her superb rump as if I am about to pray. Pray for the courage to do what I have dreamed of doing. Slowly, I bring both hands up to within an inch of her skin, rising up her legs. The heat in my hands flows out into her thighs as they pause in the air, hovering, reflecting the double curves of her rear. I hold my breath. My hands make contact, each coming to rest gently on a pantied cheek—and she stops, tensing her muscles, surprised that a man has her in his hands.

"Whoa...!" she protests.

"Keep brushing," I respond, working to keep my voice steady. She hesitates...not a good sign...but what the hell did I expect?

"Nothing is going to stop me," I try urgently, and make the point by pressing into her flesh, gripping her buns forcefully.

"Oh, you think so?" she comes back, half rebuff, half challenge. But she is still bent over from the waist, unflinching. I wait, watching carefully for any sign of movement, and finally her right hand wavers, angling the brush back into her hair, ready for the next stroke. She begins to brush. I breathe out slowly, thankful as the tireless dryer creates a thousand watts of sonic space for our play.

I savor the imminent exploration, aware of my growing erection as I kneel behind her. My hands cup her firmly, then stroke her mounds in time to her brush strokes. They relax under my touch. Moving down, underneath, I sweep my fingers lightly across her crotch, skimming her small thicket of hair caught behind the blue cotton. She edges back toward me very slightly, invitingly. The tips of my fingers trace the outlines of her sexual lips, rubbing over them until her panties slicken with moisture. The dark wet stain spreads as I lick my fingers. This is what I want—the taste of Marlena in my mouth. My head begins to spin, sex drunk, as I see myself ripping her panties in two, but curb my daring by slipping them down her thighs, all the way to her feet. Never missing a brush stroke, she lifts one foot to release the panties and they fall to the floor. The hair dryer whirs on....

I take a deep breath before leaning forward, using both hands on her bare butt to steady me as I slide my tongue down past the ring of her anus until it rests hungry and hard against her moist cleft. My tongue insinuates between her swelling lips, teasing her tangled hair. I breathe in, smelling her sex, tasting the juices that have begun to flow. The rhythm of her brushing becomes erratic when I insert my nose into her pink orifice, stretching my tongue down until it comes to rest precisely on her clitoris. I brush it with my tongue-tip. She responds by stroking her hair more vigorously, picking up speed. But I will

not be hurried. I begin to graze, licking and nibbling her warm sensual pasture. When she shifts her stance, spreading her legs wider, I drive my face deeper until she is moaning. I lap at her lazily, never wanting to end the languorous tonguing.

But Marlena has other ideas. She drops the brush and reaches for the floor with one hand, and uses the other to aim the fierce little dryer upside-down straight back between her legs. Like some trick-shot artist at the sex rodeo, she targets my balls, heating them with a blast of warm air. Yeowww! This only incites me to lick deeper and more passionately her utterly wet pussy. I lick as she flicks the stream of air from side to side, heating and cooling my reddened cock. Fluttering her clitoris with one finger, I bury my nose in the crack of her ass and stab my tongue far up her exquisite dripping cunny. She wriggles, but I keep going, piercing relentlessly until mercifully she drops the hair dryer to steady herself on the floor with both hands. She is on the edge, breathing hard, tensing her entire rear, moving it in time to my deep licking and steady fingering. Flexing onto the tips of her toes, her legs begin to quiver in spasms. Suddenly, Marlena lets loose a loud wail and releases a powerful gush of sweet liquid to my waiting mouth. I drink what I can of her, possessed, the excess trickling warmly down my chin. I suck and swallow madly until she squeals, "Stop...!"

Marlena rests for a moment, just enough to catch her breath before she turns around. I fall on my back as she bends over me. Her eyes are hidden behind a tapestry of golden hair. My hands cannot resist its allure; I weave my still sticky fingers into the hair, leaving traces of her juices in the sheen. Marlena's face, her mouth, is so close to me I feel her breath in my lap. Parting her lips, she takes me into her mouth, slowly gliding her tongue along the full length of my erection. She moves her head up and down smoothly, soothing my burning phallus, then releases me.

"My hair owns you," is all she says, and I watch as she gathers handfuls of her silken hair and rubs them on my shaft. She teases me with tresses that rustle and shimmer as they wind around me. Deftly, she separates two long hanks, and brings the ends

to the base of my erection. Snaking the lengths around me, she braids my cock into her hair. When she lifts her head my body moves with her, caught in the taut leash of hair. She jerks the leash from side to side and my engorged sex is pulled brusquely. As she rocks her head back, I am forced to thrust. And as I tilt my pelvis down, her head bobs forward into my crotch. We play this way, the blonde coils twisting deeper into my stiff flesh. Back and forth she rocks, and I rise and fall, delirious as I give my body to the bondage of her hair.

Sensing my surrender, Marlena quickens the pace, driving me to explode, whipping her head back sharply and rapidly, again and again, as her hair tightens its grip on me and I begin to buck wildly beneath her. I strain against her braids, swelling until my crazed cock is wound so tight I cry out with the pleasure and pain. At last, I arch my back and shoot sperm wildly up into her open mouth and waves of amber-colored hair. I come deep in her wheat, and collapse.

We lie together, completely relaxed, in the place where we fell on the soft carpet. Then, with great care, she unbraids our erotic caduceus, and lifts her head. Where my semen has soaked in, the weight of it has darkened her hair. She looks up at me, smiles, and rises to her feet, a little unsteady at first. As she steps over me, Marlena murmurs, "My hair can always use a good creme rinse." Then she giggles. I hear her move aside the curtain. The faucet turns. The shower water sings. I laugh to myself, still lying on the floor, knowing that brush and dryer and my body will join her in ritual once again.

Leaving

Anna Hausfeld

SHE DOESN'T KNOW IT YET BUT SHE'S LEAVING. Despite the great sex she's leaving. I've never put up with any guy treating me this way. I'm not about to start with her. S/he thinks that because she's a woman s/he gets to behave like a jerk with impunity. S/he thinks that because she's a girl she.... Oh never mind. I never allowed any guy who earned twice my salary to turn up at my house empty-handed month after month, eat my food, accept me paying for his movie tickets, turn up late again, leave me naked in bed to go out dancing the weekend before his other girlfriend arrived in town. No. Get a clue.

If you want to keep your next girlfriend, arrive with something at her door. Three nasturtiums picked from the street, a bottle of lemon-flavored Calistoga water to refresh her during sex. Something that says you thought about her before you arrived. If she is woman enough, and generous enough to welcome your other lover in her life don't arrive at her door, kiss her half-heartedly and blurt out your date together is ending early tonight so you can go dancing with yet another girl. Don't look up with hang dog eyes all remorseful saying "Yeah, I'm so stupid, I'm such an idiot," then go and do the same thing all over again. You may think it's butch, but really you're just being a dime a dozen, run of the mill, seen it a thousand times a day macho jerk.

What is your excuse for lacking social skills? You're not a man. You weren't subject to that appalling socialization. You chose this behavior. You adopted it consciously. So, my ex-girl, what is your excuse? Don't tell me you're stoned 'cause you ain't. No reason due to pent up sexual charge making you act crazy. No reason due to age. Hell, you're nearly forty. No reason

due to anything but confirmed chosen decision and acting on it I can see. I'm only asking 'cause the sex is so dang good. I'm only asking 'cause if I knew, I could maybe avoid it in the future. You know, see it coming and get out of the way before my heart got all messed up. You know, before I got all bonded through the great sex and all.

Not many people can recall their last fuck but since you don't know it's over yet, I can tell you exactly how it went. Then you'll have something to remember me by and me you. We had just seen *Il Postino* at the Opera Plaza Cinema on Van Ness near Turk. It was in one of the two theaters at the back. The doors on the left. You got quarters from the ticket seller and went to feed the meter while I got us seats. You paid for my ticket, something you rarely did. Maybe you knew it was the last time, so made an exception. I sat in the third seat from the aisle behind a guy sitting alone (his lover turned up later, as tall and burly as he) and in front of an older couple who were speaking in Italian. The seats were worn red velveteen, giving an aura of decayed elegant pretensions. I go there for just that mood.

You arrived and sat beside me. I left for the lavatory, candy and tea. They only had Earl Grey. I put two sugars and milk in the huge paper cup. It was so hot even the tissue around it didn't stop it burning my hands. I got Jujyfruits. They stuck to my crowns. I was afraid of losing one at each chew. The danger made them sweeter. I ate all 400 calories of the things except for the two you had. You didn't like how they stuck to the roof of your mouth. When I came back we found ourselves again in the gay section. I am always surprised how that happens. Two beefy women sat beside us near the wall. A single guy who laughed a lot beside you on the aisle. The two guys in front.

It was beautiful and sad. The Mediterranean Sea blue against the red fishing nets. You held your hand across my pussy in the dark after I put it there. Your fingers moved deliciously across my clit and vulva but you were never in just the right spot to make it really go anywhere. I started heating up so much due to Beatrice's cleavage the woman on my right started fidgeting noticeably. I kept my hands discreetly in my lap over yours and

timed my exclamations to appropriate places in the film. I squeezed my thighs so she didn't notice. But you did. A smile plastered your face for the whole show.

You asked where I wanted to go afterwards. I said "to the beach." We parked at the ocean below Seal Rock and watched the fog come in as night fell. I took off my seat belt and lay with my back against you. I unzipped my jeans. No panties just like you. We wiggled our bodies closer so your shorter arms could reach all the way inside my tall frame.

You moaned as your fingers reached the wet, the swollen flesh of me. I held my breath and got silent. The feelings took over. I was concentrating so hard not to miss a single nuance. Then I remembered to breathe. I knew you wouldn't go anywhere for a while. I wanted you there.

My head was thrown back across your chest. Our mouths were glued, one organ feeding. It must have been almost two hours later when we noticed the windows fogged. The empty car spaces on either side. The silhouette of pedestrians passing. The car of four guys sharing a joint.

You fucked me with your fingers inside me and stroked the shaft of my clit. Finally pounding my cunt so your palm was the only contact on my engorged bud. It was enough. Saliva flowed like nectar deep in my throat and I swallowed gulping. It tasted bitter and my cheeks sucked in. Just like tasting pussy. It woke me. Made me want more. I swallowed again mashing the blood-filled softness of my lips into yours. Feeling the velvet fur on your upper lip. It weakened me. The blaze in my belly singed deeper parts of me open. My mouth gaped. I couldn't return the insistent pressure of your mouth and tongue. There was only opening. I waited to be filled. Longed for your cock in my mouth.

I cultivated that opening. That longing. It has so much heat and power in it. Waves of hot wind rippled up my back along the outsides of my arms through my chest and deep in my clit. Gasping, I waited. You came to me then, met me on the inside. Touched me there. We both knew it was your cock. I could feel it inside me swollen and red. You pumped your come into my mouth with your tongue and into my cunt with your hand. You

felt it. We both know when it happens. You dripped sweat onto my upturned face. My elbow jammed between your legs gave you something to grip with thighs as you worked the seam of your jeans against your reddened vulva and swollen gland. Warmth washed over the soft skin of my upper breasts. My nipples still erect felt an electric spark. I laughed. You wanted to lay on top of me then, straddle my thigh and ride my pubic bone. But front seats don't allow for that sort of thing. You never mentioned it, but I asked. You blushed, saying "yes."

You said you felt good, complete. It always worried me that you wouldn't let me touch you there. Give you the pleasure you gave me. Your smiling eyes, brown and clear, your calm unlined face told me yes you were happy, but I still worried. You give me so much and I often want more. What do I have to bargain with if you won't let me make you come?

After a shower at home I lay naked in bed as you went off to dance with the new girl at the G Spot. You didn't make a date for camping like we talked about. Your other girlfriend would arrive from out of town on Wednesday. What could you have been thinking of? I lay in my bed and wanted to cry but I didn't. I'm training myself to be steel and say "no thank you" next time you call.

I just had great sex and yet my heart is hurting. I feel like shit because you left without feeding me even when I told you I was hungry. You left without setting a date even after we agreed that's how we would handle her visit. You left too quickly without getting off.

Somehow it makes me feel this bad even when you tell me no one has ever made you feel the way I do. That you have had more of what you want with me than with anyone else in your entire life. When you tell me you love me I'm flattered. Even though I love you and like you, I'm not "in love" with you. How can I let myself love someone who I can't get off? What can I ever give you that will make me feel as full as getting you off? What will keep me wanting you because it makes me feel so complete? It's written down now. Our last fuck. Unlike so many others, we will have something to remember us by.

A New Adventure

Cat Ross

HERE I WAS ON A REAL LIVE DATE WITH A MAN I'd been getting to know. There was an incredibly strong sexual energy between us since we first met. Something I hadn't felt toward a man in twelve years. I joked to my friends that I was turned on by him because he had everything I wanted in a woman: long hair, a petite frame and a soft quality; intelligence, a sense of humor and good looks. But they were surprised to hear that I was even toying with the idea of an involvement with a man. I had once said that if I was ever involved with a man again, he would have to be a *very* special man.

It had been so long since I'd had sex with anyone, it had begun not to matter to me if it was a man or a woman. I was horny as hell and every time I spent time with this person, he drew me closer to him.

We ended up back in my apartment slow dancing to Barry White. I just got more and more turned on and finally pushed him down on the bed. His arms went up over his head. He was obviously ready and willing for whatever I wanted to do, for however far I wanted to go. I closed my eyes and kissed his neck, my face nestled in his shiny, thick hair. His back arched. It was almost as if I was with a woman.

This is strange, I thought, as I pulled his shirt out of his pants and slipped my hands underneath. Soft skin but no breasts, beautiful long hair and a five o'clock shadow, arms thrown back overhead in a "do me" position, but a body with a penis instead of a pussy to do. No matter, I was as usual in a "doing" mood. I ran my hands over his jeans and felt his hard-on. High school came back to me now. I'd forgotten the joy of such an obvious acknowledgment that I was turning someone on. I pulled his

jeans off and pushed his thighs up. His legs wrapped around my back. I saw myself in him. With his small frame underneath me I was in heaven. I hardly noticed his cock smashed between his stomach and mine with every thrust of my hips against him. But he obviously noticed. With every thrust he moaned and with every moan I became more turned on.

When I thought of sex with men I always thought of penis-vagina intercourse. Tribadism was a lesbian activity, but here I was, humping this man, with as much pleasure as when I fucked women with my strap-on. I can get off simply from the mental excitement of humping a woman in this way, and with the added pressure of my pussy slapping against his balls, I knew that I would come.

His deep voice became higher pitched. It was as if he was going to a place he hadn't been before. A place of total surrender. I didn't know if that was true, but it felt good to believe I was taking him there. I bit into his neck. I wanted to devour him.

He lifted his legs even higher. I always take an invitation, so I quickly put my arms under his knees and brought my hands up under his back, to grasp his shoulders. He was practically rolled up into a ball underneath me, which I was pushing against, squeezing, fucking as hard as I could. I whispered in his ear, "You're just so incredible, I can't believe you; you really turn me on, you're so hot." His moans became more like sobs and he started to shudder. "Hang on to me tight, 'cause I'm gonna make you come," I said.

"I'm gonna come," he echoed. I was pounding against him harder and harder. My pussy was so wet; I could feel my clit throbbing. It seemed as if we were going to come together, something that had never happened to me before, certainly not in my few high school experiences with men, nor even in my twelve years of being with women. My pussy was contracting. I was starting to come. "Give it up to me now baby, let go, give it to me," I said. He was shaking now, his voice somewhere between a moan, a yell and a sob.

"Oh God, don't stop," he said.

"Come for me now baby, hold on to me tight."

"I'm coming," he screamed, as he came in an incredible shudder. He was shaking so violently I got worried. I was used to my own body, all my fuses short-circuiting, but this was like a major outage. "I can't breathe," he whispered. He was hyperventilating. It was scary. Slowly he relaxed his legs but his body trembled as I held him tightly. I rolled him on top of me. He would shiver, then relax, then shiver, then relax. I stroked his shiny hair, ran my hands over his buns.

"Oh baby," I said, "you're so sweet." He came for the longest time. Again I saw myself in him. I'd never known a man who could climax like a woman. Eyes shut, he felt the sensation throughout his entire body, and it went on and on. I kissed his sweaty face. I kissed his lips. He kissed me back. The waves of electrochemical energy went through our bodies, rippling from top to bottom.

After what seemed like a very long time, he laid his head on my chest, and nuzzled in under my chin. We were finally relaxed, melting into the mattress. After a while, he turned to me and said, "You are a very special woman."

I looked him in the eyes and said, "You are a very special man." I could tell I was headed for a brand new adventure.

Peeping Tom

Rampujan

HE WORE DELICATE AND ELEGANT JAPANESE SLIPPERS which didn't make a sound. He wore dark clothing. He was a small man of indeterminate age, one of those people who have a quality of being invisible. He was a self-effacing polite sort of gent, not someone I would choose as a friend. We were thrown together by fate, as he was a close friend of the mud wrestlers and for a while a neighbor of mine. And strange to say, his name was Tom, although he preferred to be called Thomas. He was an arch-voyeur, king of the watchers, and he was shameless and frank about his activities.

He told me about his sophisticated fiber optics lens-peeping at the hotel where he was employed as handyman. He described complex stalking routines which gave him access to remote woodland hideaways. He recounted an exploit where he was hidden for three days in a refrigerator crate. He was willing to endure the most rigorous hardships if they would give him a chance at observing an unusual or a passionate sex exploit.

And he had never been caught or discovered. Only once did he have a close call, but he was able to produce fake ID to establish himself as a telephone repairman, thereby explaining his fiber optics paraphernalia.

Thomas' greatest fear was being mistaken for a narc or a private detective. He had no respect for these occupations. He felt ordinary spying was repulsive and degrading. As long as he could remain unobserved, he felt that his peeping was beyond reproach. This strange innocence about his voyeurism I found to be quite touching. As I learned more about him I really began to like the guy. I told him about my exploits in the big oak tree as a youngster. It reminded him of an experience of his own.

"In the early days of the 'Energy Crisis'," Thomas said, "I obtained a contract to install insulation in the attic space of a series of condos. The building was a long row of townhouses with one attic the full length of the block. There was an access to this space in the form of a trapdoor into each of the bedrooms beneath. Generally this was right over the bed. I installed peephole lenses in each of these and while laying the insulation in the attic, I provided myself with a kind of track across the rafters which went the full length of the building, right over each of the peepholes. Fitting a special kind of skateboard to this track, I was able to travel silently from one to the next and observe everything within view of these wide angle lenses in each bedroom ceiling. My labors were well rewarded.

"There were, in all, sixteen bedrooms on my little 'route,' which I could access at any time through a vacant apartment at one end of the block. I went there nearly every night for a year, until the vacant apartment became occupied. I don't doubt that the entire setup is still there," he said with a little laugh, "except for the skateboard. I took that home with me after my last session."

Thomas continued: "There was a peculiarity in the landscape lighting of that building that was very fortunate for me. As you may know, many people like to have sex in the dark. The garden lighting in this complex threw a beam of light across the white ceiling of each bedroom, enough for me to observe whatever was going on in the supposedly darkened room.

"The first bedroom on my route was that of a couple in their seventies. They began by retiring early, each with a twin bed and a book. Then one would interrupt the other (usually it was the woman initiating) with some casual remark, something as trivial as 'Did you lock the front door?' An argument would ensue with yelling, mean remarks, and finally profanity. This did not vary from night to night, only the details of their struggle. Sometimes the woman in frustration would tear up the bedclothes of the man's resting place.

"I came to know them well, after a fashion. The man, Seth, in response to his wife, would start making crude remarks about

Agnes' behavior. One that was memorable—and he used it more than once—referred to his wife's visit to a kennel or veterinarian to pick up their dog. 'I was there,' he said in a sneering tone. 'I saw you sashaying down that row of cages like a whore on the street corner, your tight red dress showing your hips! What do you think was driving those dogs crazy? I couldn't hear myself think in that place, with the barking and growling. It was disgusting.' He delivered this remark in an offended tone and he leaned over his poor wife who sobbed and cringed. He pulled on her nightie, exposing her to more shame.

"And Seth starts barking and howling like a dog! It was difficult for me to remember my position and maintain absolute silence. By now they were both in the same bed, the room disarranged, all the lights on.

"He tears at her nightie again and it comes off. She crumples up in the bed and clutches at a sheet to cover herself, trying to stifle her humiliation. He pounces on her—I was afraid for her the first time I saw this—shouting 'whore', 'dirty cunt', 'dog licking bitch.' Ineffectively she tries to get away, finally allowing him to fuck her briefly. Then more sobbing and crying while he consoles her. He apologizes. He begs her to forgive him. He kisses her adoringly. She finally allows him to service her, and this is the only way in which the routine varies. Sometimes he arouses her by fondling her nipples and breasts with his tongue and fingers. Sometimes his attentions are confined to her pussy. One time—and I found this fascinating—he sang to her some old-fashioned Irish or Scottish ballad, a romantic song. Then, when Seth returns to his own bed, it's time for me to move on."

"Thomas, I've got a question for you. How did you stay so quiet during all this action? All it would take is a sneeze and your whole trip would be blown."

Thomas, who was curled up in his chair telling me his story, stretched and smiled appreciatively. "Your interest in my little hobby is really gratifying," he said politely. "That's an excellent question, one to which I've given a lot of attention. You may know that I am a follower of Vipassana, which is a very strict method of meditative sitting. You should try it sometime," he

said with a quick laugh which faded into his habitual catlike grin. "In this attic that I spoke of, I was subject to a lot of ordinary dust, and also the fiberglass insulation, if disturbed, gives off dust of its own which produces a light but audible cough. I always carry an asthma inhaler with me." He whipped it out of his pocket to show me. "This will stifle any respiratory problem which might be hazardous to my well-being."

"Well, what about the old couple's dog?" I asked him. "Surely the dog can sense your presence behind that fragile partition of a ceiling."

"They never let the dog into the bedroom," he said. "I never saw the dog except once when they were locked out and the owners' association called me to help them. They seemed so ordinary when I met them. And they looked quite different when not viewed from above. But I don't guess that's very surprising."

Here Thomas took a little break, going to his kitchen and returning with a couple of soft squeeze-pack drinks. When I declined, he poked the straw into one of these and sucked on it thoughtfully for a moment. "I like these drinks because they can be consumed in utter silence. That is so long as you don't get greedy and try to get that last little bit out of the bottom. This 'quiet packaging' is a lifesaver to me. Can you imagine what a pop-top can would do to my sex life?" He grinned his modest grin again and settled down to another tale.

"In the next apartment was Dennis, a man who lived alone. For a long time I thought he was a male model. Rarely had I seen a man whose face, body and movement formed such a unity of perfection. He was tall with a well-knit form and limbs that flowed when he moved so that it was pure pleasure to watch him. He would come into his bedroom fresh from the jogging path and preen before the mirror like a peacock, slowly removing his jacket and t-shirt, and then he'd strike a variety of poses as if for a photographer. He was obviously in love with his own form and was getting as much pleasure in watching himself as I was. He was an Asian man, probably Japanese. What an enjoyment it was for me after observing the push and pull of

partner sex, night after night, to sink into the tranquillity of observing the silent ritual of this sensual man. Here—I thought—is only the nobility of the flesh without the pitiable foolishness, awkwardness and strife of relationship.

"It was fortunate for me that Dennis was shamelessly addicted to his own self-pleasure. He was a man of very regular habits and I could depend nightly on a good half-hour show of passionate eroticism as this man coaxed his own body through a wonderland of carnal sensation. From my hiding place I was hard pressed to stifle my own groans and contortions of release at the end of one of Dennis' masturbation sessions.

"He was very particular to be absolutely sure to be unobserved. I could hear him double-lock the door to his apartment. Then, clad only in a towel and fresh from the shower he would pull the blinds on the bedroom window, shut the bedroom door and turn up the lights.

"Slowly he would caress and fondle himself all over, except in the genital area. Lovingly he would stroke each of his smooth muscles, either with his hands or using the rough nap of the towel to excite the skin. Next he would slowly brush himself all over, watching in the mirror as his nipples became erect and his cock lay in half-awake readiness. Dennis was a swimmer as well as a runner and the results of his exercise lay on his body like the hand of a master sculptor on granite or marble. It was enormous pleasure to see him touch his own male flesh and coax it into life.

"Mixing sex play with his own regular body care routine, Dennis next did a series of isometric exercises in which one muscle after another stood out in tense definition. This had none of the silliness of the body builder about it. It was more like a sensual dance, an utterly male ballet, a prayer of tensile strength and power. As a bicep or thigh stood out in bold definition, it seemed to glow with a life of its own. And indeed Dennis' intense physical focus was endowing his body with extraordinary beauty. When this isometric routine was complete he would—still working in front of the mirror—put on a pair of clean thin white nylon warm-up pants and begin to fondle his

waking penis through the thin, semi-transparent fabric, never touching himself directly. Soon I could see the white cloth become wet with his pre-cum fluid and eventually soaking with this liquid, as Dennis had an unusually large discharge of pre-cum. The nylon, now sodden with the fluid, clung to the enlarged uncircumcised cock, revealing all its outlines as he continued the rhythmic movement as if he were a bass player plucking the strings and evoking a deep inaudible vibration which filled his room and penetrated into my hiding place above his ceiling. Still, he was not touching himself directly. There was that thin membrane of fabric between his hand and that excited flesh.

"But my attention was not genitally focused. I could see reflected in his large wall mirror the handsome square Asian face of this young man transformed by the pleasure. No longer crossed by his natural reserve, his features glowed with feeling, his eyes and expression came alive and in that face I could see baby, boy, young man, old man, wise man and god. In that face I could see woman and girl, I could see the animal, the beast, and the angel. All in the setting of an ordinary modern American bedroom under the bright lights.

"As orgasm approached, Dennis would tear off the encumbering shell of the pants, throwing them into the corner of the room. He'd stagger close to the mirror, crying aloud as the waves of pleasure tore through him and out of him, the ejaculate streaming hard against the glass, running slowly down the mirrored surface, as his subsiding spasms left the man whimpering in the privacy of his delight and completion.

"I would usually stay with him although there was little more to see. I would not move on to my next performer until he was dressed and meticulously cleaning and polishing the mirror, whistling cheerfully, straightening up the room. Dennis indeed was one performer who commanded my full respect.

"Now as a change of pace I found some good light entertainment in the next apartment where the gay wrestlers made their home. This room with a view was a completely padded little arena, no furniture, just mats covering the floor and most of the

wall area.

"This twosome was into a completely different scene than our friends downstairs." (Thomas was referring to the imaginative couple who were my neighbors, lesbians to whom I have referred in these pages as the 'mud wrestlers.')

"Instead of getting as dirty as possible, these boys were as clean as possible. Each day after work they would shower and shave. Tod always wore a bright blue wrestling singlet. Buck wore sweat pants over a standard jock.

"There was a delicate moment when they would square off and grapple. Just like dancers, there was an instant of uncertainty about how to begin to make contact. Tod was a dark-haired man in his twenties with a squarish face and short crew-cut hair. Buck was the same, but his hair was light and he was slightly heavier, although both men had no extra weight on them. They would put both hands on each other's shoulders, holding the other at arm's length and leaning into each other, looking at the other's eyes, seeking a break, an opening. As they were well matched it would be sometimes a very long minute until one of them would risk for a reach, for a hold. They would tussle and say Tod—the lighter one by weight—would hold Buck's shoulder and elbow from behind, slowly forcing him to his knees, but weakened and slowed by the effort, leave himself open to Buck's attack which was to reach behind him quickly and pull up on his partner's leg at the knee, knocking Tod off his feet.

"Then, both holds broken, they would roll around like boys, seeking a new way to subdue each other."

"What's so sexy about all this?" I asked Thomas. "It sounds like 1950s TV wrestling."

"Oh, no, you've got entirely the wrong idea," he replied. "Tod and Buck would soon get themselves in a position where one would have the other in a hold that couldn't be either improved upon or broken. Thus their energy would pour out into each other like stags with locked antlers until both were totally exhausted. They would lie there in this state for several minutes, almost motionless, silent, as all the aggressive feelings,

all the frustrations of the day would drain out of their bodies into the mats.

"Then, in a subtle exchange, the energy would shift. Tod would let go and collapse on his subdued partner. I could hear them sigh with the ending of exertion. What followed was the tenderest lovemaking, as like two butterflies they celebrated the stoppage of all striving and competition. With languid ease they served the god Pan, ministering to each other's sensual fantasies, where the most delicate touch was transformed into the deepest satisfaction. Never have I observed such sexual sensitivity, except between two disabled individuals, a blind heterosexual couple, but that is another story.

"Buck and Tod were responsible for many uncomfortable overtime hours that I spent in my attic crawlspace, long after I should have returned to my own legitimate bed. Watching them I could truly see the aerobic euphoria that is stronger than any drug and I would bemoan my own lack of exercise. I'm in the wrong business, I guess. Watching others makes my heart beat faster, but it's as rough on the body as the inactivity of the computer keyboardist. Oh well.

"The last person I will tell you about was a night club and coffee house singer of some reputation in this city. If I mentioned her name you would probably recognize it, if you are up on such things.

"She was a solitary person, lived alone. I would say she was in her forties as she often had a married daughter visit her.

"Her voice, her face, her body all had a classic elegance— more European than American—that made her beauty ageless. When not working she often sang to herself late into the night. Her hair, long and dark, seemed to need endless combing and brushing. Her voice was deep, but had a range that was quite extensive in pitch and in mood. She could have been of Italian or Greek ancestry. When she was alone, she was much addicted to self-pleasuring which she combined with her other private activities.

"I will call her Angelina and tell you of a typical session: As I silently slide to the end of my 'track' in the attic, she is singing

sweetly and brushing her hair. The room is candlelit and a sweet smell of incense, or maybe it is sage or sweetgrass, reaches toward my senses. She has apparently been here for a while. It is most likely a Monday, a night when she never works.

"Her song is one of a kind, a prayer perhaps. Would it be a prayer to the Virgin? No, she was not religious in the conventional sense. Perhaps it is a prayer to her own mother. Anyway, I hear 'Mother' addressed many times in her lyrics. In some way an offering is being made. I have no experience of this sort of thing and I watch with rapt attention, witnessing without understanding. My satisfaction seems to come from the act of witnessing. Understanding does not always come and is never necessary.

"She is clad only in a slip or nightie. Before her on the mirror table are a number of dolls, placed carefully as if they were real babies. One, however, is not a baby, it is an image of a black African woman, a very phallic shape made of what might be ebony. Angelina's singing has changed into a very melodic repetitive chant. She begins to caress her legs with long massage strokes covering the area from belly to knees, over and over again. Soon she gently focuses on the pubic area and plays with her outer lips, but still continuing the long strokes. The song fits the rhythm of her hands. The candlelight flickers. Suddenly I realize I am watching a seduction, a self-seduction.

"Angelina'a sexual energy is rising. I strain to hear the words of the chant, but as her arousal grows, the song's words turn into mere sounds. Now she is rubbing the head of the black doll from her pubic bone downward in short strokes, brushing her clit and passing the outer lips, reaching the pussy itself, moving the glistening black sculpture up and down. She is standing now, leaning on the wall, stepping lightly, in time to her inner music: her stroking rhythm. Soon this unique dildo is fully inside her. Gradually the song slows its pace. Angelina, now squatting, is baring a breast and fondling the nipple while she continues the vaginal play. At a particular point the song fades completely as if she has forgotten she was singing. But her voice is not idle for long. She begins deep moans of release accom-

panied by a full body shudder. The spasms continue, moving up her body. Her fingers, trembling orgasmically, nudge repeatedly on the erect nipple. The moan becomes very loud and then abruptly subsides. Her body rests, although it is still shaken by aftershocks.

"There is silence in the space. I gaze at the candlelight, held spellbound by the pervasive odor of sweetgrass. I see her rub her juices into the ebony of the doll and carefully wrap it up in a gold cloth. I am no longer watching her. I have turned inward. She is the last stop on my route. I lie on my padded board in the dark, reviewing the night's highlights, feeling I have been in the presence of a great mystery, something far greater than mere sexual fulfillment."

Excerpted from *Confessions of an Omnisexual Athlete.*

For Joe

Patricia Engel

(It is my intent that this piece be taken as a fantasy for adults. PE)

I.

EVERY NIGHT MY DADDY GIVES ME HUGS and carries me up to my bedroom. He undresses me and helps me into my cozy flannel nightgown with ribbons and birds on it. He kisses my cheeks and helps me into bed. He turns out the lights, and the moon and the stars shine through my window. My daddy holds me and sings soft songs about unicorns and fish. He undresses me and climbs under the covers and lies next to me. He is big and strong with soft dark fur on his shoulders and thighs. His voice is deep and loving. My daddy lifts up my nightgown and puts his fingers between my legs and gives me warm feelings. He puts his big hard cock up inside of me and pleasures me back and forth and back and forth until he wets me with his juices. Every night he kisses me and tells me how he loves me. He tells me I am his little girl and that he will always take good care of me.

II.

EVERY MORNING WHETHER THE RAIN WETS the leaves outside my window or the sun pours onto the floor and walls, I wake my daddy up with my kisses and he puts his arms around me and pulls me close to him. Sometimes he tickles me and makes me laugh and laugh. He is laughing too. We are both laughing uproariously. We both watch blue dragonflies and tiny gray feathery moths flying all around the room. Then what I love, he lifts my nightgown up again like he did the night before and we fuck and fuck and fuck all the morning long and we never stop. And we love how it feels and we love each other and we are so very happy and content.

Fucking Jen

Marianne Hockenberry

I'M SITTING HERE TRYING TO FIND THE WORDS for how it feels to fuck you, but this is no easy task.

There have been so many moments with you for which there are no words, yet here I am again trying to formulate letters to words to sentences. Trying to squeeze out intelligible portraits from the mass of raw feelings inside. What do I feel when you fuck me?

When you fuck me with your tongue, the moment right before you touch my cunt seems to expand until I don't know if it will ever end...the anticipation. I start to imagine what it will feel like. My legs open wider. My hips reach up to your mouth. Then, finally, I feel the very tip of your soft/hard tongue against my starving flesh. When you're fucking me like this, I can't decide which gives me more pleasure, watching your head move between my thighs, black curls in your eyes, or tilting my head back, eyelids closed, completely giving myself over to the ride you've pulled me on...the twists and turns, your tongue and teeth. When I come, my hips push up, pressing against your chin, and as a moan passes through my lips I feel a muffled vibration against my wetness as sounds of pleasure try to escape your mouth, but hit the wall of my flesh in their flight and are trapped there dancing.

When you fuck me with your dick, I like to get you inside me without using our hands, just the motion of my hips. I work my body around...slowly...until I feel you slide inside; lowering myself down on you as you fill me up; or you pushing into me, your weight heavy on my body. I like to watch your face as I move beneath you; your breasts pressed to mine, my legs spread wide for your hips fitted so perfectly between them.

When you're beneath me, I let my hands curve around your soft, round hips. Your fingers squeeze my thighs and lightly drift across my chest. Fucking you like this always leaves me disbelieving how I could have fucked boys for so long, because having a dick inside me could never be as sweet without the sight/feel of your breasts and the knowledge that you are a woman and you can fuck me with as much power and strength as I could ever desire...and I tell you what I desire...I say, "Fuck me *hard*, Jen," and you're thrusting harder and faster and I'm coming...again...and I swear it's *your* flesh inside that my cunt is gripping so tightly.

When you fuck me with your fist, sometimes I don't think I'll be able to take all of you inside me. I know how big your hands are. But you start slow, prodding and teasing my flesh. Your first finger slips into me and my cunt tightens around it affectionately. Then there are two fingers easily moving in rhythm to my breathing...there is still so much room. Now there are three fingers inside me and this is when I start to feel some pressure...on the outside...but you don't stop there. Now you're working my cunt and I don't know what exactly is going on between my legs, I just know it feels so...good...and my body wants it...all of it...more of it. I feel my insides open up as if the walls of my cunt are moving back from your hand, leaving more open space for you to move in. I start to wonder how much of you is actually inside me, and I reach down to feel your hand. I'm always surprised when I can't feel the top of the rubber glove, only the smooth skin on the inside of your forearm. Is your whole hand, wrist, really inside me? Now I'm coming. I can feel my muscles clenching your fist as it continues to move inside me...your motion is pressing in on my contractions and you moan from the pleasure. And how many times do I come? Maybe someday we really will count the times...one after another.

When you fuck me by pressing your cunt to mine...grinding yourself into me...I think I'm most amazed. I don't even have to feel your naked skin against mine...just the pressure/weight of your body, your face so close above me, and the pleasure's

running deeper than I ever could have imagined. I look into your eyes for you to see the colors running through me. How is it I could spend so many years fucking, not coming, when now just the feel/sight of you sends shock waves through me that ignite every nerve ending?

It doesn't really matter how we fuck, just that we do, and we will, because pleasure is important; to let yourself feel it is to give to yourself, and to give it is to give to someone else...and I want to give it...and I want to feel it...especially with you.

I Need More Hands!

Brian D. Young

(As I was contemplating writing some erotica of my own, I came across this short piece my husband had written in one of his journals. Brian died of AIDS *in March of '95 and I thought it would be a great experience for me to read one of his stories at the circle. I polished it up and brought "I Need More Hands!" (his title) to the Co-Ed Erotic Reading Circle at Good Vibrations in August 1995. —* Linda Poelzl 4/8/96)

AS I READY THE VIDEO CAMERA and check that the mirror angles and lighting are right, my cock stiffens in anticipation, swelling against my tight jeans. The monitor shows my body in more detail than I had imagined. I press START.

I glide my right hand down my pants and stroke the bulge at my crotch as my left hand teases my nipples. As my penis grows erect, so do my nipples. Watching myself on the monitor, I'm surprised at how good I look.

One button at a time, I open my fly, exposing my pubic hair. As I ease my thumbs against my groin and slide my pants slowly down...my hard cock leaps out. I reach down and tug at my balls, coaxing them out so that cock and balls are exposed at the valley of my jeans. My hands alternate from stroking my cock to caressing my balls to flicking my erect nipples. As my nipples get harder, my dick gets harder. As my dick gets harder, my breathing gets faster. As my breathing gets faster, my hand strokes more rapidly. I begin to squeeze my nipples...and my cock jumps, now totally rigid. I begin to moan. I stop long enough to push my jeans to my ankles and drop to my knees, pulling at my cock, pinching my nipples, my legs spread apart. I paw at my tightening stomach muscles, slowly arching my

head and shoulders back, luxuriating in the feel of my hands on my body, my firm cock and hard belly. My balls crave attention, but my muscles feel sooo good. I need more hands! I leave my cock to take my balls, caressing, pulling, squeezing.

In my mind it's another man's body I touch. I love the feel of his balls in my hand. I love the feel of his hard muscles, his stomach, his pecs, his thighs. I need more hands!

I see the monitor, having forgotten the camera was there. Again, I am surprised at how good I look—it's hard to believe it's me up there on the screen. I look at the camera and smile— the sly smile I know that she loves. I need more hands!

Bombshell

Tristan Taormino

AS I DIG FOR QUARTERS IN THE POCKET of my leather jacket, I realize that I'm the only woman on the bus tonight. I strut toward a seat in the back, and one by one several of the men check me out. They think these dark red lips and these long, curly, perfectly coiffed locks are for their consumption. I feel them staring at my fishnet-stockinged legs. It is ten at night and I could have gotten a cab. I might be in trouble. When I return their gaze, they lose interest. I suddenly imagine that they all have ESP and they have read my mind (instead of my body), figured out where I'm going, and they don't want to bother me. But I still expect to be followed or harassed by one of them as I dart off the bus.

I'm already late, so I walk past the club's main entrance and go directly to the back room door. Inside the bathroom, I toss my flowery dress on the floor and quickly change into a crisp white shirt, bright red tie, and a black men's suit. I look in the little bathroom mirror to darken my lipstick. I can hear voices and music blaring on the other side of the wall, and it sounds like the club is already full. I'm still tense from the bus ride, so I massage my shoulders, stretch a little and get into the music. In a frantic flurry, the club manager bursts through the door with Donna in tow and sweeps us both out to the dance floor. I hear Felicia the DJ announce our arrival as I jump up onto my box and that moment of nervousness hits me in the stomach.

Get off/twenty three positions in a one night stand/get off...if you want to baby here I am....

Here I am. I spin around and grab the thick metal chains at my side and peek at myself in the mirror. I'm anxious to get out of my clothes tonight.

As I loosen my tie, I scan the club for reaction. I think about how I wandered in here three months ago for purely academic reasons: to interview butch/femme couples and get material for my thesis (ethnography, right?). I look to the other end of the club at Sharon, the bartender top I've been having an affair with all summer. I study that bleached blond hair, those fuchsia lips I crave in my sleep, those piercing black-brown eyes and that pierced pink tongue. She has fourteen years on me, and ten more tattoos which tell each other stories on her body. My ivy-influenced, upwardly mobile sensibilities are transparent to her, but that's not all she sees when she looks right through me. She's a chain-smoker with no other vices except tying me up and torturing me. She's busy pouring a drink and flirting with women at the bar.

"I knew the first time I saw you—that energy, the connection. You couldn't control yourself. You had this air of innocence about you, but I knew you weren't innocent at all. I could hear all these nasty thoughts running through your head. Nasty thoughts I really liked the sound of." All of a sudden she is behind me so I can't see her and she snatches my neck and sinks her teeth into it. She has lifted up my dress and she rips my fishnet stockings with her rough hands and I can't stand how swollen and soaked I am for her as she slides her cock way up inside me. She tells me how much she loves my dress, how I look like such a little girl in it, and how much she loves that. She whispers that she wishes she had a dick right about now as she pushes harder into me (why is it that all the women I end up in bed with want cocks but already have them?). She wants to feel what it would be like to be inside me. She would fuck me harder than I've ever been fucked, she tells me, and she would come inside me (she is inside me). I tell her I give good blow jobs. She says she knew that already. She tells me I'm a good little girl as I bend over her kitchen table, and I feel the cold glass push against my clit. She fucks me furiously, then slows down until I can feel every push, every inch, and I start to scream in ecstasy. She slaps my ass and I just yell louder and grab for something, anything, and I knock over my research notes and the tape recorder goes flying to the floor and I wonder if it's still on or if it's still listening....

I look out at many familiar faces, and the dancing sea of dykes

is broken up by some fags and a handful of straight couples. I can feel their eyes all over my body. Is that man clutching his girlfriend just like those creepy men on the bus would have clutched me? Are they going to go home and have really good sex tonight? Am I part of their fantasy? One of the waitresses walks by and glances up at me, surprised, I guess, to see me fully dressed, and in boy drag. The music changes, and I catch sight of the manager sitting down in the corner. This woman never sits down, but on my last night of work, she, too, is excited that I'm stripping. I throw my tie on my box as I toss my head back, run my hands over my body, move to the music and flirt with my audience. At that moment, Joe (my other new girlfriend) walks in. She's looking as butch as ever in a backward baseball hat, bomber jacket, and some boyish flannel shirt. Kickboxing is one of her passions, cruising girljocks is one of mine. I think about the people who look at Joe and think she's just some teenage boy, and about the ones who know exactly who—and what—she is and will kill her for her clarity. Sharon doesn't know I'm fucking Joe. The club is getting crowded now, and things might even get a little more slippery.

Joe has never seen me dance before, and the look of shock on her face as I unbutton the crisp white button-down shirt makes me shiver. One seductive sex kitten look from me plus my painted nails dragging across my bra and I've got her where I want her to be, where I want them all to be. They can't stop watching and I can't stop being watched. I take the shirt off to reveal a red satin bra that pushes my breasts into torpedoes, exaggerated versions of the originals. Three women in the room know the real me behind the masquerade.

Joe reached underneath my bra and pinched my nipple as she pushed me up against her car. She slid her hand all the way up my polka dot dress and teased my thighs (all this on our first date) after I told her I wouldn't call her because I had a girlfriend (well, actually two). One would beat me (literally) if she found out, and the other would do it emotionally. I told her I didn't have time and I wasn't interested. All this was in a deserted parking lot, I have no idea where, at four o'clock in the morning when all I want her to do is fuck me with "Hit Me With

Your Best Shot" playing on the tapedeck. "Put up your dukes, let's get down to it/hit me with your best shot...."

The lights are making me hot now, and I wish I was out of the suit, but I've got to tease just a little longer. Make them all wait for it, beg for it, that's what this femme does best, after all. I unzip the pants when my ex-girlfriend Chris appears below me. I haven't seen her in over three weeks since I moved out, since she kicked me out, since I got out, since it was all getting to be too much. She's the reason I'm even in this goddamn city to begin with, but I didn't exactly anticipate breaking up minutes after I stepped off the plane, or, worse, the aftereffects and shell shock. She's got a dollar bill in her hands. She wants my love. I mean she wants my pants. I don't know what she wants or why she's here. I see all the pain of the summer—all the fighting, the torture, the lies—I see it all in her dragon-green eyes even though she's trying desperately to cover it up with her flirting. I'm distracted for a moment by my real life, and I don't want to be because reality isn't as much fun as this is. I want to get away from her, but I'm trapped on the box behind the chains. I can't even ignore her because now we're being watched, so I continue peeling sticky clothes off my limbs. She's reaching to regain her grip on me, but she can't get close enough and that makes her crazy. And that crumpled dollar will only get her so far in. After all, she's a paying customer, just like everyone else.

Except Sharon the bartender. She knows what belongs to her. All Sharon has to do is talk dirty to me, spank me really hard, or catch me in the bathroom before I start dancing, the way she did the other night.

I strutted past the bar in hopes of gaining her attention, and minutes later she was pushing me hard against the back wall and grabbing both of my tiny hands with one of hers. I felt her metal piercing on my tongue as she kissed me and smeared my lipstick. She slid my dress up my thigh and pulled my panties down as she felt how wet I was for her. She likes me to be ready for her and somehow I always am. She slid those powerful fingers inside my wet open cunt and started to fuck me right there in the hallway with no one around. That kind of

I'm-in-charge-this-is-as-rough-as-I-like-it-angry-fuck. I got wetter and hotter, and all I wanted to do was come all over her hands. Just as she felt my insides open up, she pulled her fingers out of me, let my dress fall, and walked away. "Later," she said, "later. Patience is a virtue and innocence becomes you." The door slammed behind her.

Watching me dance up here with my cleavage in everyone's face, shaking my ass, and grabbing my pussy doesn't exactly sync with Sharon's little girl fantasy. Perhaps that's the reason for the notes she sends over with bottled water periodically: "You're Mine." Just a reminder, I guess, as if I need to be reminded. The bruises on my tender ass, her lipstick smudges all over my underwear, and memories of the other night are plenty.

She blindfolded me and cuffed me, took me into the bathroom, and laid me on the cold floor. I heard her move around and then I felt the sharp points of scissors on my cunt. I must have jumped a little because she slapped me in the face and told me to stay still, then began hacking away my pussy-hair. I heard buzzing and I felt something thick and warm and vibrating against my clit. She jerked me off a little, then pulled the clippers away, and I felt warm liquid running down between my legs. The feeling was sharp again, but not so pointy as she scraped away at me, making me pink and young again, until the abrasive razor became her pointy metallic tongue flirting with my clit and lapping at my cunt, reminding me of the power between my legs and her absolute possession of it. She told me that if I was very, very good, one day I'd get to do the same to her. One day I'd get to touch her and make love to her, but not yet, don't get ahead of yourself, I'll tell you when I want to, when I'm ready.

The bruises are temporary, but the marks—her mark on me is permanent, at least for now.

Chris is still in front of me waving the dollar bill, so I take off my pants and the crowd goes wild as I reveal red satin shorts, fishnet stockings, and combat boots. The costume is turning her on, but I'm not sure how I feel about that. I want her to get out of my face and out of my space. This is my place, my turf, not her apartment in West Hollywood with all her stuff and my suitcases. This is my place with my friends and my lovers and

I want her out of here, out of my head, out of my life.

I start to sweat, perspiration running in a tiny bead between my breasts, when Donna suddenly appears on my box. This small butch is the other dancer for the evening, and the manager loves when we're together. Donna's got close-cropped jet black hair and a perfectly muscled body poured into a boy's wrestling suit. She's twice as wet as I am and her hot, slick body slides against me as we grind together to the music. She gets on her knees in front of me and shoves her face between my legs as I throw my head back and thrust my hips toward her; we perform the experience and experience the performance of the pleasure of each other, on display for everyone. She's gone as quickly as she appeared and I'm alone again.

I catch sight of Joe, who's standing in the exact same place as when she first came in. She can't take her eyes off me. I look at her as I grab my breasts, and the dance floor gets crowded, but I don't lose sight of her. The waitress hands me bottled water with a note from Sharon: "I hope you're pacing yourself. I've got plans for you after work. I want to blindfold you and lick you behind the knees and...." I feel myself start to get distracted, so I take a drink. The icy water running down my throat and the hot pink lights beating down on my face send me into a surreal state of drunkenness. I'm dancing now. On the underground concrete floor with a freshly shaved girl-pussy. Behind slippery chains and fiery lights with soggy dollar bills pinching my nipples inside soaked red satin. In front of her as she rubs her hard cock looking fiercely composed. I'm dancing. And the sharp, shiny mirrors of dyke eyes are my reflection.

My head is spinning, and I decide it's break time. I jump down off my box; I have to push my way through the crowd to the other end of the bar until I'm outside where the air is thinner, cooler. I scan the line of people smoking and chatting, restlessly waiting to get inside. I disappear into the back room where I peel the red satin off my body and slip on the black mesh jumpsuit Chris bought me in San Francisco. I fix my lipstick and venture back into the club. Someone reaches around and shoves a five dollar bill in my bra. I turn around, but I see a thousand

faces and can't tell who just tipped me so forwardly. It's like anonymous sex without the risks: no complications for my ego or my body. Or hers.

She took me to the sex club where she knows all those rough dykes and she put me downstairs in that pseudo-dungeon and I could hear her getting a crowd of girls together to watch her give me a whipping. Each sting of the whip on my flesh made me hotter and higher and hungrier and she kissed my back before the leather cracked against it and caressed my ass after the skin glistened red. She was so mean and sweet and rough and gentle, I knew she was going to take care of me. "Show your stuff, girl," she commanded. Then she made me mastur-bate while everyone was watching and I loved it, naked and raw touching myself I felt their probing eyes all over my slippery flesh. I was turning her on and seeing the look in her eyes and their eyes and hearing her talk about me to all those other girls. Making myself come with an audience...I was into that.

I get back on my box to find everyone where I left them: Sharon at the bar, Joe on the dance floor, and Chris still lurking, looking angry because I'm not paying attention to her. I glance at the crowd of dancers and recognize another face in the group: my boss from my day job at a gay and lesbian non-profit. I'm startled and slightly embarrassed as we make eye contact. He is out of his three piece suit, slightly drunk, and enjoying his friends. This isn't exactly me in a skirt and blouse answering the phone, now is it? Or me at a demo, hair tucked under a baseball hat, shouting something queer and angry. Nor am I the thesis student interviewing butches and femmes about their lives and diligently researching and theorizing. Or am I?

I realize the evening will end soon because the club is getting uncomfortably stuffy and crowded. I wonder where I'm going after this and who's going to take me there. As the lights come up, I jump down from my box and make my way to the back room. I gather my things for the last time in the cramped bathroom. Exhausted, sweaty, charged and glowing, I guzzle the last of the water and catch sight of myself in the mirror. I've smeared my lipstick. As I re-enter the club, I see Sharon's girlfriend arrive to pick her up and take her home. Guess there

won't be any blindfolding tonight as promised. Chris has dis-
appeared. Joe makes her way over to me. She announces that
she's going to an after-hours club with her friends, I was great
tonight, and we'll have brunch tomorrow.

Women pour into the street and I go with them. I'm thirsty,
hungry and one of my ankles is starting to ache. As I make my
way down the sidewalk, a pickup truck passes by and slows
down. It's one of the bouncers, a real old-world butch who's
been courting me for weeks.

"Need a ride?"

There's nowhere I call home in this city anymore, so where
she's going seems like as good a place as any. But I'm sleepy
and overwhelmed and I shake my head and smile at her as the
bus drives by. I remember I didn't know who was going to take
me where tonight. Now I know, and I throw my backpack over
my shoulder and make a run for the bus.

Live-Work

Matthew Hall

FLOPPING HIMSELF ONTO THE COUCH, John tells me, "Come. Sit."

Looking at the pastel decorating I thank him for dinner, "though I didn't expect to be taken dancing afterward. Now I'm hungry again!"—and I laugh.

"Eh, only one dinner a night," his hand gripping my arm. "I'm no fairy godmother. You goose," he adds quickly.

Smiling, I tease John about a NYC accent, brought on by gin and tonics.

With a smirk, John talks. About the great club he took me to, the great soup he bought me, the great silk kimono I should wear. "You'll love it! It'll look great on ya. Here, lemme go get it," he says. Stepping on my bag as he rushes off. "Don't go anywhere."

Gently moving my bag off to the side, out of the way, I lean back. Close my eyes.

"Sleep with me, Ben." Opening back up and I see John posed in a kimono.

Yawning, "It's been a long night."

"Sleep with me!" he roars.

"Nah, man, I just wanna sleep."

"C'mon! Let's fuck! You know you want to," says John. His hand on my neck, sitting back down on the promised couch.

"I'm straight, man—I told you that. I just wanna sleep. You said I could crash on the couch."

John's couch.

"Your couch."

"You're a fucking dick-tease. Fuck you. Out! Out of my fucking house!" John's hand tightens around my neck.

"But I like this couch," I recover. "It's comfortable."

Smile sweet, Ben, it's 4 AM, nowhere else to go. No money to get there.

"Yeah, it *is* a comfortable couch. *Everyone* likes it."

"You flirt," I even giggle.

"Flirt!?" John sneers. "You fucking *dick-tease*!" His grip tightens. But I'm already moving my hand slowly up and down. Teasing his stomach, the inside of his thighs.

John does pull back a bit, and I sit up. Place a foot on his.

"Footsies!" he snorts, kicking my foot off of his. "You just like to be told what to do. Well, you're mine." Breath heavy on my face.

I'm yours. "I'm yours, baby boy."

Grabbing me around the waist, we fall to the floor. Our legs entwine and he bites my ear. "Gentle," I'm saying. Wet your lips.

Wetting my lips, I feel his mouth close to mine. Squeeze his ass, roll over to face him on top; I will love him. He slips his shirt off, I do too. Pinches my nipples, I pinch his.

"You mimic!" he roars. Hands caressive, I pull him forward and kiss hard. Kiss long.

He's eager; we push and pull. Clothes scatter. He is warm; strong hands press my muscles. My tongue finding the curve of his breasts. Pins my arms above my head, his mouth dry and biting. I will love him.

Now he kisses downwards, no longer trying to control. Beautiful blonde pubic hair, glistening and rough, my fingers tracing their patterns of s's. Feel his body tingling so I turn him over. Keep your hands soft: I play with hairs on the back of his thighs. My finger exploring the line between his ass. Slowly, nestling, and then cupping him with my wetted hands, fingers. Licking his round promontory, "Faster!" I hear.

The body convulses and my hands are a soothing white; champions.

Rolling over, John spits, "That's better," and takes me to his bed, hugging.

Cuddled up, nowhere near him. "I am not a prostitute," I say. Looking at me, John really smiles! "I know you're not, Ben, I know that. But after tonight you should leave. No sense in feeling like a whore."

Featherfall

Will Keen

"YOU LEAD," OFFERS ADAM, AS HE AND MADI enter the shade of the woods, leaving the wide well-worn path to pick their way through the trees. Familiar with this forest, Adam wants Madi to enjoy the exploration, so they exchange the pleasure of walking hand-in-hand for that of following single file.

"My pleasure," Adam thinks, because as she moves deeper into the tall stand of pines, he enjoys watching her tightly bluejeaned ass. His attention is fixed raptly on her rhythmic movements, as though her shapely rump is an object of prey, one that he would pounce on sooner or later, given the chance.

"My pleasure," Madi thinks, not just from the intensity of his gaze, palpable to her as he focuses on her hips, but because she appreciates her decision not to wear panties that morning; how good it feels to have the hard seam of snug jeans rubbing deliciously. Hiking through the plush pine needles causes her to lift her feet extra high, raising the pliant cotton into her crotch with each satisfying step.

They walk through the forest quietly, until Madi stops in front of Adam, bending from the waist. He is intrigued, but as he reaches out playfully to squeeze her rear, she stands up.

"Look what I found!" she says, displaying a long elegant feather, subtly patterned with smoky-brown bands against a tawny background. Adam is impressed, even before he takes the flight feather from her outstretched hand.

"This must be from a raptor," he says. "See these tiny serrations along this edge? They lead into the wind, muffling the rush of air over the wing." He demonstrates, slicing the air with the feather.

"So the bird can hunt silently?" Madi surmises.

Adam nods. "We're in the territory of a predator."

At their feet, they find tucked among the pine needles a few more feathers, fluffy body feathers, perfectly fresh, with the same pattern as the first feather. Madi picks them up one at a time, gathering them intently, her smile radiant.

"I've never seen such beautiful feathers, and so sensuous. They make me feel...." Her voice trails off, but Adam can see the look in her inviting brown eyes, and that gives free rein to his desire, emboldened by the privacy gained from the dense cloak of trees. Approaching her closely, he says, "This feather gives me an idea."

She responds only by tilting her head to engage him in an arousing kiss. Just as their tongues meet, the couple is startled by a solid shadow that swoops in front of them. They stop, surprised by the form of a huge owl gliding from a low branch to a higher perch. They hold their breath until the sharp curved talons grip the rough bark. Twin ear tufts swivel their way, and luminous yellow eyes are trained on them from twenty feet in the canopy. The owl settles in, ruffling his plumage, then hunkers into an unnerving silhouette, with only an occasional blink to interrupt his fierce stare.

Madi whispers, "We're being watched."

"Yes, by no less than a great horned owl. Should we continue, now that we have a voyeur?"

"*I* want to...." she replies, her eyes flashing.

They shed the rest of their clothes, pulling off their jeans and shirts to stand naked in the half light, knowing the owl's superb eyes could see every square inch of warm-blooded skin, every flush of color.

Turning their bodies so the watcher can view, Adam begins by tickling Madi with the long stiff feather. He sweeps her nipples until they deepen red. She coos when he brings the feather tip between her legs, and strokes her pubic mound. She reaches down to open her lips with the fingers of one hand. Slowly, he draws the full length of the feather's web along her exposed clit. Madi trembles. The quill is damp with her moisture as Adam wafts it under her nose, and she looks up dreamily

at the vigilant owl, knowing that it's his feather bringing her so much pleasure.

Adam bends down to her ear, hovering as if he were about to say something; she cocks her head to listen, expectant. Without a word, his body flies at hers, overpowering her balance, catching her with his arms as she hits the ground. He is hard, and impales her, pushing himself inside. She is wet, and opens her legs as she tumbles back, letting him cover her whole body with his. He brings his weight to deepen the impact of his thrusting. Pinned to the earth, she claws at him and they grapple.

Adam sinks his nails into the flesh of Madi's shoulder, and the unexpected pain puts her over the edge. She shudders, breathing furiously, grasping dry needles in her hands, snapping them in her fists. She is pulsating, tightening on Adam, who passes the point of no return. Both of them want to howl at their release, ready to fill the forest with their primal sounds.

A scream pierces the air. Eyes closed, lost in the struggle, each one thinks the other has succumbed first, but they hear frantic wingbeats above. Another shriek tears through the trees, branches crack, and as Adam and Madi cry out in their inarticulate climax, they look up to see feathers. Feathers falling everywhere. A warm blizzard of feathers descending on all sides, as if a small dark angel was dying, unwinding in the sky.

The owl, having moved under cover of the lovers, now lifts the lifeless body of a night-heron. In mid-air, the honed beak rips pinions from the prey. It is terrible, yet wonderful, the humans think below. As they wait for the owl to be satisfied, a faint mist of blood descends.

Adam and Madi lie entwined between tree roots, clinging to each other at the exact center of the kill-site. The arch of her back slowly relaxes, and still the downy, soft feminine feathers come floating down. Madi rises, feathers sticking to the sweat on the skin of her naked body. She squats for a moment, letting their mingled juices drop thick as eggwhite to glisten on the layer of rich humus. Quietly, she moves about Adam, collecting a few twigs and heron feathers, and carefully builds a ritual nest around the wet spot on the forest floor.

Adam lies back, observing her curiously, as she continues to gather more feathers, bending to the task purposefully. Madi walks to him and stands with feet apart, straddling her man, holding the sheaf of feathers for him to see.

"As soon as I weave these in my hair, Bird-Woman is going hunting."

He meets her steady gaze, but smiles inwardly, sensing the owl growing hungry again.

"And then you'll feel my talons as I devour you," she promises.

"We'll see," Adam says. "We'll see whose feathers fall first."

Return to Rawhide

horehound stillpoint

i'm waiting for a man with enough rope
 to catch me, hogtie me, strap me over his knee
 pull out his trusty branding iron of red-hot steel
 & make my butt his personal pork-belly property
 for the rest of my life
you can bandy about words like limits, control, & projection
when my studfucker shows up
i'll kick off those codependent theories along with my socks
i'm not here to learn & grow, learn & grow
okay maybe i am
maybe i'm a lying son of a gun when i go
i just want to stay home to make hay with my husband
get fucked so hard the tears in my eyes'll be
 half blood and half ejaculate
 nothing less will really grab my attention
hetero boys from the plains are always asking:
 don't it hurt, gettin' fucked?
i look 'em in the eye and answer:
 damn straight it hurts
 it's supposed to
 pain is foreplay, sweetcakes
 pain puts us on the edge
i want a man who'll take me over the top and around the bend
hell yes it's gonna hurt
i haven't opened my heart in so long
 let alone my ass
 it won't come easy
 i'll be kicking, squirming, spitting, screaming, & bawling
baby, it'll be hard as being born all over again

so i change my mind as often as i change my jockeys
forget about affirmations in front of a mirror
'at the right time, a perfect lover will appear before me'
i just scream my number—882-457ha!—in dark dirty rooms
 from coast to coast
hoping the reverberations will swing low enough
 to find some drifter out of the blue
 whose gallop to the rescue will leave heaven in our dust
i'm not talking about some dainty canoe trip
 down a man made tunnel of love
 i'm talking about the buttfucking adventure of a lifetime
 between two men with heavy baggage & equipment
i want a man who'll make my heart sing yippieyiyaaieyaay
a man who'll get me in dutch with ghost riders in the sky
a man who will shower me with gold straight from the mother-
 lode
a man who will manifest hawk, scorpion, coyote, dove
 in the breath of dreams we will share at night
i want a man with a whip on his hip
 manacles at his side
 a tarantula for a pet
 & a bag full of devices i can't even name
oh wait, that's marcus, how did he get in here?
ex-lovers need not apply
just between us, friends and strangers
ex-lovers are dying off like flies it's a wasteland
 a boneyard a desert of withered dreams
 under a two inch sky that doesn't leave much room
 for erections
it's an old story told too many times
ex-lovers don't always survive
words get stuck in the throat
 i know all about the gag reflex
i could even end up teaching cocksucking
 on some dude ranch/stud farm
people say, stick with what you know
i know cock

firm fleshy dicks, steel-belted pricks, thick juicy sausage, hot rod
 pistons, knobby
nightsticks, silky smooth shafts, purple veined ramrods, pulpy
 horsedicks, seedy
weepy members, blue-collar cock, delinquent cock, fresh young
 cock, athletic cock in
a cup, cheesy cock, wet greasy pissers, overworked hardons,
 hung huge honkers,
uncut tubesteak, and old faithful
the curve of my tongue remembers every one
marcus jason johnny anthony tom ad infinitum
somewhere out there is yet another man
 with the pearls to turn me into swine
 show me where to put my nose
 watch me bring home the bacon
we're gonna need all our strength
god damn, my heart's singing out rawhide already
 "...something something something
 we're hell bent for leather
 something something something... "
tan my hide, cure my meat, whip my ass, break my balls
come on, let's go, let's ride off
 into the burning sunset
 through the badlands and mount the high country
we'll find out just how tall the sky is
 in the bottom of our bedroll

Open Throttle, Full Steam Ahead

horehound stillpoint

once upon a time
i thought regular sex with ten to twenty thousand guys
 ought to be enough to last a lifetime
then i got a faceful of your kink
nothing has smelled the same since
 taking that bath in your fountain of youth
 turns my mind back into primordial soup
i am frog prince now born of the ocean
 in exile from the kingdom hallelujah
 unfit for dry land amen
certain no candy magic kiss will change me back
 this is no fairy tale
 this is the marshland
 we are all swamp meat tonight
 we go splish splash in the dirty water
 drench each other in heavy fetid metal
 watching our sins turn into steaming beverages
 dripping off our chins
fear is one more vapor in the bog
i love going under and taking you with me
 our nostrils open up
 we take great big sniffs
 we snort and slurp
jockey for position
 like pigs at a trough
we lost our names long ago
we know each other by stink
we will reek of each other before this night is through
 it happens in the tingling of an eye

letting out the inside dirt
zero to sixty in the opening of a valve
getting a pocketful of your exhaust
adds fuel to desires i never knew i had
once upon a time many many times
we were told to keep it all bottled up inside
thank god for evolution
amen everybody
we mutants have learned to let it flow
we breathe sighs of relief our mothers never dreamed of
we're breaking old chains link by link
i need a witness
a hundred a thousand a legion to witness
a simple trick
nothing to it
come on i know you can do it
gimme a faceful of your kink
wanna get down in your dirt
wanna blow smoke up your ass
the past hurts when you sit on it
& you never know what mysterious aroma is around the next
corner
what smelly tidepool might catch us up
carry us home
what secrets of life are lying at our feet
can i get another witness
oh the lower you go the more juice you get
you can find me down on all fours
barking like a dog
begging for a bone
once upon a time at least twice tonight
there's something about you
sweet as pie
it's not what people think
it's swell your swill
amen hallelujah
there's rapture in a faceful of your kink

Walking in Circles

(A True Story From the Days Before Safer Sex)

Scotty Brookie

YOU CAN SPOT IN A SECOND a man who is making his first visit to a bathhouse. He will always walk too quickly, as though he is about to miss a bus, or his pot roast is burning. But in fact he is only walking around the building in a big circle, like everybody else.

It's my first night at the baths, many years ago, and I've been walking around in circles—too fast—for a couple of hours now. Partly because I'm nervous, partly because I'm shy, partly because I feel picky. There may be 400 men here, padding around in skimpy towels, but *I'm* saving myself. Although, after three hours, I notice that my standards are starting to relax.

There's one door downstairs I've been avoiding, for some reason. I'm ready to look now. The door creaks open, a warm cloud billows out—I get it, it's a steam room. I feel my way past the hissing steam jets into the room, let my eyes adjust to the foggy scenery, and sit down. I keep my legs spread, my arms at my side, and my head up, trying to strike that delicate balance between naive and vulnerable on the one hand, and jaded and overripe on the other.

Presently I feel comfortable enough to look somewhere besides straight ahead. Sitting next to me on my left, I notice a slender young man with curly brown hair and lean, hard-looking thighs. Now, this is more like it.

But what do I do next?

I look at him. He looks the other way.

Oh, the hell with it. Taking a deep breath, I reach over and lay my hand on his thigh.

There. I did it.

My sense of achievement doesn't last very long. Raising his arm in a mighty sideways swipe, he knocks my arm off his leg, sending it all the way back to my lap.

Hmmm. I think I've been rejected.

Did anyone see that? I don't think so. Did I do something wrong? I don't think so. Am I totally undesirable? I'm not sure....

Now, the cute guy next to me hops off the bench and approaches one of a cluster of men in the middle of the room. This other man is huge—probably in his late fifties, well over six feet tall, maybe 250 pounds, and covered with hair from head to toe, including his back. The person who so decisively just rejected me is perhaps twenty-two, slender, hairless—and short, like me. Without any further ado, he turns the bear-man around and proceeds to enter and fuck him, right then and there. A look of astonished ecstasy crosses Bear-man's face, his big body rolls with the vigorous fucking. His compatriots press closer, jockeying for a good view. A murmur of approval fills the steam room. The steam jets hiss. The air is hot, damp, close.

Then just as suddenly, the young guy pulls out of Bear-man. With his small, jauntily erect penis preceding him, he strides out of the steam room without saying a word.

The men relax again. It feels like intermission. I survey Bear-man, who looks very pleased. Well, I think, reflecting on the slender young fuckmaster, I guess I wasn't his type.

Feeling a need to rejuvenate my self-esteem, I make my way out of the steam room and head back upstairs to take a few more laps around the building. I'm getting a little discouraged.

Hey wait a minute, look! There's somebody else here with long hair! Oh, he's *cute*. Where's he going? Back downstairs? Me too.

I catch up with him on the stairs.

"You're the only other person I've seen with long hair here!" I blurt out.

He smiles. "I know. I saw you in the snack bar." I feel my heart start to go faster.

Sitting together back in the steam room, he tells me he's a

baker, that he lives in Harlem, that he's from Wisconsin. His name is Paul. I steal glances at him: he has a smooth, broad chest, and arms strong from kneading dough. His dark blonde hair grazes his shoulders. He has a wonderful smell.

We sit comfortably for a while talking and resting, our steam-damp legs touching. Then he leans over, his mouth opening. We kiss for a long time. By the time we stop, we're both getting very hard. The men in the steam room are clustering to watch.

He draws back and looks at me. "Do you want to go to my room?"

"I thought you'd never ask."

In his little cubicle, three floors up, I undo his towel, and it falls to the floor next to mine. As we kiss, my fist knots in his hair, pushing his tongue deeper into my mouth. We wrestle; I pin his arms with one hand, lick my other hand and wrap it around his cock—he has no choice, he can't move.

We switch: he breaks free and climbs on top of me.

In the cubicles around us, the walls don't reach to the ceiling, and you can hear everything. You can hear men slapping and sucking, and crying out in pleasure. With my mind already delirious from this background haze of sex-noise, Paul leans his mouth into my ear:

"I *really* want to *fuck* you," he says hoarsely.

I'm so turned on I can't talk. He slides his cock into me, pushing.

"You've got such a tight little ass!" His tone is almost reproachful, as though I don't want him enough.

It's all the encouragement I need. My legs crawl up his back as he bears down on me. We flail and fuck and thrash, banging our bodies into each other, kissing furiously and crashing into the flimsy metal wall, moaning and screaming and making a tremendous racket, even by bathhouse standards.

We come like trains, him deeply ploughed into me, our bodies slippery with sweat and cum. We collapse onto each other and fall asleep.

IT'S DAWN WHEN I PUSH OPEN the discreet black door at the bottom

of the stairs and emerge, blinking, onto the sidewalk. Paul walks with me back to the place I'm staying. We hug and kiss, and say goodbye.

MY LOVER WAS WAITING UPSTAIRS. He had gone to a different bathhouse, had very little luck, and gone home at one o'clock. We fought the rest of the weekend.

Midsummer

Rachel Power

IT WAS THE LONGEST DAY AND THE SHORTEST NIGHT of the year. My friend Joy belonged to a group of witches that gathered together to celebrate the eight Pagan holidays. Tonight she had invited me to join her coven's celebration of the Summer Solstice. My body teemed with nervous energy as I prepared for the evening's festivities. I took a leisurely, hot bath, then carefully brushed my long blonde hair and anointed my body with jasmine perfume. Following Joy's advice on what I should wear I slipped on a long black dress with nothing underneath.

I had been reading books on Witchcraft and practicing magic on my own for about a year, but I had never been to a coven ritual before. I was excited and expectant, imagining a raging bonfire, surrounded by people singing and dancing freely, uninhibited. Yet I also felt nervous and self-conscious. What if I didn't know the words to the songs? Would I really be able to dance in front of all those people? I chased these worries away and focused on the evening ahead.

Joy came and picked me up and we headed for a local park thick with trees. We hiked along a path leading down to a grove. Although it was still twilight, the trees' branches blocked out most of the sky. As we descended deeper into the woods our surroundings grew darker, yet I could still see the bright glow of a waxing moon between the treetops. Ahead in the distance I noticed a small red speck that as we drew closer turned out to be the bright flames of a bonfire.

We came upon a group of people dressed in festive garments, like those you might see at a Renaissance Faire—long flowing skirts, satin corsets, garlands of flowers—gathered around the fire. They were laughing, singing, and playing various instru-

ments. Joy introduced me to the group and someone passed me a silver goblet full of a dark steaming liquid. It tasted warm and sweet as it slipped down my throat. Later on I would find out that it was a blend of ginseng and mandrake root—both potent herbal aphrodisiacs. A moment later my cup was replenished by a beautiful woman with a wild mane of curly red hair, topped with a crown of fresh flowers.

"I'm Selena," she said in a soft, sultry voice. Her dark green eyes looked me up and down.

"I'm Diana," I said, sensing my face flush and my body grow warm as she stared at me. The combination of the fire, the steaming liquid, and Selena had an unexpected effect on me. A wave of desire coursed through my body and I felt keenly aware of my nakedness, covered only by the sheer material of my dress.

Then a bell chimed three times and Selena walked away. The others formed a circle around the fire. I followed them dreamily, foggy from the heady atmosphere—the sights, sounds and tastes—and the unfamiliar surroundings. All eyes were focused on Selena and a tall, dark man with long black hair. A large silver pentacle rested on his chest, supported by a thick metal chain. I surmised that they were the leaders of the ritual when they lit a bundle of sage and began to swirl the smoke around each coven member.

After the purification, Selena and the man drew an imaginary circle around the group and called in the four sacred directions. The group began chanting softly, creating an eerie sound that reverberated throughout the woods. Then the man walked over to me and took my hand. He led me towards the center of the circle. Curiosity conquered any fears as I followed, wondering what was going to happen next.

He addressed the group as I stood by his side. "Welcome all. I am Gabriel. Tonight, on this shortest night of the year, we gather to acknowledge the slow decline of the sun. We also come together to celebrate a new addition to our group. Let us welcome Diana!" The coveners clapped and cheered. I hadn't been expecting this kind of attention and my face turned red. Next,

Selena came up beside me. Again she lured my gaze into those deep green eyes. As I stood transfixed by her beauty, she lifted my dress up over my head with a swift, graceful movement. Before I could protest, I was standing naked in front of a group of strangers.

Then the two of them guided me towards an altar table near the fire and indicated that I lie down on top of it. Full of apprehension, wondering what would happen next, I closed my eyes in an attempt to shut out all the faces staring down at me. With my eyes closed I felt more at ease. I began to relax and let my senses drink in the sounds and smells around me. The energy contained within the circle and the power that had been raised during the chanting created a charge that tingled up and down my body.

Lying on the alter, naked, surrounded by a group of strangers, one would think I would have felt nervous—even scared—but instead I felt alive, bold and ready for anything. The thought of my body exposed in front of all these people sent a thrill down my spine and a throbbing between my legs. The fire burning beside me made my skin hot and slick. Selena and Gabriel sat on either side of me. I noticed they were holding small bottles of colored liquid, which they poured over my legs, arms and stomach. The rich scent of roses and sandalwood assailed my nose as the liquid streamed down my limbs.

They massaged the oily liquid into my skin, bearing down deeply on my limbs, but brushing lightly over my more intimate parts. The feel of hands all over my body sent me into a state of excitement beyond my control. The man's hands moved in strong, sure movements, up and down my arms. Selena's touch was lighter, tenuous yet purposeful. She started at my feet, then moved up. As she traveled past my knees she gently pulled my legs apart. I felt a yearning, a dull ache, growing in my groin as her hands massaged my inner thighs. Involuntarily I arched my pelvis towards her hands, hoping she was headed there next.

The man massaged my breasts, rubbing my nipples with the tips of his fingers. I opened my eyes and saw my body coated with oil, the fire reflecting on my skin. I saw my nipples stiff

with pleasure, responding to the pressure of Gabriel's diligent fingers. Then I looked down at Selena. I was seized with desire as I saw her face, surrounded by that wild red hair, looking at my vulva longingly. She softly caressed the hair on my pubic mound and then parted the lips of my slit with both hands. I ached for the sensation of her fingers inside me and my cunt throbbed with longing. Tentatively, she let one finger slip inside my lips which were slick and wet from her touch. She spread my lips open wider, then brought her mouth down to taste me. She licked the whole length of my cunt, up and down, then paused at my clit and flicked it with her tongue. With one of her free hands she began to touch my ass, letting one finger push gently inside. Her tongue was driving me crazy as she circled my clit and then sucked it into her mouth. A low groan slipped out of my mouth as I rocked my hips back and forth, trying to push her tongue deeper into my slit.

I was aware that the coven members had moved in closer to watch the spectacle before them. This knowledge excited me further. Although my eyes were closed, I could imagine the sight of Selena's mouth on my swollen cunt. I pictured them standing there transfixed by the scene. I could still hear their voices chanting softly in the background mixed with my moans which grew louder by the moment. Gabriel's fingers, then tongue on my nipples heightened the ache that was quickly mounting between my legs.

Selena's tongue continued to dart in and out of my cunt while one hand briskly massaged my clit. I couldn't hold back any longer and felt my craving reach its peak, then waves of pleasure washed over my body. She kept up the steady rhythm with her mouth and hand, causing me to climax two more times. My body remained stiff and tense as the last orgasm ripped through me, and then my limbs relaxed.

Selena kissed my lips softly and helped me sit up. I felt almost drunk from an overdose of pleasure, yet keenly aware. My whole body seemed to be in a heightened state of arousal; my senses were alert, ready for action. I felt transformed, renewed, like a snake that had just slipped out of its scaly skin. As I faced

the group of people, the modesty I had experienced earlier completely dissolved. Gabriel looked me over, acknowledged the change and addressed the crowd: "She has lain with the Goddess and God and now she is one of us. Welcome, Diana, and let the festivities begin." Once again the group clapped and cheered.

I was delighted to find out that the celebration had only just begun.

Night

Cathie Poston

IT WAS A HELL OF A NIGHT AT THE DISCO. Well, it wasn't a disco, not anymore: it was a club. It was the '90s version of a disco—loud music, drugs, and lots of sweaty people. Music with a deep beat that appealed to hungry bodies on drugs, who desperately wanted to mingle with others. It was all new, yet the same old shit that had always gone on within the walls of the dirty old dance hall.

Jade was in the middle of it all. Dressed in black, hanging back from the crowd, looking all too bored. Older than the rest, and there on business. That well-planned look of indifference protected her from all the external chaos getting mixed up with her own internal chaos. She, a self-styled bitch and whore, was getting too old for this shit. The '70s had been her time of self-exploration in the disco wasteland of San Francisco. The old group of beautiful gay boys had passed away, and she mourned them. Old fag hags didn't seem to die, they just faded away without their muses to give them life. So she sat there, thirty-four, feeling old, feeling sad, watching the kids give it all they had on the dance floor, desperately wanting to smell the smell of poppers and hear the disco beat. It had been a hell of a night at the disco.

She was no longer a full-time whore (if you can call someone who gets $225 per hour just a whore). An old friend had made the referral. A john who wanted public sex, her specialty. They met at the john's hotel and taxied to the club. This was a time trip back to the old days.

In her little black evening dress, heels and leather trench coat she looked like a tourist in this club. But she was Jade, a whore, working the room. A long, tall woman in a black dress, she still

got looks, even if she did not out-dress the room.

Jade went to work. For $225 and some coke, the john got what he wanted: a dry hump on the public dance floor. Coke, how retro! X and other designer drugs ruled the dance floor here. Coke was so '70s of him. She dipped her finger into the cool water of the ice melting from her drink. The wet digit slipped up her nose to grease the passageway. She was handed a small snowy peak of powder, offered up on a golden spoon. Snorting it was like a blast from the past. It was all still there: the rush, the burn, and the feeling of euphoria.

Onto the dance floor. Tucked away in a dark corner she let him lift her dress and run his cock up against her pantyhosed ass. Within the time of two songs he was done. Blessedly the coke was all for her: most men can't cum like that if they are coked up. One more toot for her before he left.

So there she sat, pantyhose sticking to her butt, a $300 dress stinking of sweat and smoke and she was higher than a fucking kite. Coke was one of those things you build up a tolerance for, but the silly girl had not done coke for five years. She was wired for sound.

Finishing the last drag on her bummed smoke, she headed for the bathroom, grabbing her coat on the way. Hiding in the stall with a handful of wet paper towels, she cleaned up some. Peeling off the pantyhose, she dumped them in the small trash can. Her dress still clung to her. She slipped it off to wipe down and could not bring herself to put it back on. She slipped her naked body into her full length coat. It felt good and it would do to get home. Back on went the shoes and she headed out of the club.

The street air was like an old friend. But it was not cold enough to cut the jitters of the drug, so she thought she would walk for a while, then get a cab. Her body took her where it would, deeper back to even darker places than the disco. Drawn down the dark street, busy with people exiting the many clubs of SOMA, to a place of history and legend. Ringold Alley's dark mouth opened wide, beckoning her. Her Jade persona was all but gone, she was just Beth, little teenaged Beth, who had heard

of mighty Ringold Alley in its heyday but would never have dared to go there—though she had wanted to. Now when she played with her various leather-clad playmates, she went there in her mind: The day of the leatherman ruling Folsom Street was gone, but not forgotten. While it still maintained the leather image and reputation, the men who had totally dominated the area were gone. Did guys still go to Ringold? What would she find if she stepped into the shadows?

She stood in the middle of the street, clicked her heels three times and walked into the alley—into the open arms of a mugging or a rape? At this point in the evening she was willing to take the risk. Her heels echoed on the street and bounced off the walls. There were people in the shadows, by the tones of the voices, grunts and moans, male people, big ones. One step, two steps and *bingo* there she stood, toe to toe with a full leatherman, with his boy kneeling at his feet. He had stepped into her path out of the dark and into the yellow light of the street lamp. He looked down at her, quite a feat when she stood six foot in her heels.

"Are you a real girl?" the leatherman spoke.

"See for yourself," she said as she pulled open her coat. She could see her body reflected in his mirrored shades. Sunglasses at night. From his leather hat to handlebar mustache, from his chaps to his bare chest covered by his harness, from his shiny boots to his soft leather jacket that fit like a glove—he was a Master. Every boy's fantasy and a few women's to boot.

"My boy here," he went on, "has never fucked a woman, ma'am. I want him to service you."

Her clit jumped as he said this. She walked over to a parked car and leaned back against its hood, pulling her coat back, exposing her cunt to the boy in leather. For the first time she looked at the boy. Smaller than the man, a black hood covering the boy's head, collar with a chain leash, boots on his feet, not another stitch covered him. Wow, she thought, how hot! At this point she was not sure what would happen: would this boy really fuck her?

Well, yes and no. The Master fitted his boy with a gag that

had a dildo sticking out of it, a condom muting the black color of the rubber dick. Lube came out of nowhere and rubbed down the dildo. The boy plunged in. He took to it like he had been a fuck toy before, just not for a girl. The Master stood back and watched the scene he had set up, a smile on his lips. He walked over to her on the hood of the car, pulled the coat totally open and started to run his leather-clad hands over her.

He may have been a leatherman, the leatherman of all leatherman, but he sure had been with a woman before. Circling her breast he moved to her nipple, pinching down with a steady pressure till she gasped, getting even wetter. As she responded to the pain he gave her more. His hands moved up towards her face. He rested one cheek in his hand and stroked the other. She knew he would hit her soon just by the way he held her. Slowly, he started to slap her cheek, stinging and steady moving up to painful and scary. Right to the point she couldn't stand it, he stopped and then added just one more. At this point she wrapped her legs around the boy's head and pulled him in even deeper.

"What a slut you are, girl," the Master whispered to her. He climbed on the hood of the car and straddled her head. "Open wide," he said. "Open...*close*," he said—leaving the tip of a condom in her teeth. Gently, she slid the condom onto his cock till he filled it. He didn't just want head. He fucked her face the way his boy did her cunt. All her holes were filled and ready to fire.

Overwhelmed, the need to cum rushed over her. She dropped her hand to her clit and started rubbing herself in time with the fucking and the sucking. She came first, but the boy went on fucking her till the rapid-fire pummeling of his Master in her face stopped as he came. He stood over her on the hood of the car, towering, stepped to one side and jumped to the pavement. The boy moved towards him to remove the drooping condom from his cock and knelt. He removed the boy's gag and had him help her to her feet. As she stood, the boy dropped to one knee in front of her and licked her shoes. A well-trained boy, a wonderful boy. She gathered up her coat remembering that

this was a dark alley in the middle of the night. She rubbed the boy's head and told him how good he was. She walked forward, towards the end of the block.

See you, a voice said from behind her. She had to take one more look. When she did, she saw the Master take off his hat, letting down his long hair, and his boy light his cigar. He took off his shades to give her one last look. "See you next week at the party. You are coming, aren't you?"

Shit, she knew him. Not well, but from around the scene, the local s/m party scene. She smiled and said "Sure, and thanks."

The town sure was too fucking small.

By the time she had reached Market Street she was no longer shaking. She stood there, all fucked out, looking at the cars going by. At the light across the street a limo stopped, people hanging out of the sun roof and the windows. They waved to her. A smile came over her lips. As they drove by she opened her coat to show them what they were missing. They almost fell out of the windows. Then she pivoted on her heels and headed down the street.

She was now Liz, an s/m prince of her own creation out for a night on the town.

All I want...

J. A. Vasconcellos

All i want
is to have
one
real
feeling.
One really
deep feeling.
Just one.
And just once.

Forget the search
for God;
the good fight;
the spirit in the
forest.

'Cause I got
my heart set on
the feeling.
You know,
the real
deep one.

When I lay down in the field of mustard flowers,
spread my legs
and direct the erect penis slimed with saliva
to my ass.

I want to feel:

not the friction from a water-based lubed condom,
but the
warm blood-rich muscle.

Just one.
Just once.
I want to have the real feeling.

And with the natural tilt in my spin,
I rock
and so does the body on top of me,
and all I'm aware about is the
pain
throbbing against my muscles, and the
pleasure
sparking in my eyes,
in my hands,
in my heart.

When the come shoots up inside my colon walls,
I want to feel
it rushing back down.
When I won't think of H-I-V, or Hepatitis B
or C
or Z;
or my friend Scott who died of AIDS.

No, I want the real feeling.
The real deep one, without being reminded
of my
mother and her love
or fear for her youngest.
'Cause even if I cough around her, she spurts out,
"I hope you're not sick...."
and never finishes with what she wants to say, "...with AIDS."

Maybe I should strap a Jelly Roll dildo,

the one with the bubbles under the surface,
purchased from Good Vibrations,
on my mother
and have her open me up.
She could warm the dildo between her breasts,
while drops of olive oil pour onto her Spanish skin,
and then together,
we
slip it through the O-ring.

Together,
'cause I want someone to
give me the real feeling
with care.

She could wipe the tears that
fall from my face,
while I stare at her birthmark with
three black hairs just below her belly button, and we rock.

When I scream, "Wait,"
and then pant, "Slower,"
I know that she would respond.
Then proceed in initiating me into the secret world
of
feelings,
since she knows well about it
or I would not be here.

She
could
be
the
perfect
guide.

'Cause all

I want,
just once,
is to have
one
real
deep
feeling.

The Cucumber

Lori Selke

SHE TAKES A CUCUMBER FROM THE REFRIGERATOR and peels it. I'm in the bedroom, naked, lying on my stomach, stretched out so that none of the sunburn that covers my arms touches the mattress. She walks into the room and stands over me, cucumber and short chef's knife in hand, her hair falling over her face. Her skin is dark, it never burns. Grrr.

I begin to roll over, but she says, "Don't move."

She bends her body over me, bringing the knife and cucumber up near my face. She kisses me once on the lips, then cuts off the tip of the cucumber and pops it in my mouth. I chew and swallow quickly, and with relish. She starts to cut round slices off the cucumber, as thin as she can manage.

"Do you want them?" she asks.

"Yes."

"What do you say?"

"Please."

"You'll have to do better than that."

I try not to make a face. She likes to play these games with me, and usually I'm happy to play along as well. But I'm grouchy and uncomfortable this afternoon, and I don't want to work for anything. "Please, mistress."

"You still sound grumpy. I don't think you mean it."

I can tell this is going to be difficult. I take a deep breath. "Oh, mistress, please, grace me with your cucumber slices. I can hardly stand being without them. I'm aching for your lovingly carved cucumber. Please, please, I beg you, bestow upon me your cucumber, so carefully prepared. Lavish me with cucumber love."

She smiles. "Now you're getting snide. But since you begged

141

so prettily, just this once...."

She leans over; her hair falls just short of my tender skin. "Don't move. I'd hate to have to tie you down; the rope might chafe your burns."

And carefully, she starts to lay rows of cucumber slices down my sunburned arms. I stay as still as I can, but I still moan slightly. The cucumber soothes and cools my sunburn, better than any lotion or spray. I'm almost in heaven already, pinned by cucumber slices to the bed. I sigh contentedly.

"You like that?" she asks.

"Oh, yes," I pause, "mistress."

"Do you want more?"

"Please, mistress."

Her mouth turns down into a mock-frown. "But, honey, I've covered all your sunburn, and I still have half a cucumber to dispose of. Hmmm. Should I just eat it by myself?"

I have to remind myself not to sit up in dismay. "Oh, no, mistress, please don't do that."

"What do you want me to do with it, then?" She smiles sweetly at me.

"Give it to me."

"What?"

"Give it to me, please, mistress."

"How?"

"Any way that pleases you, mistress."

She grins. "Should I make you give it a blow job?"

I sigh. "If you wish, mistress."

She taps me with the cucumber-end. "But you have such nasty little teeth, you might just bite it off. And that would be no fun, would it?"

"No, mistress."

"So, what should I do with it, then?"

I grit my teeth. She's going to make me say it, of course. "Please, mistress, fuck me with it."

"In your cunt?"

Sometimes I hate that word. "Yes, mistress."

She leans the cucumber against her chin, thinking. "Oh, but

that's so pedestrian. Cucumbers up your cunt. Can't you think of anything better? Even a housewife has a better imagination."

"Oh, please, mistress," I moan in frustration, trying not to roll over or rise up to grab the cuke.

She laughs and moves out of reach. "Besides, with all that's going on inside you, you might pickle it. Tuna with pickles, ha! Spoil a perfectly good cucumber."

"Mistress, I beg you. Sincerely. I want you to fuck me with your cucumber."

"Well, if that's what you really want...."

She moves around me and shoves the half-used cucumber deep inside. It's still refrigerator-cold, and I have to fight myself so as not to roll over or clench my legs shut. It feels glorious, slippery and chill. She leaves just the tip of the blunt, cut end protruding outside me.

"I know. I'll just finish it off before you spoil it."
And she starts nibbling the end of the cucumber, pulling it slowly out of me with her teeth as she eats. I can feel it sliding down the walls of my cunt, and she is flicking her tongue against my clit before each tiny bite. I spread my legs just a bit wider and fight the urge to thrust my hips or push my butt up into her face. There's so much cucumber inside me, wide and cool; and she's being so dainty with her restrained and intimate bites. This is going to take a long time; she's barely begun to feast.

Clothes Make The Man

Lawrence Schimel

GEORGE'S APARTMENT WAS A NIGHTMARE scene of half-dressed fags. George designed porn CD-ROMs for a living, but this wasn't a shoot for his latest title. In one of the previous jobs on his long and checkered resume he'd been a mannequin designer, and it was for that reason ten gay boys had descended upon his apartment like a plague of locusts before the harvest. When the mannequin company had folded, George had been left with over a hundred wigs in his possession, and while he'd lost or given away many of them over the years, he still had sixty or more left. Every year a dozen or more fags would show up on his doorstep on Wigstock morning (and also Halloween) begging to borrow a wig and be made up.

Now, I've always found partial clothing to be extremely sexy. The way a man in a vest with no shirt on underneath will wind up inadvertently giving you a flash of nipple every now and then, and soon you find yourself waiting for it, watching for it, because it's so unexpected when the drape of fabric will suddenly fall back to reveal that pert brown circle. Or your lover in silk boxers, walking unabashedly about the apartment you share, and your eyes keep falling to the fly as it gapes and yawns and gives you a flash of the dark hair beneath and—what you're really hungering for—a glimpse of cock, momentary, like a flashbulb on a camera, and like that brilliant light it lingers on your vision even after it's faded away.

And there's something about men who are partially dressed in women's clothing (especially butch men like the Chelsea gym queens now before me) that's even more attractive, because it accentuates their masculinity. For instance, Bernie (short for Bernardo) was one of those deceptive Italian studs; all muscle

and meat on the outside, but such a soft and nelly voice the moment he opened his mouth, seemingly so out of character with the rest of him. But right now he had his mouth quite closed as he puckered his lipsticked lips and, shirtless, postured in front of the full-body mirror on the closet door in a pair of silver elbow-length gloves. He put his hands on his hips and pouted into the mirror, trying on different expressions.

I marveled at the intense musculature of his back, the way his shoulders and biceps faded into those slender-seeming gloves, the way his top-heavy torso faded into his Calvin Klein boxer-briefs, which poked out from beneath his practically non-exis-tent cut-offs. He had a firm, round ass, and his legs were undeniably male: thick columns of muscle. I imagined them wrapping around me and squeezing tightly, being unable to move, pinned by their strength and bulk.

Bernie caught my eye in the mirror and said, "Honey, you're going to need to tuck that thing." He stepped aside and I got a look at myself in the mirror and blushed. I was wearing an orange and yellow dress that looked like it had once been the wallpaper on Continental Airlines back in the '70s, and I had an erection tenting it out in front of me from watching him and fantasizing.

I strutted forward, wobbling a bit in my heels in part for effect and in part because I didn't really know how to walk properly yet, until I stood right behind him. I rubbed my crotch against his ass. "You want me to tuck it in here, did you say?"

I got whistles and hoots of laughter from the other boys, who'd paused in their own preparations to pay attention to this latest mini-drama. Or maybe they'd all stopped to check out my basket. I stepped beside Bernie and stared at myself next to him. How could I properly cruise any of these boys when they couldn't see how my body really was? My best friend (who was to be called Royal Flush today) and I had arrived at George's before any of them, and my makeup had been well under way by the time anyone else had arrived. I was done up to look like Agnes Moorhead as Endora from *Bewitched*, with bright orange lipstick and blue and purple eyeshadow on thick. George had

done wonders, but that was always the case with him. He had one of those senses of style that could create art—or camp—out of anything or anyone.

I wore chunky plastic rings in various loud colors that matched or accentuated the dress, and plastic yellow bangles. A string of yellow pearls was wrapped twice around my neck like a choker. My wig was sitting on a mannequin head atop the television: Elizabeth Taylor big hair, the same color as my own so I didn't need to worry about the back of my own hair showing through at the bottom of the wig in a little dovetail. All I had left to do were my nails, in a garish orange glitter I'd found for a buck fifty that morning at the corner drug store.

George's latest CD-ROM was playing on the computer behind me, and everyone was ragging him over the dialogue and the script and the performers he'd cast. Eric sat at the keyboard, controlling the action.

"This one's balls look deformed, George, couldn't you have found someone who looks more normal?"

"His cock is big and that's all that matters in these things."

"That's right, it's only when you've got a little dick that you need to have a perfect body and face."

I couldn't keep track of who was talking, but it didn't really matter, the overall effect was what was important. I knew George from before today, but had only just met all the rest of the boys, except of course for Royal Flush, who'd somehow talked me into going in drag, and also Jordan, who was the boyfriend of one of George's friends and had been the boyfriend of someone I'd known at college. There were a few boys I'd been able to pin names to, but I had quickly forgotten most of them as soon as I was introduced. Half the boys seemed to know each other from before, although I couldn't tell if they were friends or just remembered each other from George's apartment last Wigstock. I saw at least two boys exchange phone numbers, and there was certainly a fair amount of cruising going on still, especially as guys took off certain articles of clothing to struggle into dresses.

I had my eye set on a boy named Nathan since the moment

he walked in. Right now, he was just sitting on the couch, watching it all happen around him, and there was something about the demure way he sat that really turned me on. That semi-overwhelmed look made him seem so wholesome, like a Midwestern tourist on his first visit to New York, and in some way it made him seem so young, even though I thought he was probably three or four years older than I was, maybe twenty-eight, twenty-nine. Which was a bit young for how I usually liked my men, when I wanted a relationship, but just fine for some hot and sweaty, guiltless sex.

Nathan was wearing a very slutty clubbing shirt, very East Village, an all white sequin crop top with a wide collar and a zipper down to his navel, but all very much a boy's cut. He wasn't planning on wearing a dress today, just a wig. Half the boys, it turned out, were just doing demi-drag, although they were having fun trying on various dresses while they were getting ready, and using it as an excuse to strut their stuff for each other. Nathan had found a little blonde bob, like Marilyn Monroe in *Some Like It Hot*, which suited him quite well.

I didn't know him, and I didn't know the couple he'd come here with, but as an excuse to start talking with him I took the bottle of orange nail polish that worked so fabulously with my equally-garish dress, sat down next to him on the couch and stared into his eyes while I asked him, fluttering my mascara-ed eyelashes and trying to sound forced-innocent as I held the bottle out to him, if he would do me.

He gave me the once over, unmistakably undressing me in his mind, having caught the obvious double entendre. I felt even more turned on than I usually did when I knew someone was checking me out, because I knew he was able to see the male me beneath the dress. And also because I knew my body was different because of the drag: I'd shaved. Chest, legs, armpits, all smooth flesh. Soon I'd have stubble all over my body, coarse and prickly, rubbing against the inside of my clothes, rubbing against other flesh. I tried to imagine how it would feel to run a tongue across my stubbly chest and nipples. This decision I'd made—to do drag for Wigstock with my friend—was going to

be with me for many weeks.

My friend, Miss Flush, was a swimmer, and had even taken a medal at the Gay Games last year. I remembered the stories she'd told me (her makeup was done now and she had her wig on, so her gender had changed over when we talked about her, same as mine had since I was also mostly done except for the nails and wig) about shaving down before the meets, how everyone was checking each other out as they shaved each others' nearly-naked bodies down, how it was all intensely erotic, male flesh everywhere, bulging out of tiny Speedos. The scene here was kind of like that, with everything serving to remind you that these bodies were so male underneath the makeup and the wigs, underneath the shaved chests and armpits and legs.

I'd never done drag before, except once during my freshman year in high school when I'd had to play Juliette in a skit we performed at a pep rally. As the youngest member of the track team, I was given the most humiliating part, and because I had that lanky young boy runner's frame I looked much more femme than any of the women, who were all rather square-shouldered and thick-calved from running with the team and working out for years.

"Sure," Nathan said, and took the bottle of polish from me.

The phone rang. George picked it up and said, "Salon."

I looked over my shoulder to watch the computer screen for a moment. They were picking strippers, and a not-especially attractive skinhead with a big dick was beating himself off on the black leather couch that Nathan and I were sitting on. I tried to imagine this apartment as the set of a porn shoot. One way to cut costs.

"Look at this," Eric was saying, "the leather guy just said he was twenty-five in the sound byte, but his statistics say he's twenty-nine."

"Can't we watch the guppie sequence again?" Bernie begged.

"Look at how long his nails are," Peter exclaimed, as the action moved in for a closeup of him fisting his meat just before

the cum shot.

I looked down at my own nails. Nathan was working on my third one, painting with even strokes from the moons towards the tip. I couldn't help glancing down past our cluster of fingers into his crotch, so near at hand, as it were, and looking oh so inviting.

"Flo has such lovely long fingers," Nathan said, lifting my hand for a moment to show everyone his handiwork at painting my nails, then replacing my hand on his knee. "I bet they'd feel great wrapped around a cock."

He didn't look up as he said this, but continued to paint the next nail. It was the same sort of machismo semi-porn talk we'd all been making all afternoon, so I didn't really think he meant for me to act on it. It was all bravado. But I wanted to take him up on it, so badly, and I wondered what he'd do if I called his bluff. He was flirting with me, I knew, which felt great since I was so unsure how I looked right then. I'm not usually much of an exhibitionist, but then, I wasn't usually wearing a dress; maybe there was something about already being so far out there, in terms of my appearance, that made me bolder than I normally would be.

"That can be easily arranged," I said, and with my free hand I unzipped his jeans. My fingers snaked into his fly and worked their way across his underwear, groping along his cock and balls. I could feel him began to stiffen under my touch, through the fabric. He was wearing white briefs of some sort, and I tugged at the elastic waistband to free his cock. I pulled it through the fly of his jeans, as it continued to swell within my hand, and began working my way up and down the shaft.

Around us, everyone was going about their business as usual. The phone rang and George answered it, "Futura Bold."

Simon declared, "Looks like we've lost two queens before we've even started."

But once they'd gotten a look at Nathan's prick they went back to their own preparations.

Except for Bernie.

Bernie was digging about in the cardboard box of wigs and

a moment later came striding over to us with a long blonde braid that was meant as an extension.

"I always knew you were a bottle job," Bernie told Nathan, as he wrapped the extension around Nathan's cock and balls, tying it off with a flourish and a bow. "There, now," he said, "crotch wig slash cock ring," and turned on his heels away from us. I was still pumping up and down on Nathan's cock as he painted a second coat on the nails of my left hand. His strokes were no longer as even as they had been, but he was trying.

"So, how do they feel?" I asked him, squeezing as I brought my hand down towards his balls.

"Good," he said, his voice cracking a little, unexpectedly, as his breath caught.

I smiled. "Good. Now, blow on these until they dry," I said, holding my hand in front of his face as if I intended for him to kiss it, "while I blow on this."

I slid off the couch and with my free hand pulled my dress under me as I crouched between his knees. He gripped my left wrist with both his hands, and his stiff cock jerked in anticipation. I wanted it down my throat, but I was going to tease him until his balls ached. I leaned forward and kissed the head, all lip, leaving the imprint of an orange lipstick crown.

The phone rang and George answered it "Helvetica Black," and at the same time the doorbell rang.

My heart began to pound within my chest as I realized I was having sex in public like this, in front of total strangers. With a total stranger, for that matter, although that didn't bother me. Not knowing the onlookers, however, especially not knowing who had just come in or how they would react, did disturb me. Sure, most of the guys weren't watching us all the time, and they weren't watching us with the intention of getting off from watching us, but they certainly looked over at us from time to time, curious if nothing else. I wondered what they were thinking. They hadn't exactly voiced their acceptance of Nathan and me having sex in front of them, but they hadn't withheld their consent either. The newcomers hadn't yet had a chance to withhold their consent. As my face hovered in front of Nathan's

eagerly twitching cock, I wondered what to do, how they would respond, and a zillion other hangups and concerns that held me frozen with indecision.

Then I remembered that for today I was a bitchy, irreverent drag queen and I opened my mouth. None of these queens would recognize me out of drag, anyway. My tongue met the warm, dry flesh of Nathan's cock and eagerly began bathing it in saliva, wetting it down for my now-orange lips to glide smoothly along the shaft. With my right hand, I grabbed the base of his cock and pulled it toward me, positioning it. My lips sunk lower, toward the blonde braid that Bernie had tied on. I rocked back and forth on my high heels, his cock sliding into and out of my mouth with the motion.

My own cock was throbbing insistently beneath my dress. With my right hand (I still didn't trust that the nails of my left were dry) I reached beneath the folds of fabric to grab hold of it, poking out from my loose boxer shorts. I began to jerk off, thrusting into my palm each time I rocked forward onto Nathan's cock.

My knees began to ache, and I stood up. My knees felt like I'd been doing squats at the gym for two hours solid. "Now, don't you move," I told Nathan. He twitched his cock. "Well, *you* can move," I conceded, pointing at it. I reached beside him on the couch for my clutch purse and opened it. I pulled out a condom. "A girl's got to be prepared," I said, and tore it open with my teeth.

Before I had a chance to roll it over Nathan's cock, however, Nathan had lifted up the skirt of my dress and tugged down my boxer shorts. He pulled me toward him, and his mouth closed about my dick as he eagerly shoved himself onto me.

"I told you not to move," I complained, although I didn't mean a word of it—I wanted him to move and keep moving, his mouth sliding up and down along my dick, his pointed tongue probing into the loose folds of my ballsac as my entire shaft was in his mouth, or swirling around the crown when he'd pulled back.

The couple who had come in when the doorbell rang—a towheaded blond and his dark-skinned Brazilian-looking

lover—were staring at us, curious and unbelieving and semi-uncomfortable by such blatant sexuality. They looked away when they noticed I'd seen them watching. I didn't care, let them watch. Not that they could see anything, anyway. My skirt had dropped over Nathan's head, so all they could see was the bobbing orange fabric. All I could see was bobbing orange fabric, too, but damned if it didn't feel fine.

Nathan pulled off my cock for air, and lay back against the couch as he caught his breath. One hand still held his own cock, which he'd been tugging on as he sucked me off. His dick was bright red, swollen from his desire and the "crotch wig slash cock ring." I delicately stepped out of my boxer shorts, which I only then realized were foolish things to be wearing when I knew I'd have to be in drag and would need to "tuck." The unrolled condom in my hand had begun to go dry, but I had a small bottle of lube in my clutch purse. "A girl's got to be prepared," I said again, as I knelt down in front of Nathan again, with the lube in one hand and the condom in the other.

I greased his dick and rolled the condom onto it. "Hold this," I said, and lifted my skirt. Nathan held the edge of the fabric for me, and I lubed my ass quickly, slicking my hole down for easy, painless access. I squirted some more lube onto his condomed cock for good measure, and then straddled him. He was still holding my skirt up, as if he were a voyeur peeking under my dress to see my genitals. That turned me on. Slowly, I lowered myself onto him, positioning his cock with my hands.

It is always a curious feeling, I think, to have a man's cock inside your body. No matter how much I want it, my body still resists, at least a little bit, something to overcome. I wrestled with myself—I want this cock inside me *now*—and tried to relax. He was in, but something still was not right yet. I shifted, I adjusted, I breathed deeply. His cock felt good in there, I felt good. I flexed my legs, lifting myself off him slightly, and then slid back down. I was in control. Nathan lay on the couch as I fucked myself on his cock, holding my skirt up so he could watch what was happening, the inches of his cock disappearing up my ass.

I felt I was getting near to coming as I rode his cock. I settled onto him and stopped for a moment, resting, delaying the moment of orgasm to draw out this delicious feeling of sex for as long as possible. We didn't move, but we changed roles. He took charge. I unzipped his sequined crop top. His stomach beneath was pale, with a small thatch of hair on his chest. The sides of the shirt fell back as his body shifted on the couch, thrusting his cock up into me. I tweaked his now-exposed nipples, but soon abandoned them to lift my dress. Again, I felt a delicious exhibitionistic thrill as I held the skirt of my dress aloft, it felt so dirty, like I was flashing him, and I think that feeling turned me on even more than the mere fact of our flesh sliding together.

I was bouncing up and down on his cock, holding the dress away from my cock, which flopped rhythmically against his abs. And then my cock spasmed and I was cumming, orgasm rolling through my entire body in quick shudders. Four of them, then a long sigh.

My cum shined on Nathan's chest like melted white sequins. His cock was still inside me, and once I caught my breath he continued to thrust up into me. I leaned forward and rolled his nipples between my fingers again, urging him on toward climax. Suddenly I tugged on them, hard. Nathan cried out, and began to cum. I clenched my ass, holding onto him tightly as his cock squirmed within me, shooting his cum into the condom's reservoir tip. When he lay still, pleasantly spent from his orgasm, I grabbed my purse, which lay beside him on the couch. His cock was still comfortably inside me, as it began to go soft. I took out my lipstick and, using the mirror in my compact, began to touch up my make up. When I was satisfied, I leaned forward and left a perfect lipstick mark above his right nipple.

Nathan smiled, dreamily, and started to sit up, to disentangle his body from mine, where we were still joined together under my skirt. I pushed him back down on the couch.

"Where do you think you're going?" I asked him, and handed him the bottle of orange glitter polish. "You've still got to take care of my other hand."

Men in Skirts

Jack Davis

I'M AT A SEX PARTY. I HAVE TAKEN A BREAK from cruising the hunky men and am lying on a platform in the middle of the room. I lift my camouflage skirt to jerk off when a shaved-head boy in a leather harness and a short black skirt appears at the side of the platform and starts to tug on my tits.

He's really good. I stroke my dick and he plays with my balls. I pull on my balls while he squeezes my dick and pulls on one of my tit rings. He lets saliva drip from his mouth onto my dick and slowly jacks me off. I lift his skirt and grab his ass, but mostly I get to receive.

I just lay back and let him play. He helps me slowly build to orgasm. When I come I make enough noise to be heard throughout the warehouse. My head hangs back over the edge of the platform. I look at the upside down men who are watching two men in skirts having sex and wonder—why are they all just watching? Why aren't they playing with each other?

I'M IN ARGENTINA AT A DRAG REVIEW. The medium-sized theater is packed. There is some familiar classical music playing, but I can't quite place it. The stage is flanked by two bare-breasted women draped in pearls. It looks very Art Deco. Two men enter in formal wear. With one movement they rip away their tuxedos to reveal very proper underwear: athletic undershirts, boxer shorts and garters holding up their socks. They strike muscle man poses. What is the name of this piece of music?

The star of the show enters. He's wearing four-inch heels, nylons, a garter belt, silk tap shorts and is naked from the waist up. He's in full make-up with a three-tiered red wig that looks like a Christmas tree. In the middle of the stage is a two-foot

high cube draped in cloth. He stands on the cube and begins a surreal interpretive dance. He is a transgender Isadora Duncan in high heels.

The women in pearls and the men in underwear have left the stage. The star tears off his wig. He is bald and bare-chested, but he is still a beautiful femme fatale. He dances gracefully over the entire stage and repeatedly drapes himself over the cube. I still can't place the music. I'm too distracted.

The queen is standing on the cube. He reaches down and pulls fabric up to his waist. He is now eight feet tall, bald and wearing no top, in a white skirt that reaches to the floor. It is at this moment that I know the music. It is the Ave Maria. He bends to grab a piece of blue fabric and places it on his head as a veil, then stretches out his hands. This drag queen is the Virgin Mary, the Mother of God. The mostly Catholic audience goes wild. They love it.

I'M CRUISING THE FOLSOM STREET FAIR wearing only my high black lace-up boots and my short camouflage skirt. I see this guy that I mostly see at street fairs. I don't remember his name. He's waiting in line for the Porta-Potty.

It's really hot out today. He's wearing just short black boots and a leather jock with his dick hanging out. As I walk toward him, I start to get hard.

I comment about the cops that are standing twenty feet away. He says that he likes exposing his dick and he particularly likes exposing his dick at this street fair. He suggests that the cops might even like seeing his dick hanging out. Then he reaches under my skirt and grabs my naked dick. I grab his. The guys in line behind us are joking about us jacking off each other in the street. The cops don't seem to mind.

Now it's this guy's turn for the portable toilet and he has to piss really bad, so we go into the tiny plastic building together. He takes off his jock and sits on the seat and starts talking dirty. I pull up the front of my skirt and tuck it into the waistband, so that he can suck my dick while he is pissing in the toilet. We're both almost naked. The guys who were behind us in line know

exactly what we're doing in here. It's really hot.

When he takes a breath from sucking my dick he's talking dirty again. He says that he likes the feel of my pierced dick on his tongue. He says he wants me to come in his mouth. I slap his face as I tell him, "No, it's not safe." I lean over and use my right hand on the back of his head to force his mouth onto my pierced tit. I jack my dick with my left. When I'm ready to come, I push him back and let my semen drip onto his pissing cock.

I HAVE JUST MET JIM AT A RADICAL FAERIE PARTY. Everyone is wearing skirts. He is in this butch denim number that reaches to the floor. His long curly black hair is arranged on top of his head with a pink plastic Minnie Mouse tied up in it. I am wearing something short as usual. I approach him from behind and start to play with his tits. Under his skirt he is wearing Munsingwear Kangaroo Pouch briefs that he refuses to let me remove. He will let me stick my hands into them but he won't let me pull them down. As I am leaving the party Jim approaches me with his phone number and asks me to call him so we can make a date to play some more.

The next time I see Jim is at a faerie gathering. He has just arrived and has joined a circle that is in progress. The day is hot enough to be naked. He is wearing only a hair tie around his pendulous dick and balls that are now free from their Kangaroo Pouch.

It is evening before I get a chance to talk with him. It has turned cool. We are both wearing skirts over our long underwear. When he says hello to me, I am not very civil. "You son of a bitch, you didn't return my calls. We were going to play."

"Well, when do you want to?" he responds.

"Now!" I say.

We move to the bonfire where several faeries are trying to keep warm. I stand behind Jim like I did at the party. He isn't wearing briefs now, he is wearing long johns with a drop seat. I lift the front of my skirt and the back of his. I undo the back flap of his underwear and discover that he is just the right height

for me to stick my hard dick between his legs. With my arms around him I discreetly fuck his thighs while watching the other faeries around the fire.

I'M AT THIS FAG NIGHTCLUB with my friend John. I've been here before; it's his first time. The music starts to get really good around 11:30, then fags take off their shirts and the dance floor gets crowded with sweaty barechested men. I know this club. I know this ritual. And no one except one of the gogo dancers is wearing a skirt tonight.

I push John into the bathroom and lock the door. I make him take off his clothes: his flannel shirt, his t-shirt, his baggy shorts and his boxers. I tie his long sleeve shirt around his waist like skate boys do. This covers his cute ass. I tie my shirt in front to cover his dick. Now he is wearing a skirt that is really two flannel shirts. I use my much larger body to push him against the cold concrete wall and kiss him as I twist his pierced nipple. "Give me your tongue, John," I say. I fight an urge to explore the place where his dick used to be pierced. Both of us have hard-ons as I lead him back onto the dance floor.

I know this place, I know this ritual. This mosh pit is a reinvented ritual that is centuries old. John is the only fag wearing a skirt. Fags dance this ritual with hands and chests and butts. They move as one organism. Because John is wearing a skirt he is pushed into the middle. There are hands on his tits, on his butt, on his dick.

Sure, this is a public space, but this is a fag space and these fags like boys who are naked under their skirts. Pants and shorts are slipping down over hips. Some boys are getting blow jobs in the middle of the dance floor. There are plenty of hard dicks to go around. The shirts have been removed from John's waist and are used to blindfold him and to bind his hands.

I know this place, I know this ritual. All it takes is one fag in a skirt to make it happen. John is lifted above our heads and is passed around the dance floor by dancers with pants around their ankles and dicks in boys' mouths. There are a few moments when it seems like we will drop him, but we don't.

It's hot in here. It feels like there isn't enough air to breathe in this room with a too-small dance floor. John is gently lowered to a standing position and unbound. We press in around him. More boys are on their knees. Now I can explore John's frenum piercing scar with my tongue. I know this club, I know this ritual. This is one of the ways that fags get high.

IT'S SKIRT SUNDAY, A DAY WHEN FAGS IN SKIRTS take the streets. Today we meet at Lynn's house in the Haight where we change from boy drag into our skirts. The object is not to pass for women, the object is to look like men in skirts. It is clear that we are confronting the male status quo. It is also quite clear that it is safer for us to do this in a group.

The skirts that we wear are many different types and lengths and colors, from the sedate and sensible grey wool that comes just below the knee to a bright orange mini skirt that barely covers butt and balls to a pink petticoat worn with cowboy boots. We leave the house and walk through the sacred ground of Buena Vista Park where secret sexual things happen between men at night. It is a pilgrimage through a holy site. As we reach the other side of the park we see two words scrawled on a concrete wall: "KILL FAGS." Someone whips out a marker that writes in gold and changes the L's to S's. We put on lipstick and leave pink lip prints around the words "KISS FAGS."

We walk down the hill to the Castro. As we pass an expensive little red sports car, its car alarm goes off. As we cross Market Street both poles of a Muni bus come off the overhead rails and one of them breaks. As we cross 17th Street, one car runs into another.

It's about wearing a skirt in public and having a dick and balls between your legs.

THIS SLAVE IS GROVELING ON THE SAWDUST FLOOR. He's wearing only a leather jacket and a heavy chain that goes between his legs and over one shoulder. I have my thick Vibram-soled boot on his dick pushing the chain into his crotch while I'm playing with my dick under my skirt. I can tell the slave really likes this

even though he's not talking loud enough for me to hear. I take my boot away from his dick and pull on the chain to make it dig into his butt crack, then I pinch his tits. I don't let him touch me or touch his own dick. I'm the one wearing the skirt. I'm the one in charge.

IT'S THE CLOSING NIGHT FOR THIS FAG NIGHTCLUB. The word is that tonight anything can happen. I have come late hoping that things have already started. I'm wearing sturdy boots and my long camouflage gauze skirt. The dance floor is crowded and the boys are hot and sweaty. In the early days of this club by this time of night there would be boys getting blow jobs on the edge of the dance floor. But tonight the only sexy thing that is happening is the gogo dancer on stage. He slowly rips off his underwear and throws it at one of the fags who is pretending not to watch.

I am on my way out when I see Sabrina, one of the performers I know, sitting on the edge of the stage. He is wearing a short sequined skirt and his face is painted like a stained glass window. I give him a kiss. It's very hot in here. We begin to make out right at the feet of the gogo dancer. I lick Sabrina's arm pit. He pulls up my skirt. I pull out his dick. He licks my face as he makes growling noises. We are making a show that is way sexier than the dancer's. I pull Sabrina's little skirt up and off over his head. Now he is wearing only boots and face makeup—that is, what is left of his makeup that hasn't smeared onto my face.

We stop our show at the edge of the gogo stage and Sabrina walks naked through the dance floor leading me by the hand, with my hard-on making a camouflage tent out of the front of my skirt. We go through the back room, outside and climb to the first landing of the back stairs. Sabrina sits on a step. I lift my skirt, put my right boot up on the railing and push my sweaty balls into his face and slowly stroke my dick while Sabrina plays with his.

As much as I like having sex while I'm wearing a skirt it's time to take it off. Now we are two naked fags wearing only

sturdy dance club boots jacking each other off on the very well lit back steps of a soon-to-close nightclub. While we are playing with each other's sweaty bodies in the cool evening air, I can hear conversations from the apartments close by. If somebody walks into that second floor bathroom, they could easily see me moaning and sucking on Sabrina's balls while I come. Sabrina says, "I want to jack off while I'm kissing you," as he stands over the pool of my come on the stairs. I gladly oblige him.

Later, with my skirt back on, I am in a state of post-orgasmic bliss as I walk back through the club across the dance floor. The lights are on. It is still hot in here. They are announcing that everyone has to leave unless they are sleeping with the help. This is the last night of the club. As I walk out into the cool air I think that if you expect a night to be a night where anything can happen, sometimes you have to make it happen yourself.

IT IS A GATHERING OF THE FAERIES in an urban forest. It is Queer Day and we have just flounced, marched, and paraded down Market Street. Now we are resting under the trees. There is cast-off drag scattered everywhere. The faerie with bleached blonde hair in the black skirt asks about the pink necktie. "What is it good for?" he asks. When I say that it's used for tying up people, he asks if that is an invitation, with a cute sort of mock innocence.

As I bind his hands I announce that he is now at the mercy of the faeries around him. Hands are on his thighs and playing with his tits. I pull up his skirt to make his shaved dick and balls accessible. When he complains that he can't use his hands, I put his pink polyester tied hands on the dick and balls of the naked faerie who is painted blue with the red and gold banner draped over his shoulders.

In this warm sunny place, in this city park, I am holding the blonde-haired faerie who is jerking off the blue-painted faerie who is playing with the tit of the faerie in the pink brocade skirt who is stroking the dick of the faerie who is lying with his head under the red petticoat of the faerie who hands me my water bottle because this one lube sample that some faerie picked up

earlier today isn't going very far among all of us and we need some water to make it multiply like the loaves and the fishes.

Now the blue faerie is jerking off the blonde faerie and making him moan while the rest of us assist. When the blonde faerie ejaculates, there is a pool of come on his belly. He says, "What should I do now?" A faerie next to me scoops up the come and places some on the foreheads of those of us around him. As he anoints each third eye he says, "This is a life force."

Kindred Spirits

Blake C. Aarens

THE MOON IS IN HER EVENING GLORY, GLOWING FULL and round, a
milky opal in the sky. In perfect rhythm with her phases, my
body sheds its monthly blood. I feel wild tonight. I cannot help
myself. I stop in the middle of College Avenue and howl, long
and low; the sound rumbles deep in my chest.

What was that? Somebody being cute, howling back at me.
Close. Real close. There. Over in the bushes just past the Chinese
restaurant.

*She sees me. How is it that this mortal can penetrate my ability to
conceal myself? And she is mortal. I can smell it on her. Just beneath
the musk and jasmine fragrance she wears, the scent of the grave, of
perpetual decay.*

He expects me to run. Yeah, right, and give him something
to chase? I don't think so. I'm just gonna stop. Stand here. Let
him know I know he's there. Watch him get that flustered look
they all get when you confront them.

*She is unafraid. I could take her in this moment. But something
within her prevents me. She wears some sort of psychic armor. There,
in a doeskin pouch between her breasts. A strategically placed talis-
man, it twitches with the beating of her heart, and keeps her safe from
me.*

He's staring at my heart, watching it beat. The heat of his eyes
is palpable. Makes me want to grab the satin cord and flip my
pouch of stones to my back, out of the way.

But wait a minute. Out of whose way? No. I will not remove
my charms. I will not unprotect myself.

*Her will is too strong; I cannot mesmerize her. Cannot manipulate
her into doing my bidding. Who and what is this creature? I step
forward and she squares her shoulders. Her eyes appraise me. The*

162

corners of her mouth begin to turn up. A sexual flush quickly upon her. I have never known such instant desire. Fear, yes, loathing, most definitely, but lust? Strange mortal indeed.

He's kinda cute for a white boy. A little too skinny, and he could definitely use some sun, but nice and tall with a thick head of hair. Jet black. Natural, not that shitty dye job so many of the kids are wearing. And this one's no kid, but a man, with wrinkles around his eyes and a few strands of gray. And wearing a black leather jacket—ooh baby, where's the motorcycle?

She throws her head back and howls again. Her throat upraised to me. The flawless brown expanse of her skin dotted by a single mole right over her carotid artery, as if marking the spot. She stares me full in the face, daring me on this public, suburban street to answer her howl with my own. I howl back at her without breaking our gaze. Her pulse accelerates. She licks her lips. I tell her she's a wild one.

I say to him, I don't resist my mother's pull, and watch him cock his head toward my voice. He lets the sound hit him and a little shudder of pleasure passes through his body. I make a point to drop it even lower the next time I speak.

Will you have a drink with me?

I feel him ask the question before he even opens his mouth. A caress of words. In my ears; in my mind. I know just where I'll take him, too. The Lobby, I say over my shoulder as I turn without another look at him—though I'd like one—and walk towards that bar with its deep couches and lush music and dim lights.

She doesn't wait to see if I am following her. This dark and lovely mortal stirs my blood—what little I possess having not yet drunk this night.

I can feel his eyes on me, traveling slowly down my body. Well, let him look.

Short hair. A crop of wild, unruly curls. What ecstasy just to run my hands through its texture. Ah, this mortal! A lovely neck. Broad shoulders. A fine, strong back, firm ass encased in jeans—black women do such wonderful things to denim—and strongly muscled legs that carry her firmly on this earth. Surely, she has some magic about her to have me appraising her as a mortal man would, and not as the food

she is. She steps into the dimly lit bar and reclines on the couch. She stares at me—open-eyed and unafraid.

His skin is so white. Not peach, or buff, or even ecru, but a dense, translucent alabaster—the kind of complexion Victorian ladies would have killed for. He'd probably burst into flames if the sun tried to kiss some color into those sculpted cheekbones. He sits opposite me with that slightly dumbstruck look still on his face. Maybe I'm the first black woman he's ever been attracted to. But is he attracted? Even I'm not sure what's going on here.

If I were made of weaker stuff, I might flinch under her scrutiny. That slow smile again. Signaling delight. At what, though? I ask her to explain that smile of hers.

He wants me to say it. To tell him how handsome he is. How much I like looking at him.

Her eyes wander over my body. She likes being the one to reset the boundaries a little closer to my skin.

I like his meeting of my gaze. One minute his eyes say he'd like to touch me long and slow, the next minute I think he means to eat me alive.

More true than she could possibly know. She seems altogether her own person—more attractive to me to possess, to feel that strong, brave heart thudding and slowing and finally, in the last, leaving mine to beat all the more strongly for having taken it.

He's smiling with his mouth closed. Full, pink lips that look like he's been kissing forever. And violet eyes that he keeps letting travel over my body like he's testing out an unfamiliar route. Won't let me look in 'em for too long though. Not like he's hiding something, more like he's shielding me from them. Humph. I don't think I come off as the kind who'd wither with a look, but they tell themselves all kinds of crazy things about women they encounter so they can feel in control.

He tells me his name is Gannon, but his lips don't move. I have never experienced such psychic rapport. In all my longing to connect with a spirit as wild and free as my own, it terrifies me to think he might be sitting across the table from me. I'm afraid of my own openness.

I've frightened her. She sends me away. On an errand. To get her a drink. A glass of red wine. Preferably merlot.

I watch him move his body, unfolding his legs to their long length, side-stepping the corner of the couch, trailing a hand along the arm of it as he heads for the bar. The man likes to touch things. He comes back with a single glass.

She raises an eyebrow at my lack of beverage. Careful so as not to frighten her further, I hand her the glass without touching her with my icy fingers. She drinks. She closes her eyes as her mouth fills with the smoky red liquid. Murmurs in her throat as the wine slides down. A sister sensualist. This is driving me wild with hunger, and a desire I haven't known in quite some time. But for the protective pouch she wears, I doubt I could keep myself from her throat.

He watches me like a man longing for the sensation of drinking rather than the drink itself. I hold out the glass to him, but he doesn't take it. I shrug my shoulders and smile. I take another drink and play to his pleasure in watching me.

All I can think about in this moment is how exquisite it would be to watch those perfect teeth of hers fasten on a throat, their white surface stained red as the wine she's sipping.

Just when I thought I was boring him, he fixes on my mouth with such keen interest I have the impulse to play the coquette and cover my lips with my hand.

I ask her if she is married. She raises both hands—her palms toward her face—and wiggles her fingers at me. They are ringless.

He tells me he was married. Once. A very long time ago. He makes it sound like ancient history. Like he's still trying to forget a painful divorce.

I want her. Here. Now. Bent over this low, sturdy table that separates us. Her throat open to me. And her future. Her blood, mine for the drinking.

And I want more. Her. To drink. From me.

He wants to tell me something important, but I have to ask for the information, and be willing to take responsibility for what he tells me. How do I know all of this? Ahh. With a whisper into my brain, he tells me.

She says she is willing. Says that she wants to know. She speaks

with a strong voice, but not without some uncertainty. Her aura is a confused swirl of colors—orange, changing into a deep rose red, bleeding into green, then becoming a dark blue. I wait. I can. Finally, the deep rose red returns. She asks, in a clear, unfaltering voice, How long ago did your marriage end?

I heard him say it. I did. He said, One hundred and twenty-seven years ago. I heard him say it.

There is no one but the two of us in this moment. I can feel the fierce intelligence behind those deep brown eyes. Can taste the inhale-pause-exhale of her breath.

But then the squawk of a police radio intrudes. Two uniformed officers enter the bar and take cursory note of its occupants. I make sure they do not perceive me. She reaches across the table and places her hand on mine. She does not flinch from the cold she encounters there.

I understand who he is now. What he is. I watch him obscure himself when the cops enter. I touch him to let him know it is unnecessary. His hand is cold and dry, the skin soft and nearly unlined. When the police exit, I pull a little on his fingers to draw his attention back to me. I ask him to smile for me.

He no longer shields me from his eyes. At first the power in them threatens to overwhelm me, but I take the current into my body and feel myself grow steady. I meet his gaze. Match it. He curls his lips back from his teeth and I see them. The elongated canines. Sharp and glowing bright white in the light from a street lamp through the window. The sight sends a thrill through my body. My pulse pounds in my temples, in my chest, between my legs.

I can see every vein in her body. Every artery. The sight makes my mouth water, makes my teeth ache in my jaw. I turn my hand over and her fingers rest lightly in my palm, her blood pulsing in their tips. I ask her if she is ready to come with me.

She nods, stands, makes to move toward the door. But then she grabs the wine glass by its stem. Half way to her mouth, she changes her mind and sets it back on the table, leaving the wine unfinished.

We walk out of The Lobby side-by-side. Around the corner to a big, no-name motorcycle. Looks like he put it together

himself from spare parts. Except for the red velvet seat cushions, nothing but polished chrome. He motions for me to mount first. Then he climbs on. But before he can start the bike, I grab his throat and bend his head back to me. I kiss him. Slowly. Chewing on his mouth, licking the corners, pressing my tongue against the points of his teeth.

She kisses with her laughing eyes wide open. She puts her fingers in my mouth. I plant my feet to steady me as I straddle the motorcycle. I reach up and back to grip her by the shoulders. I want this kiss to last forever. But she pulls away. She bites me on the neck and whispers into my ear, Drive. I do as I am told.

I flatten my breasts against the broad expanse of Gannon's back. I close my eyes and inhale, reveling in the rich, oily smell of his leather jacket. The slow rumble of that big bike vibrates the cheeks of my ass apart. I'm gonna walk bow-legged for days afterward. For nights afterward.

He takes me to the summit of Mt. Diablo, high above the Bay and all its bridges. The lucent moon is only just out of my reach. He asks me if I am afraid as we stand together in her glow. I grin at him and say, No, I'm not afraid; I'm thirsty. He closes his eyes and nearly swoons. I grab his hand to steady him.

I have never held the hunger this long within my body and I am weak with need. I look down at our intertwined fingers. My pale ones and her dark. I feel the steady beat in the base of her thumb. I release her fingers and run my own thumb across the long, parallel scars on the inside of her right wrist. I feel the tiny bumps left by the needle that was used to stitch them closed. Touching her there, my mindstream is nearly flooded by her memories of the pain that brought on these self-inflicted wounds.

He stares at me as if he does not remember why we have come here. When I ask him why he hesitates, he tells me that it has been several days since he last fed, and he's hungry. Holding his gaze, I remove the pouch from around my neck. I fling it away from me and listen to it tumble down the hill. Then eat me, I say, drink me.

She unzips her jeans and steps out of them. Her underwear too. She reaches between her legs and removes the rubber cup that catches her

menstrual blood. It is full to the brim. My nostrils flare at the smell of it. I tip my head back and she feeds me.

He licks the cup clean with a surprisingly pointed tongue. He tosses the cup over the cliff to follow my pouch of stones. He kneels before me, grabs my hips, and buries his face between my thighs. I tangle my fingers in his hair, bend my head back, and press him toward me. I feel the sharp teeth on either side of my clitoris. The puncturing of my most tender skin. The pain is almost unbearable. And then there is his sucking. Gannon. Sucking. Pulling me slowly, steadily toward an abyss that I would run to, leap from. I am falling.

Mmmm. Feeding. On the blood of life itself. And of death. Her breathing grows more and more shallow. Her hand untangles from my hair; her arm falls limp near my face. I pull away from her then. My eyes burn in my skull and I lick her blood from the corners of my mouth. I stare up at her. Her eyes are closed. She is barely breathing. I shake her. Call her name. Her eyelids flutter but do not open. I pull her down into my arms.

The lasts beats of my pulse throb between my legs. I hear him calling to me, a whisper above the raging wind that accompanies my descent. With effort, I open my eyes. I have no strength to hold up my own head. All that I have I use to keep my eyes open and fixed on him.

He unbuttons his fly. He withdraws his penis. It is hard and thick. Uncircumcised. A milk white pole. He pulls the foreskin back and the dark pink head pokes free. With the sharp points of his long fingernails, he scores the length of his cock. A strangled growl leaves his throat. The blood rushes forth. My blood. His blood. Our blood. He cradles me in his arms, grips my hips, and lifts me up. He lowers me onto his erection and I envelop it all, take him into the depths of me.

Warm. Moist. Pulsing still with life. Contracting. Her nether lips feeding on me, seeking to drain me as I have drained her. I have more to give her. So much more.

He claws another wound into his own throat. I press my mouth against it. He rides me. I suck at him. We urge each other onward. Upward. Forward.

I taste the essence of all that I have been. I sprout luminous black wings and begin to soar. He joins me in the air above the cliff, diving deep and circling, hovering just below the orb of the moon.

She has an appetite to rival my own.

I come. Trembling. Screaming. Crying. The little death preceeding the final one.

I give her all the tomorrows she could ever want.

"There. And there. And there," he growls at me. "Take it. Take my blood." He comes inside me. I clench my muscles to draw every drop of it deep into my belly. It takes a long time for the bucking of our hips to slow, then stop. I climb off of him and feel the wet run down my leg. He traces a finger up my inner thigh; he sucks on that finger. I grin and strip the rest of my clothes off to stand naked in the last moments of true darkness. I walk over to him and begin to complete his undressing.

She wants me naked as well. Wants to have her cooling flesh against my cold. Wants me to hold her while she dies.

He nods in agreement. Just before the sun begins to rise, we hide our clothing and burrow into the earth.

The Dragon Means

M. Christian

HER TATTOO: A CROSS-BREED, INTERNATIONAL DRAGON that crawls hungrily around her arm, Chinese feet digging into the folds and wrinkles already there, Celtic glyphs like shadows cast on its skin. It's alive, this dragon: familiar or curse, it's hard to say.

THE MICRO-DYKE (her name in the real world was Sarah) bled: black blood from the nimble scalpel of the Baroness (Betty beyond the playroom walls) trickled down into a deep burgundy catch-all towel. Casually, for such was the routine in the dim dark of the Pit—pop-eyed equaling rude—Demi's eyes skimmed over the scene. It was a quiet night, a routine night in the dungeon: the colors matte black, the smells dim and musky. Occasionally, a glimmer of stainless, a flicker of chrome. A cry, a moan, a scream, bounced off the thick walls. Run-of-the-mill. A too-many party weekend. The energy was unfocused and indirect. A cold spot formed in a corner; the people there talking house painting and parking problems. No one seemed to mind the chill.

That kind of party, the energy bedrock low, but still there were screams and moans and flesh and the smells of burning sex. There were a lot of faces that meant something to her, that spelled recognition, so when the narrow, spider fingers reached from around and under her shredded tee she didn't complain, didn't shrug and glare. The thumbs and forefingers pinched and her nipples ached to tautness. Legs locked together, squeezing her cunt tight, she ran fingers over the fingers over her breasts. They were muscular spiders, and knew their job. A squeeze there, a pinch, the roll of a nipple, a tug—first down then

upward: her breasts suspended by her nipples, hung like heavy bells. Demi felt them as names—the usual suspects—trickled through her head (Sally? Doi? Paula? Cougar?). It wasn't a comprehensive inventory, as her head was addled with the vivid impressions of steamy lesbo sex. Her concentration failed completely when one hand let go of one tit (the left, if you must know) and, with unabashed and screaming lust, started kneading her jean-encased cunt.

A head came from behind, and below, arching towards a breast that'd managed to pop free of Demi's tee: hair the color of tar on asphalt, rows of knotted rope, spiced by bone beads and the chiming of bells. Through a fog of rampaging lust the inventory came up snake-eyes. She didn't know any black women.

She had a beauty that stopped things: conversations, cars, thoughts, the tracking of eyes. Everything, it seemed, in the Pit, had to stop and stare at her as she stepped out from behind Demi.

Demi wasn't invisible, she knew—she could stop a conversation or two if she tried, get a whistle from a gang of girls, but she felt knock-kneed and buck-toothed next to her, the heart-stopper, the breath-taker.

The woman smiled and Demi felt invisible fingers race up and down her spine. Goose-bumps shimmered over her body and the Pit; the steaming dyke bathhouse seemed chill, cold.

With a movement part ballet, part geisha, the dark-side beauty parted Demi's tee and slipped short, unpainted nails under the sweaty underside of her right breast. Her face was like polished wood—deep and rich. Lips like a cunt's. Eyes like whorls in exotic wood.

Impossibly, the woman smiled wider and the brilliance of it seemed to hit the room like a lightning flash. With it, Demi's chills vanished and the Pit seemed like its name, central heating straight from a desert hell.

Dark dropped then, hovering full lips inches from Demi's right nipple, painting it with her hot breath. The restraint, the power of her slow and sedate movements roared the bonfire in

Demi's pants. Her legs were weak and she had to force herself to breathe slow and steady: good S/M dykes don't swoon on the playfloor....

Demi didn't know her. Had never seen her before. But she knew how to suck tit, though.

First a kiss, then a gentle lick (sudden wet chill on burning nipple) then a more passionate kiss, then a very passionate suck. As her lips drew, her fingers pulled. It was an easy tug, her hand cupping and pulling Demi's tit—a milking with her lips working her nipple. She did this for too long—like how it took her too long to actually touch Demi, too long to actually suck her nipple.

Then she stopped. The stop was a slap—a ringing blow to Demi's cheek. Then it was quiet. A pin dropped (from the piercing scene in an opposite corner). Demi didn't like to get hit there...normally. This woman, though, this woman had her by her steaming self. Scared, Demi realized with a shock second only to the slap itself, that she would let this bitch do almost anything to her. Almost anything. It scared her, yes (shivers and shakes and the Pit seemed chill again), but also turned her cunt lips to melting butter and her knees to jelly.

Demi wasn't surprised to feel she wasn't alone in her pants. Without even an "excuse me" dark fingers forced their way between jeans and Demi's gentle tummy.

"Hands behind your head, bitch. Assume the position." Voice like summer thunder, a late night storm.

Dark snapped her around and forced her, and her quivering legs, against one of the playroom walls. Demi was a drooler, so soon the wall was wet—and it wasn't the only thing. Her ass was cool and her cunt was hot.

"Hang on, bitch." Brass and horns, big drums.

Jeans around ankles, panties down and sticking to her legs, ass up and way out, she felt dark fingers (slick with latex and juice) trace her cunt. She felt herself splash like rain on her thighs as fingers parted her lips and explored her burning heart (where it was, at least, that night). One finger, two fingers, three—fisting wasn't this powerful, this angry, this driving but that night,

that night—four, five. In. All the way in. An elephant with gold fingernail polish humped her from behind while a midnight Amazon hand snaked around and started jerking on her tits and screamed pure lust into her hungry ear.

Her coming caved in her legs and dropped her, a stringless puppet, to her knees and then to the playroom floor. Panting, heaving, what remained of her white tee bunched around her neck, she turned back and behind to see Amazonia, her Dark. And while she wiped the drool from her chin, neck, and chest on the back of her hand she heard her Dark say to another, a narrow riot grrrl with blue hair and jewelry sprayed all over her face:

"Boring party tonight."

"Yeah."

"So let's blow."

"Yeah, boring; let's blow."

They left together, not even a coin, or a "nice" tossed over their shoulders, leaving Demi just a spent tissue on the floor. Demi didn't like "down" games, didn't like being less—and she sure as hell didn't like it after that night, in the Pit.

THE DRAGON TATTOO SAYS: *I'm the only strong thing that's going to be with you forever.*

Good Humored

Simon Sheppard

I'D JUST ABOUT FINISHED CLEANING OUT the house I'd grown up in when I heard the bell of the ice cream truck. At first I thought I'd imagined it; my father's death had left me emotionally vulnerable, and being in the old house had turned me into a nostalgic wreck.

But there it was again, that familiar sound from my childhood. I was mildly amazed that there *were* ice cream trucks anymore, even in the white-middle-class suburbs of my youth. Andy. Andy the Ice Cream Man, that was his name, the guy in white who'd driven the truck. Funny how I could remember his name after thirty years, remember it better than the names of people I'd met last month. Maybe that's because, though I hadn't understood it at the time, my very first crush had been a crush on Andy. He seemed very grown-up then, though he probably was no more than twenty-five. And handsome. And strong. Thick, hairy forearms against a summer-weight white shirt.

Even then I realized he was a bit slow-witted, but he always was nice to me. "Howdy, Champ," he'd say to me as I ran out to his truck. "The usual?" And he'd reach into the freezer compartment of his big white truck and pull out my favorite, The Sundae-On-A-Stick, a chunk of vanilla ice cream wrapped around a gooey caramel filling, coated with a thick chocolate shell and dusted with a coating of chopped peanuts. All that on a stick, and all that for just a quarter. And the wink Andy gave me when he handed me the ice cream always made me feel kinda...gooey inside.

It wasn't till I thought I was too old for Sundaes-On-A-Stick that I'd realized what was what. It happened at the locker room

174

of the public swimming pool. One afternoon I was changing into my trunks when Andy walked out of the showers, big dick swinging. He took one look at me and winked and grabbed at his crotch. *What a half-wit,* I thought. But I could feel a hot blush rising to my cheeks. And I could feel my own dick getting hard. So I got out of there quick as I could, blood roaring in my ears.

That fall I went off to college. I never saw Andy the Ice Cream Man again.

And now I was back in the room I'd grown up in, and from the window I could see that familiar white truck coming slowly up the tree-shaded street. Couldn't be Andy in that truck, not after thirty years, but maybe the ice cream was as good as I remembered. So few things turn out to be as good as you remember, but it was worth a quarter to find out. Or, more likely, a buck-seventy-five.

The truck came to a stop as I approached. The driver started to open the door. I gasped.

"Andy?"

"Yeah. Who're you?"

"You used to call me Champ."

"I call all the boys Champ." I guess he saw my disappointment. He added, "All the boys I like, I mean." Somewhere in his fifties, he was still good-looking. Heavier, but then most of us are. I found myself staring at the crotch of his white pants. Nice basket.

"What'll you have?"

I took a deep breath. "You still have Sundaes-On-A-Stick?"

"Sure, what flavor?"

"It comes in flavors now?"

"Vanilla, chocolate-chip cookie dough, or cappuccino crunch?" His eyes were asking more than that.

"Vanilla. How much do I owe you?"

"Why don't we go in your house?"

"What?"

"I remember you, y'know." And he said my name. "You're the one who got a boner in the locker room."

And suddenly I was getting another one, standing there with

my Sundae-On-A-Stick.

I was leaning up against the wall of my old bedroom. Cowboys and Indians wallpaper. A pile of ancient *Popular Science* magazines my father had inexplicably saved. I peeled the wrapper from the ice cream bar as Andy went down on his knees. I took a bite. Andy opened my fly. I took another bite. It tasted just like my memories. He pulled out my dick. Andy the Ice Cream Man started slurping away at my cock. With my free hand I reached down to unbutton his shirt. His mouth came off my dick.

"You want to suck me, too?"

"Yeah," I said, my mouth full of caramel filling.

Within moments we both were sprawled on the familiar carpet, clothing seriously awry. Andy's dick was as big as I remembered. Bigger. I took a bite of the ice cream bar, then slid my mouth down on his cock. He gasped and grabbed the Sundae-On-A-Stick from my hand. A cold, sticky shock hit my dick, followed by Andy's warm mouth. There was melting ice cream everywhere now. On my chest. On my thighs. On his hand, which was stroking my face. I grabbed hold of what was left of the bar and smeared it all over his chest, down the dense ribbon of belly hair, rubbed it into his salt-and-pepper bush. He shivered and giggled. And I licked the sweetness from his tasty body, stopping to chew on a nipple, finally landing on his sticky dick. Then I sucked him off and he sucked me off and just before we shot our loads we took our mouths away and came all over each other's bodies until we lay, exhausted and smiling, in a puddle of chocolate, vanilla, and cum.

"See? I did, I remembered you." He grinned. The grin of a half-wit or a saint. Or a man who used to sell me ice cream. "I remembered you." Were those tears in his bleary brown eyes? "I remembered you, Champ." And he winked.

Sophie's Smoke

Mark Stuertz

IT WAS MY FATHER WHO BROUGHT ME TO IT. Sophie took it to another place, a deep place.

When I was young I could take the strength of the clouds and hold them, feel how they pricked and burned. "Where do they come from?" I asked him.

"They're grown. They're made of leaves." My father had little patience for questions. But for this he made an exception. "You see the leaf?" He held it in front of my eyes and ran his finger along the veins hidden in the leathery tan wrapper.

"What about the inside?"

"The same," he said. "It's rolled tight, squeezed together, then cut." He sat in his leather chair with a book next to the all-in-one lamp and end table. I was next to him on the floor, sitting Indian-style. My mother was in a chair to his left. She thumbed through magazines. She didn't mind it. Seeing him there, putting it quietly between his lips, taking in the smoke, letting it out. It brought her some peace. It gave his breath form and was there for all of us to see.

It was loud when he struck the match; a screaming hiss. He used large kitchen matches, never the books they gave him at the tobacco shop. "More sulphur on the head. A bigger, hotter flame. The tip has to have an even light," he said. The first cloud was the most aromatic. The tobacco was fresh, more vaporized than burned, and it mixed with the sulphur and wood from the match. It opened the senses like the first cold wind in the fall.

I was fourteen when my father gave me my first cigar. He taught me how to hold it, how to clip the butt, how to strike the match, always a large wooden match, and how to pull in the flame. He taught me how to smoke it: how to puff, then wait,

177

then puff again.

"Don't puff too hard," he said. "Hold it away from your face after you take it in. Let it breathe and cool. You never want it to overheat. And it never hurts to look at it after you take it out of your mouth.

SOPHIE IS TALL. HER HAIR FALLS STRAIGHT to her shoulder and folds under like a dried out leaf, a rich brown one. Tiny freckles speckle her skin like bits of ash fallen from the sky signalling some distant inferno.

"Do you mind?" I ask.

"I love the box," she says. "Cedar is a smell I wish I could drink."

I open it and pull one from the bottom row. I slip off the red and gold ring. She holds her thumb in front of my lips. The ring goes over her thumb easy. She kisses it. "You'll need some help with the match. I can see the tip better than you." Her smile is like the stretch of elastic.

I bite the butt and flick a wet brown wrapper speck to the floor with a spit of air. She likes this crassness. I put it in my mouth, taking in the cool freshness before the burn.

She picks up the box matches. I hear the cardboard scratch as she slides it open. She pulls one from the box. "These are gold," she says. "You can get them with colored heads?"

"Strike it," I say. "My mouth is watering. I'm soaking it."

"Some day, I'm going to poison you." She says this slowly while she strikes the match. The sulfur bursts into a fizz as "poison" leaves her lips. She brings the flame to the end and holds it. "Make the clouds big, big enough for me to hide myself naked."

I suck in her flame with my eyes closed, drawing it gently, firmly. My puffing thickens the air with grey. She pulls the match away from the tip of the cigar and douses it in a sizzle on the flat of her tongue.

"You're crazy enough to poison me," I say. She holds her hands in the clouds and pulls the grey smoke to her face where she sucks some of it in. I take her head from behind and press

it hard into my chest, puffing above the top of her head.

She twists her head so that her mouth is close to my ear. "Play with it," she says. "Get it going. Then pull it from your mouth and show me the wet part, the part you soaked."

I DO PRETTY WELL FOR MYSELF. I know how to make deals, size up situations, maximize opportunities. I'm making enough money for a cushion on my cushion. "It's like a museum," he said. "Why do you want a museum in your house?"

My humidor is small, a bit larger than a phone booth. I had it built out of a useless coat closet. I had a carpenter do it. Work was slow for him so I made him an offer we could both live with. He installed the compressor, the fans, the lights and the glass door. He wired the whole thing together, but probably not to code. The shelves are oak.

I stocked it carefully and I have some prizes in it. There are the Cubans: the Romeo y Julieta and Hoyo de Monterrey Churchills, the Davidoff Chateau Margaux and the 4000's. I have the Partagas #2's and the #10's from the Dominican Republic, and the Honduran Aliados Valentinos.

"Pick one," I said.

"Sure, it smells good, but why in your house?"

"It keeps them fresh. I can age them."

"Age them?"

I brought my father to see it when it was finished, completely stocked. I wanted him to have the first one, to christen it in a sense. But he didn't understand the purpose, what it was I wanted.

"Listen," he said. "This is what it's about. You find one you like. You shop for it like a car. You go to the tobacco shop and go into the room and smell them all together. Then you look, pick them up, feel the weight, how they hold. Get a half a dozen this way. You might have one with the clerk before you bring the rest home.

"Try each one, live with the damn thing in your own living room. Then you go back and get a box or two of the best of the six. When you're getting low, you go back and do the whole

thing all over again. But this, this is hoarding. You expecting a war?"

We had our smoke. The room had its christening. But it wasn't how had I imagined it. We talked a little. I didn't ask too many questions. He enjoyed the smoke, I could see that without asking. Through the smoke, through the talk and the non-talk, I could see some of his way.

Eight months after that he died of an aneurism in the aorta. I went through his things with my mother and found a box and a half in his sock drawer. They weren't expensive, but they were good. I don't remember what they were. I took them along with his watch and some cuff links. The boxes are on the top shelf in my humidor, behind the Davidoffs.

SOPHIE IS DARK AND SMOOTH, like a fresh sable brush. I whisk the back of my hand over her face, draw her to my chest, close my eyes and hum low enough so that she can't hear, only feel. She turns her head up and drives her lips into my throat. "I want you to smoke for me," she says.

"For you?"

"You don't know what it does to me." She doesn't say this in a teasing way. She wants me to know of the mystery of the smoke and how it works her.

"We should go to the humidor. I'll let you choose," I say.

Sophie is like a stab wound for the good, one that draws off dangerous fluids. She moves at me brutally from all sides, looking for the fundamentals. She cuts to those dark, unexpected spaces that bring the pain you would never bring upon yourself, even if you knew it was good for you. But once it's there, you revel in it.

Sophie opens the boxes, touching each cigar, lifting them from their rows. She holds them under her nose and takes deep breaths, rolling them in her fingers, rubbing them on her cheeks. She kisses one, imprinting the leaf with lipstick.

One stops her cold, drawing off her attention from the others. "This one," she says, "is remarkable." It's a Cuban. The band is gone, so I'm not sure exactly what it is. But I see it's a chocolate

brown Colorado. This much I know. She holds it in both hands: the tip in her right, the butt in her left, each end pinched between her fingers.

"Look at the shape," she says. She lifts it to her eyes and stares it down like it's a string of diamonds. "The end looks like a nipple," she says. "And the butt is tapered, like a cock with the foreskin still attached." Her eyes widen when she says this. She closes them and passes it under her nose.

MY FATHER NEVER SMOKED CUBANS. He thought the embargo was a worthy thing, more worthy than enjoying the best smoke in the world. He never said much about my Cubans or how I got them. He would refuse my offers to try one with a quick wave.

"I don't want to put any change in Fidel's pocket," he would say. "Let him and his revolutionaries drive their '50s Calves and smoke their cigars until they drop. But they won't get any working change from me."

I would light one of mine and he would smile, peeling the cellophane from a cheap Jamaican. "You think I don't know," he said. "You think your old man doesn't know as much as you. Well let me tell you, before you were born, before the Bay of Pigs, I got them by the box. I still remember too, the thick flavors and the spice; going down to shop for them like you would a pound of pork chops. Now you have to take a vacation and smuggle them back, or find a way to smuggle them in without having to trouble with a 'vacation'." He said "vacation" with a sneer. "Does getting them this way make it smoke better?"

"You know Kennedy picked up thousands of them before he put the embargo in place," I said.

"That's just like a politician. Make rules for everybody else and exempt yourself. But I still think it was the right thing to do, you know."

SOPHIE ASKS ME TO KISS HER HAIR. I fill my hands with it and bring it to my face. I smell the soap and the sweat through the strands. I kiss her scalp while she fills herself with the smell of the Cuban. "The wrap, look at the wrap," she says. "The veins are thick and

they're sprawled over the length of it in branch after branch after branch. It's like the purple veins that weave through a cock."

She asks me to kiss her ears, then her neck. Her smell is crisp and sharp. I drill my tongue into her ear holes and move down her neck. A chill rolls through her. I seal my mouth over a patch of her skin at the base of her neck and let a flow of fresh saliva warm her there. The Cuban is under her nose the whole time.

I pull her sweater back and kiss her shoulders, long hard kisses so that I can feel her bones in my mouth. I stretch the sweater collar, pulling the shape out of it. She licks the tapered butt of the Cuban. My mouth floods, like it does at the first bite of a lemon. I slip my tongue under the straps of her bra.

She asks me to lift her arms and lick the sweat from her pits. "I don't use anything. I'm all that you'll taste," she says.

She is rich and strong, like dried apricots. I lick and take in all I can from the delicate, prickly pit skin. She shivers and from this I know I've reached her. I lick until the taste fades, and then move to her other arm. She growls. The sound comes from her chest. I move back to her throat and suck on her larynx as she hums. She rubs the Cuban against her cheek.

"Please."

"Sophie."

"Smoke." Everything she says will be all breath now.

I'm hard. I feel myself grow, turn sticky with sweat, the drops of liquid pushing from me. Sophie pulls away and leaves the humidor. She has the Cuban in her fingers, pinching it at the part she said was like foreskin. I follow her. She drops to the floor and stretches her legs out straight in front of her, pulling her skirt up along her thighs, rolling it to her hips. Her green panties darken with a spreading patch of moisture. She pinches the elastic edge and slides them down her legs, pulling her right leg out of them, leaving them dangling from her left ankle. She folds her legs into her body, spreading them out from her hips, poking the carpet with the sharp, thin heels of her shoes. The space between her thighs bristles in its fullness, glittering with sex salve.

"Please, sit down," she says. "Hold me. Let me help you with

this."

She holds her hands out to me and I clutch them, dropping to my knees. My prick drains heavily. The head of it sticks to the fabric of my briefs. I squeeze her calves and draw her legs further apart, exposing more of her thickness to air. The salty seaweed smell mingles with the spice of the Cuban tobaccos. Her soaked pubic hair shimmers like a fruit glaze. She brings the Cuban between her legs and parts the lips, swollen and full, with the tapered butt, the uncircumcised tobacco cock. She twists it there slowly, working it like a drill bit, pushing the folds away from their center, pressing it into her body. Her lips encase it, soaking the leaf wrapper.

She moans and raises her ass from the floor, working the Cuban deeper. With her eyes closed, she rolls her head from side to side. Her pussy drools generously, dribbling down the scrunched inner cheeks of her ass in thick, yellowish trails, spotting the carpet. The chocolate wrap of the Cuban blackens, drinking her in.

I can see how she works her pussy muscles, squeezing the cigar into her body. I feel the muscles in her calves tighten and relax erratically, like jolts of car battery juice shooting through her.

She moves like this until she has the Cuban completely hidden in her body. The narrow nipple cigar tip pokes past her lips like a second clit. With her head snapped back, she rattles in her throat. I watch how her wet turns to tobacco spit and I hear locomotive roar in my ears.

Then she stops. She raises her head and opens her eyes. "Let's smoke this." She pinches it by the nipple and slowly withdraws the Cuban, twisting it a little, moving it from side to side. It shines like chocolate frosting. I wonder how she could have gotten so wet. She raises her ass off the floor when she passes the butt from her pussy. She offers it to me, pinching it in her fingers at the nipple. I grip it in the center and put the butt between my lips. I taste the sweat, thick spice and sea spray.

It sizzles when she puts the match to the tip. I draw on it gently, her juices coating my lips. The nipple burns quickly.

Sophie moves her face close to mine as I puff. She licks the length of it as I smoke.

She asks me for a puff. I take it from my mouth and touch the butt to her lips. She licks it as I run it over them. She pulls in some smoke.

I kiss her in a cloud of thick, musky smog. Then I give her the Cuban and undress. She smokes it through the unbuttoning of my shirt and through the unbuckling of my trousers. Naked, I take it from her and smoke. Driving between her tobacconized pussy lips, I puff hard. Then I let her taste it, blowing her face with smoke. She screams, leaving a hard ring in my ears.

Her screams plow a silence in my head, like a bulldozer clearing deep-rooted trees. Through the ring I open to her warmth and everything stops. Through the silence I hear my father's footsteps on the sidewalk. I hear the crunch of gravel and ground glass on the soles of his leather shoes as he walks to the tobacco shop to get a box or two of the best of the six.

Artemis

Carol Queen
(writing as Artemis Golightly)

MY NAMESAKE, ARTEMIS THE HUNTRESS, the Ever-Virgin, ran with dogs. "Virgin" once meant not chaste, but "she who belongs to no man." Once I believed that Artemis was a sapphist, consorting only with women. Now, I think the obvious was overlooked.

Artemis ran with dogs. Once, like the sapphists, I could envision communicating, consorting, only with my own kind. But then I met a priest of Artemis: a man who explored the most sacred of the perversions, whose sense of love and connection did not stop with humans. I met him where people gather to share special knowledge about the erotic realms; I saw him and knew he had something I wanted. I wanted *him*, wanted to be set apart by his touch. He was ready to be friend and lover to me, as he already was friend and lover to the creatures sacred to Artemis.

When I am most in love, usually, my heart and cunt and spirit align, and the more love I feel, the more pleasure that comes to me, the more I can envision: why had it never spilled over this way, covered all of creation, before? My priest saw no boundaries between creatures, none between sex and worship and play. Why should anyone or anything not make his cock rise like a satyr's, and who could deny him his brotherhood with the beasts? My spirit was already thoroughly pagan, but what kept me from putting the world in my mouth and sucking, from spreading to it so it could ride me? I wanted to learn what he knew. And with his breath on my neck, covering me like a hound, flowering me into sweet, howling screams, I felt ready.

MIDSUMMER CAME, TIME TO HONOR the heat of creation. He said he

was going to the country, better to do ritual there, a full moon you could *feel*, not just see. I wanted to learn what he knew; I asked if he would take me with him. Driving away from the city we told each other stories: how watching the moon, high and clear in the mountain night, I had found myself shaking with lust before I was old enough to know what lust was. How prowling the house and yard when his parents were asleep, under the spell of the same moon, he would end up in the garden fucking his hard boy's cock into the soft brown dirt, how it furrowed open for him as his fingers dug themselves in to hold him against the earth, fucking wildly, and he picked vegetables to slide up his ass so the earth could fuck him back, pumping til his jizz geysered out and splattered into black spots on the dirt. The pagan lusts of children, when we're still so close to being animals: how they punish us for it when they learn. Fighting such odds to grow up to be shamans, when sexual shamanism is the most dangerous art of all.

That night as we lay in a strange house I imagined I was soft loam spreading out forever, furred with green grass, whole wide earth for him to plow his cock into. I dreamed my body had leaves and vines; my cock was big and green, vegeate, and he knelt above me and it disappeared into him, up his ass and he howled like a dog when he came. I wondered what he looked like when he was ten. I remembered what my body looked like, nearly breastless, like his but with a slit instead of a cock, that I had only just learned to slide my fingers into while I stared out mesmerized at the moon and felt my clit a small throb against my hand. He would have been my brother and we would have grown up together, not alone. We stayed with his friends who kept dogs, and outside the windows of the room they gave us we could see garden and trees and hills in the distance, not lights and cars and concrete and sound. We fucked like children as the moon rose.

The next day we went outside and the dogs came to mill around us, they were friendly and curious, four big ones, and I wondered which of them had taken him under other full moons

while he knelt in the dirt or in the house in front of a winter's fire, casting weird shadows, men are not supposed to kneel for other men, they are not supposed to kneel for beasts.

"Choose," he told me.

I felt like a little girl, scared and excited. And virginal, thrilling with ignorance. How do the parts fit together? How do we begin? I don't remember how to talk to animals. I want to remember. My human arrogance, thinking that *I* would have to initiate. They closed around me, sniffing my skin, the scent of willingness. They were so beautiful, taut muscles under skin under fur. The hounds of the Goddess: the people who kept them honored them that way, they weren't *pets*, they knew how to talk to humans. Two brown ones, sleek-pelted, one big, the other huge, a black one, and a white one. The white dog, an arctic dog, fur edged with grey, had ice-blue eyes, and he regarded me calmly while his brothers circled us, and it was so simple. I went to him, knelt in the grass before him: would he choose me back? He came to me and I felt his harsh-soft fur, and then he began nudging me with his nose, push-push-push, it was so simple. I pushed back at him, elated that I *did* know how to talk to him, he nudged me again hard. I was a child playing a game with a doggie. I was a woman being chosen.

The blue-eyed dog trotted beside us as we walked away from the house. The black dog and the brown ones watched us as we went. We came to a circle of trees and stones, where so much ritual had been done that the smell of it hung spicy on the air. The dog knew the place, had almost seemed to lead us there, and stood in the circle's center watching my lover's hands on me, watching him strip my clothes from me, watching my body almost devoid of fur as it emerged to him. The man's hands and the dog's eyes were on me, I felt each hotly, I did not know which realm I belonged to, I was not sure I was human any more, I was not sure how to speak. I knew that the man's hands passed over my skin and I was so aroused I could hardly breathe, and I was confused, the dog still held my gaze, his paws should not feel like this, his paws feel like hands.

I was ready. And at a word from the man the dog came to

me, he had been waiting the whole time for my readiness, watching, and spellcast, I was ready to be his bitch now. My lover was at my back; I felt his cock hard between the halves of my ass. The dog leaped up and embraced me, as tall as I was, his paws on my shoulders, hot breath nuzzling, such blue eyes, and my arms closed around fur over live flesh over breath and blood and heart pounding, his heart beating against mine but the rhythm different, I embraced him and felt his fur rub my breasts, nipples so hard I want his tongue now, I feel his cock against me and I want to sink to my knees, in heat *this* is what it feels like to be in heat. The man had stepped away from me, the dog and I embraced in the middle of the sacred circle and our bodies rubbed together, it was like dancing, is he going to fuck me?

I *did* fall to my knees, I think I was crying, hugging him to me like a child would hold a puppy, like I *did* hold my doggie when I was a little girl and I loved him but he died, with this goddess-dog he was alive again and I a child, he was the first dog I had loved since then. But my hands on the hard muscle of him the fur softer on his belly, almost pink through the white fuzz, his cock is fully out now long and slick and red, I touch it and the child vanishes the heat is back it is growing bigger, it is pointed, at my touch he has turned fully sexual and thrusts it in and out of my hand, I make a fist for him and in a minute it will be my cunt, I am almost there, I will be a witch who talks with animals.

My shaman sits atop a flat stone, cock still high, eyes glowing. He is the wizard, the facilitator, the bridge between worlds. He has been a dog between my legs humping wildly for entrance to my cunt, a warm wet lodge for his cock, so hot he's not human. He has been a virgin kneeling like a bitch, waiting for the pointed cock to find its mark, loose its jism in him, shoot him full of a knowledge a hu/man's not supposed to have. He knows everything already and he watches me, the dog and he have exchanged places, he watches me now: when the knowledge comes to me he will be with me, looking into my eyes when it all changes.

He beckons the dog and me to the stone. I lie back like a

sacrifice, like an altar offering. My legs just touch the ground, dangling off the edge of the rock which is as high as a bed. My pussy is spread wide to the white dog and his tongue is long, longer than anyone's who's ever licked me there. He likes my juice, it flows onto his tongue, he laps harder, his nose streaks cold along my thighs, I feel his teeth sharp he scares me I am shuddering and coming for him, he is going to be my consort. It is Midsummer I will be the wolf-queen I realize that I am crying aloud for him to take me. He is my consort he leaps up on me again only now I am lying spread for him, my arms circle his chest my tits buried in his fur I have his ruff in my fists he is stroking frantically against me now no one has ever wanted me more. It is so simple, I reach one hand down take his slick red cock aim its point between my wet lips next stroke he is in my wolf-king my consort fucking me so very fast so fast, hard and he's big now, he's swelling, sticking inside me his knot so I can't escape I'm his bitch this dog's bitch his queen I am gasping but I want to howl. All sweat and fur he's swollen huge now, he's stopped thrusting, I'm writhing and growling, bitch who wants to come.

And above me my shaman-lover stands and strokes his cock slow, he is my witness, later I will ask him to tell me in human words what happened, I am not a human right now maybe I will never quite be a human again. The dog is not fucking now he is coming, standing quiet he is ejaculating tongue hanging and now his eyes do not quite focus on mine. And I am growing fuller and fuller dogs do not cum quickly he pumps it into me a little at a time. His knot starts to shrink and he's not stuck any more, his cock pulls out of me and I stroke him as he stands over me now he's spraying his fine jet of cum on my belly and the ritual has peaked, I am less dog now more woman, he is more dog and less king but I know what I would do if he were a man: But why not, there are no boundaries between creatures now. So I slide down and raise my mouth to him, if he were a man I'd suck him so I take his cock, honor him like a lover since he *is* my lover. His juice jets onto my tongue, it tastes salt and clean and animal, I get my lips around his knot and it slides down my

throat warm, he is calm I stroke his fur this is all controlled by instinct.

I look up at my human lover just in time to hear him name me in the breaths before the cry he made as he came, the last fast cock-strokes and I reached my tongue to catch it as he spurted creamy rain less delicate than the dog's, but I was greedy *he* would be my animal now, falling into holy rut on the stone while the white dog curled and slept, true brother and sister: I heard him whisper, *Artemis.*

The Contributors

BLAKE C. AARENS is the great-granddaughter of Esther and Hattie, the granddaughter of Dicy, and the daughter of Cobia. She is a survivor of childhood sexual abuse who writes award-winning erotic fiction. She has been published in *Aché: A Journal for Lesbians of African Descent*, the *Herotica®* series, *Best American Erotica 1993*, and *Penthouse*. She has just completed her first novel, *Cowards of Conscience*.

MARK ELK BAUM weaves together movement, music, and speech to create performances exploring questions of love, sex, and spirit.

SCOTTY BROOKIE thinks that if more people talked openly about sex, the streets would be safer and there would probably be no need for the 40-hour work week. He lives in Santa Cruz, California, and publishes the *Lavender Reader*, a quarterly queer journal. His work has appeared in *Gay Community News*, the *Santa Cruz Metro*, and other publications.

CAPRICE lives in sunny Oakland, California, building boats and living a pagan life of pleasure and ease.

M. CHRISTIAN's stories have appeared in *Best American Erotica 1997*, *The Mammoth Book of International Erotica*, *Hot Ticket*, *Noirotica 2*, and *First Person Sexual* (Down There Press). He is the editor of *Eros Ex Machina: Eroticizing the Mechanical* and *Midsummer Night's Dreams*.

CALLA CONOVA relates to her favorite graffiti, "I have a rich inner life." Sharing her personal inner erotic life at the Erotic Reading Circle since its early days has been a "supportive communion" to her. She lives in San Francisco with her teenage daughter, a dozen orchid plants and a black cat.

According to Joe, PATRICIA ENGEL is an angel in a body. She

has been published in *Readers Write on the Sun*. She is a dancer, a mother, and a caretaker of goldfish, cockatiels, feral cats and roses. Occasionally she plays waltzes on a double button diatonic accordion.

MATTHEW HALL has lived in London and San Francisco. He appreciates jazz and adores his sister Mariah.

ANNA HAUSFELD is an Australian transplant living in San Francisco. She is a bisexual mother, female orgasm coach, workshop leader and breast cancer survivor. She delights in women having what they want.

TREBOR HEALEY is the author of five chapbooks of poetry and has been published in more than twenty journals and literary reviews, as well as in *The Bad Boy Book of Erotic Poetry*, *Between the Cracks*, and *Queer Dharma*. He co-edited *Beyond Definition: New Writing from Gay and Lesbian San Francisco*.

JANICE HEISS is a writer and performer who lives in San Francisco. She has performed stand-up comedy and performance art, and was a member of The Plutonium Players. Her work has been published in *Jewish Currents*, *Androgyne*, *Herotica 2*, *First Person Sexual*, *The Best of Libido*, and a Papier-Maché anthology.

JAMES HERRIOT holds a Ph.D. in Human Sexuality and is especially interested in understanding the creative fires which spark our imaginations and the passions which fuel these fires.

MARIANNE HOCKENBERRY grew up in a conservative area of California's Contra Costa County that allowed no outlet for the desires of a queer woman into S/M and sexual exploration. Freely talking about sex and desire are very important to her.

WILL KEEN uses any excuse to get out of the house and set foot in deserts, jungles or cities even stranger than his native San Francisco. His writing explores nature or the erotic and he smiles most when it does both. Another story of his appears in *First Person Sexual* (Down There Press).

AL LUJAN is a San Francisco-based writer, visual artist and performer. His writing appears in *Beyond Definition*, *Best American Erotica 1995*, *Best American Erotica 1997*, *Drummer*, and *A La Brava*. Al also works as a hospice caregiver.

KATIA NOYES writes dyke porn and investigates the arts scene

for local periodicals. Previous writing sites include *Paramour, SF Weekly, High Performance, Sidewalk, and More Out than In: Notes on Art, Sex, and Community.* She is writing a novel and a book of personal essays.

CATHIE POSTON is pleased that this is her first legitimate sale in such a wonderfully illegitimate market. Like her character she is a polymorphous perverse, pansexual pervert and recovering fag-hag. She is proud to be a trainer for San Francisco Sex Information and a member of the leather community.

RACHEL POWER is working on a doctoral dissertation focused on the experience of love at first sight. Writing erotica came naturally.

RAMPUJAN is a San Francisco urban farmer, raw foodist and bicycle poet. He is past sixty, a devoted husband and father, a swimmer and a backgammon player who occasionally matches the outrageous behavior of his fictional characters.

THOMAS ROCHE has been writing and editing in the San Francisco area for about five years. His projects include the anthologies *Noirotica* and *Noirotica 2*, as well as the Fucking Sucks! series of erotic performance readings. His short fiction is collected in *Dark Matter*.

CAT ROSS is a proud, fat, queer film maker, dancer and sex worker. Her favorite things in life are dancing, sex and food. She lives in San Francisco with her python, Felice. This is her first published work. She thanks her mother for loving her just the way she is.

LAWRENCE SCHIMEL is the author of *The Drag Queen of Elfland* and the co-editor of *Switch Hitters* and *PoMoSexuals* (both with Carol Queen), *Two Hearts Desire* (with Michael Lassell), *Food for Life and Other Dish*, and *The Mammoth Book of Gay Erotica*, among many other books. He lives in Manhattan.

LORI SELKE has been published in the 'zines *Fat Girl* and *Black Sheets*, and in the anthologies *The Second Coming, Leatherwoman III, Genderflex,* and *Bitch Goddess*. She thinks vegetables have been given short erotic shrift.

SIMON SHEPPARD's work has been published in *Best American Erotica 1997, Best Gay Erotica 1996* and *1997, Switch Hitters,*

Bending the Landscape—Fantasy; and *Grave Passions: Tales of the Gay Supernatural*. His stories also appear in *Drummer* and *Power Play*.

HOREHOUND STILLPOINT has been studying the Bhagavad Gita and the Upanishads so he can be the best waiter/writer/cock-sucker he can be. Pieces of him can be found in *Butch Boys, Queer View Mirror II, Gents, Bad Boys, and Barbarians*, and *Beyond Definition*. He eats his broccoli, too. His chapbook, *Dovetail*, is available from 574 3rd St., #327, San Francisco CA 94107

MARK STUERTZ currently lives in Dallas, Texas, where he works as a freelance wine and food writer, business journalist and graphic artist. His short works of erotic fiction have appeared in *Paramour* and *Best American Erotica 1997*.

TRISTAN TAORMINO is the author of *The Ultimate Guide to Anal Sex for Women*, editor of the annual series *Best Lesbian Erotica*, co-editor of *Ritual Sex* and *A Girl's Guide to Taking Over the World*, and publisher of *Pucker Up*. Her work has appeared in *The Advocate, On Our Backs, Sojourner, The Boston Phoenix, The Femme Mystique, Heatwave, Chick-Lit 2*, and *Virgin Territory II*.

J. A. VASCONCELLOS is a San Francisco Bay area writer.

MOLLY WEATHERFIELD'S pornography draws on the humor and irony lurking in the shadows of her fantasy life. "It Will Do For Now" is an excerpt from her forthcoming novel *Safe Word — Carrie's Story II*, a sequel to *Carrie's Story* (Masquerade). Her annotated bibliography on the theory of porn is online at www.mtbs.com.

DEBBIE ANN WERTHEIM lives in San Francisco and screams pretty. Her stories have been published in *On Our Backs, Future Sex*, and *Fat Girl*.

BRIAN D. YOUNG embodied the archetype of Dionysius—expressing playful male sexuality with women and men that came from the heart. On March 29, 1995 at the age of 39, Brian died of complications due to AIDS.

The Editors

JACK DAVIS is a faggot and one of the worker/owners of Good Vibrations. He is a weaver of men who has dedicated his life to naked men dancing blindfolded. To this end, he organizes naked queer sex rituals in the streets. His writing has appeared in *Movement Research Performance Journal, More Out Than In, Notes on Sex, Art and Community,* and RFD.

CAROL QUEEN is a Good Vibrations worker/owner, a sex educator, and a widely published writer of erotic fiction and sex commentary. She is the author of *Real Live Nude Girl: Chronicles of Sex-Positive Culture, Exhibitionism for the Shy* (Down There Press), and an erotic novel, *The Leather Daddy and the Femme.* She has also edited two books with Lawrence Schimel, *Switch Hitters: Lesbians Write Gay Male Erotica and Gay Men Write Lesbian Erotica;* and *PoMoSexuals: Challenging Assumptions About Gender and Sexuality.*

Where to find more of Carol Queen's writing

Books
Exhibitionism for the Shy: Show Off, Dress Up, and Talk Hot (Down There Press, 1995)
Real Live Nude Girl: Chronicles of Sex-Positive Culture (Cleis, 1997)
Switch Hitters (Cleis, 1996), co-editor with Lawrence Schimel
PoMoSexuals (Cleis, 1997), co-editor with Lawrence Schimel

Short Stories
Herotica 2 (NAL/Plume, 1991)
Herotica 3 (NAL/Plume, 1994)
Herotica 4 (NAL/Plume, 1996)
Herotica 5 (NAL/Plume, 1998)
Best American Erotica 1993, 1994 (Collier/Macmillan, 1993, 1994)
Leatherwomen (Masquerade, 1993)
Doing It For Daddy (Alyson, 1994)
Looking for Mr. Preston (Richard Kasak/Masquerade, 1995)
Switch Hitters (Cleis, 1996)
Best Gay Erotica 1996 (Cleis, 1996)
Best Lesbian Erotica 1997 (Cleis, 1997)
Sex Spoken Here (Down There Press, 1998)

Essays
Bi Any Other Name: Bisexual People Speak Out (Alyson, 1991)
The Erotic Impulse (Jeremy Tarcher, 1992)
Madonnarama (Cleis, 1993)
Dagger: On Butch Women (Cleis, 1994)
Women of the Light (Secret Garden, 1994)
Virgin Territory (Richard Kasak/Masquerade, 1995)
The Second Coming (Alyson, 1995)
Bisexual Politics: Theories, Queries and Visions (Haworth, 1995)
Bisexuality: The Psychology and Politics of an Invisible Minority (Sage, 1995)

Interviews
Good Sex (Cleis, 1992)
Some of My Best Friends are Naked (Barbary Coast, 1993)

About Down There Press & Good Vibrations

Down There Press is the nation's only independent publisher devoted exclusively to the publication of sexual health books for children and adults. Since 1975 we have looked for books that are innovative, lively and practical, providing basic physiological information and realistic, non-judgmental techniques for strengthening sexual communication. In keeping with our sex-positive philosophy, we also publish erotica, both literary and photographic, for women and men. Each book in our catalog is a unique, worthwhile addition to the understanding of human sexuality.

Founder Joani Blank worked as a sex therapist and sex educator in the early 1970s. She taught human sexuality at community colleges and led sexuality workshops for women. In 1977, Joani opened Good Vibrations in San Francisco, a vibrator retail store, to meet the need expressed by her clients for a "clean, well-lighted place to buy sex toys and books." In 1985, responding to enormous customer demand, she started a mail order sex toy catalog which now mails to customers worldwide.

Joani launched The Sexuality Library catalog in 1988. This list currently includes over 400 books, audiotapes, videos and CD-ROMs from publishers around the world.

Open Enterprises Cooperative, Inc., the parent company of Down There Press, Good Vibrations and The Sexuality Library, was formed in 1992, when Joani and her employees re-organized the company as a worker-owned cooperative. The business opened a second retail store in Berkeley, California, in 1994 with strong community support.

In January 1996, Down There Press entered cyberspace at www.goodvibes.com/dtp/dtp.html on the Good Vibrations Web page.

To Order Down There Press Books:

_____ **Sex Spoken Here,** *Carol Queen & Jack Davis, editors.* $14.50

_____ **Exhibitionism for the Shy,** *Carol Queen.* "A sexual travel guide...." (*Libido*) to discovering your erotic inner persona. $12.50

_____ **Sex Toy Tales,** *Anne Semans & Cathy Winks, editors.* Erotica that expands the imagination with vibrators, scanners...and more! $12.50

_____ **Good Vibrations Guide: Adult Videos,** *Cathy Winks.* Everything you wanted to know about selecting and watching X-rated flicks. $7.00

_____ **Good Vibrations Guide: The G-Spot,** *Cathy Winks.* The latest information on what some consider the ultimate pleasure spot. $7.00

_____ **Herotica®: A Collection of Women's Erotic Fiction,** *Susie Bright, editor.* Lesbian, bi, and straight short stories that sizzle and satisfy. $10.50

_____ **I Am My Lover,** *Joani Blank, editor.* Twelve women celebrate self-sexuality in over 100 exquisitely explicit duotone photos. $25.00

_____ **First Person Sexual,** *Joani Blank, editor.* Women and men describe their masturbation experiences in forthright anecdotes and essays. $14.50

_____ **Femalia,** *Joani Blank, editor.* Thirty-two stunning color portraits of women's genitals, demystifying what is so often hidden. $14.50

_____ **Anal Pleasure & Health, revised.** *Jack Morin, Ph.D.* Comprehensive guidelines for AIDS risk reduction and safe, healthy anal sex for men, women and couples. Completely updated for the '90s. $18.00

_____ **The Playbook for Women About Sex,** *Joani Blank.* $4.50

_____ **The Playbook for Men About Sex,** *Joani Blank.* Activities to enhance sexual self-awareness and consciousness. $4.50

_____ **Good Vibrations: The Complete Guide to Vibrators,** *Joani Blank.* "...explicit, entertaining....encouraging self-awareness and pleasure." *Los Angeles Times* $6.50

_____ **Sex Information, May I Help You?,** *Isadora Alman.* An "...excellent model on how to speak directly about sex." *S.F Chronicle* $9.50

_____ **Erotic by Nature,** *David Steinberg, editor.* Luscious prose, poetry and duotone photos in an elegantly designed cloth edition. $45.00

Catalogs — free with purchase of any book, else send $2

_____ **Good Vibrations Mail Order.** Sex toys, massage oils, safe sex supplies — and of course, vibrators!

_____ **The Sexuality Library.** Over 300 sexual self-help and enhancement books, videos, audiobooks and CD-ROMs.

Buy these books from your local bookstore, call toll-free at **1-800-289-8423,** or use this coupon to order directly:

Down There Press, 938 Howard Street, San Francisco CA 94103

Include $4.50 shipping for the first book ordered and $1.00 for each additional book. California residents please add sales tax. We ship UPS whenever possible; please give us your street address.

Name _____

UPS Street Address _____

_____ ZIP _____